Blooming in the Shadows

Blooming in the Shadows

UNOFFICIAL CHINESE ART, 1974-1985

Kuiyi Shen

Julia F. Andrews

Edited by Willow Weilan Hai Chang

J. May Lee Barrett

China Institute Gallery
China Institute
New York
2011

Distributed by Art Media Resources, Ltd.

The catalogue was published to accompany the exhibition
Blooming in the Shadows: Unofficial Chinese Art, 1974–1985

Presented at

China Institute Gallery
125 East 65th Street
New York, NY 10065
212.744.8181
September 15–December 11, 2011

Library of Congress Control Number: 2011932907
ISBN-10: 097405478
ISBN-13: 978-0-9774054-7-3

General Editor and Project Director: Willow Weilan Hai Chang
Consulting Editor: J. May Lee Barrett
Catalogue Designer: Peter Lukic/Mixed Art
Exhibition Designer: Perry Hu
Printed in the United States of America

Note to the Reader
Chinese is romanized in the *pinyin* system throughout the text
and bibliography except for the names of Chinese authors writing in
Western languages. Chinese terms cited in Western-language titles
remain in their original form and have not been converted.

Front cover (left to right)
Zhang Wei, *Temple of Heaven 1*, 1976 (detail, cat. no. 4)
Wang Keping, *Silent*, 1979 (detail, cat. no. 45)
Qiu Deshu, *3–5 Times Shouting*, 1980 (detail, cat. no. 61)

Back cover (left to right)
Xingxing artists at the Chinese National Art Gallery, Beijing, August 1980 (fig. 6)
Wuming artists at Beidaihe, September 1975 (fig. 5)
Caocao artists from the flyer "Caocao She: Art for the 1980s Exhibition," 1980 (fig. 11)

Photo Credits

5, 10, 28	Maggie Nimkin
6, 16, 19, 36, 56, 64	Courtesy of the lender
20, 21, 22	Courtesy of Zheng Ziyan
23, 24, 25	Wang Aihe
29, 30, 31	Beijing Caizhilin Picture and Text Design Co., Ltd, Beijing, China; courtesy of the artist
43	Kaz Tsuruta

Unless otherwise indicated, all other images are provided courtesy of the artist.

CONTENTS

LENDERS TO THE EXHIBITION

Anonymous
Carolyn Hsu-Balcer and René Balcer
Chen Juyuan
Ethan Cohen
Joan Lebold Cohen and Jerome A. Cohen
Du Xia
Fred Gordon
Cees Hendriske
Huang Rui
Jiang Depu
Na-Loretta Law
Li Shan
Liu Shi
Li Shuang
Ma Desheng
Ma Kelu
Michael Micketti
Qiu Deshu
Shi Zhenyu
Tian Shuying
Wang Aihe
Wang Keping
The Estate of Wei Hai
Yan Li
Zhang Wei
Zheng Zigang
Zheng Ziyan

SPONSORS OF THE EXHIBITION

*This exhibition, related programming, and catalogue
have been made possible in part through the generous support of the following* *

BENEFACTORS
Carolyn Hsu-Balcer and René Balcer

PATRONS
Edward A. Studzinski

CONTRIBUTORS

Asian Cultural Council asian cultural council
Anla Cheng and Mark Kingdon/The Kingdon Foundation
Virginia A. Kamsky
Dana Tang and Andrew Darrell
Wan-go H. C. Weng

SUPPORTERS

Keith Abell
James and Victoria Chang
Nellie Chi and George Sing
Richard A. and Ruth Dickes
Susan and Jay Goffman
Carol and Timothy Rattray
Sophia and Abel Sheng

* At the time of printing

INDIVIDUALS

Haiman Cai

Nellie Chi and George Sing

James J. Chin

Clairoan Foundation

John R. and Julia B. Curtis

Robert W. de Bruin

P. Benjamin Duke

Hart and Nancy B. Fessenden

Kenneth and Patricia Gaglione

Susan Burke Herera

Marie and Shau Wai Lam

Kevin J. and Laura Lavin

Robert W. and Virginia Riggs Lyons

Gerard M. Meistrell

Bruce H. Mendelsohn

Anastasie Astrid Christiansen-Croy and John M. B. O'Connor

Mary Agnes Pan

William N. Raiford

Joanne Ramos

Theresa M. Reilly

Howard and Mary Ann Rogers

Martha Sutherland and Barnaby Conrad III

Michael and Julie Waldorf

Marie-Hélène Weill

Denis C. and Kathleen Yang

China Institute Young Associates Steering Committee

MESSAGE FROM THE BOARD AND PRESIDENT

China Institute is proud to present Blooming in the Shadows: Unofficial Chinese Art, 1974–1985. This seminal exhibition will explore the rise of three unofficial groups of artists in the decade after the Cultural Revolution. The Wuming (No Names), Xingxing (Stars), and Caocao (Grass Society) each pursued diverse paths to artistic freedom, all of which flew in the face of the accepted socialist realist style of the time and what was considered politically acceptable behavior. The ideas generated and works created by these groups helped launch the avant-garde movement in 1985 and laid the groundwork for Chinese contemporary art.

This heretofore underexplored art-historical period represents a new chapter in the ever-expanding scope of China Institute Gallery's exhibition program. It also demonstrates our aspiration to continually create and organize exhibitions that provide a fresh window into Chinese culture. China Institute is very grateful to have such generous lenders and supporters—many of whom are the artists themselves—willing to share these important artworks with China Institute and the public, thereby illuminating an important period in modern Chinese history.

We would like to extend our thanks to Willow Weilan Hai Chang, Director of the China Institute Gallery, who has led this project from inception to completion. We would also like to show our appreciation to the guest curators and authors of this catalogue, Kuiyi Shen, Director of Chinese Studies Program and Professor of Asian Art History, Theory, and Criticism at the University of California, San Diego, and Julia F. Andrews, Professor of Art History at Ohio State University and a specialist in Chinese painting and modern Chinese art. The essay in this catalogue is a testament to their dedication to the ideals of the talented and heroic artists who are the subject of this exhibition. We are grateful to the Gallery staff and participants in this project as it would never have come to fruition without their hard work. Nor could we succeed in fulfilling our mission without the continuing support of our Trustees, our Gallery Committee, the Sponsors of the Exhibition, and, of course, our loyal Friends of the Gallery, to all of whom we are especially grateful.

Virginia A. Kamsky,
Chair, Board of Trustees

Sara Judge McCalpin
President

FOREWORD

Artists coming to maturity in post-Liberation China struggled with the legacy of their own traditions, the influence of Western art movements, and the pressure of difficult political events in their quest for individual artistic expression. They were concerned not only with form and medium, but more importantly and enduringly, with concepts of modernity that moved them toward abstraction and new ideas about beauty. These ideas drove them to experiment and create works of art outside the official realm, works which they defended heroically. Their art and activism broke ground for the avant-garde artists of the late 80s. Today, in our fast-paced world of information and commercial exchange, China's artists are more engaged than ever with international art movements. In this context, serious young artists may ponder the question of what is Chinese art and if such a distinction is even relevant. As they explore their own identity and new creative directions, they are indebted in some measure to an earlier generation which had asked the same questions, a generation of Chinese artists working in the shadows.

Blooming in the Shadows: Unofficial Chinese Art, 1974–1985 examines the lives and works of young artists who dared to pursue their own creative impulses and to organize themselves under difficult political circumstances. Their exhibitions in the critical decade from the late Cultural Revolution to the beginning of the avant-garde movement in 1985 defied the official art establishment and helped to turn around official policy on creative freedom.

Of the three artists' groups introduced here, the Wuming (No Name) group in Beijing appears to have been more influenced by the Western techniques of watercolor and oil painting. Their works, however, shunned the political content that was the accepted norm of their day, focusing instead on ordinary scenes of life and nature around them. The Caocao group, or Grass Society, in Shanghai experimented with the traditional Chinese media of ink and watercolor to find expression in a range of modern and non-objective styles. More than the other two groups, the modernist Xingxing (Stars) group in Beijing, garnered international attention for challenging the establishment. Whether pursuing their various artistic visions with a Chinese brush, a Western brush, a carving knife, or some other tool, these three groups—as well as other forward-looking artists' groups in the country during those years—ushered in the current era of Chinese art. Contemporary Chinese artists have caught the attention of art lovers and critics around the world not only by measure of the dollar value of their creations, but also for their expression of different points of view through visual experiences.

The initial interest in this project sprang from an exhibition of the Wuming group in 2006 that I learned about from our trustees Sophia Sheng and Yvonne Wong. I contacted the exhibition curator Gao Minglu to discuss the possibility of bringing the show to China Institute and had a meeting with several Wuming artists in Beijing. That year I presented a proposal for an exhibition of the Wuming to the Gallery Committee, whose members suggested including more groups from the same period. The current structure of the exhibition was conceived by the guest curators Kuiyi Shen and Julia F. Andrews and approved

by the Committee in 2009. It expands the scope of the project from its focus on Wuming to encompass another two of the most representative artists' groups of the late 1970s and early 1980s, the Xingxing and the Caocao. Drs. Shen and Andrews selected the artworks to illustrate the contributions of these three groups in the important ten-year period which gave birth to China's avant-garde art movement.

We are indebted to all our sponsors for making this exhibition possible and especially to Carolyn Hsu Balcer and René Balcer, whose passionate support ensured the success of many aspects of this project. I am additionally grateful to our Gallery Sponsors for their continuing support of all our programs and to those who raised their paddles to bid at the annual China Institute Gala benefit auction in May. Several members of the Young Associates of the China Institute put a fund together to support the Gallery exhibitions. Their generosity touched me deeply. To them I say proudly, "You are the future of art." I am confident that with all of your encouragement and support, we will continue to explore a great civilization's spirit of creativity and to create a bridge of understanding through a love of art.

Furthermore, I am grateful to the Institute's Board of Trustees, led by Virginia A. Kamsky, and to the Gallery Committee, led by Diane H. Schafer, for their support and guidance. I am indebted to the gallery staff, Beth Eisenstaedt, Gallery Manager and Registrar, and Yue Ma, Manager of the Gallery Art Education Program for their diligent work and assistance in the many aspects of putting together a successful exhibition. My gratitude is extended to the loyal Gallery docents and volunteers for their devoted service; to Donna Thomas, the Director of Development, who led her team in raising the necessary funds for this project; and to Agnes Hsu, Director of Art and Culture, for organizing the related symposium.

I consider myself fortunate to have worked with a talented team of consultants. My deep appreciation and gratitude go to J. May Lee Barrett, whose editing and knowledgeable suggestions greatly enhanced the quality of this publication; to Perry Hu, whose exhibition design complements the art beautifully; to Peter Lukic, whose clean and modern design of this catalog guarantees that our enjoyment of the artwork lasts beyond the exhibition's closing date; and to Nicole Strauss and Margery Newman, whose professional public relations work brought this show to the attention of the general public. Finally, I would like to extend my sincere gratitude to Sara Judge McCalpin, president of China Institute, for her continued understanding and support.

Willow Weilan Hai Chang
Director
China Institute Gallery

PREFACE AND ACKNOWLEDGEMENTS

We have attempted here to partially fill a gap in the existing scholarship of modern Chinese art history: the period between the late Cultural Revolution and the birth of the Chinese avant-garde in 1985. The artists in the exhibition sought to create within a society still strait-jacketed by Maoism a cosmopolitan art free of political constraints. They were briefly tolerated and permitted a public voice in 1979. But the political establishment closed ranks by black-listing many of them in 1982. As a result, they remain largely unpublished in China; they were forced to leave the country or abandon their artistic careers and have all but disappeared from the narrative of modern Chinese art history. A print ban put in effect on discussion of their art meant that what they did is poorly documented in the mainstream art press. Indeed, sole historiographic credit for the avant-garde challenge to the status quo, which they had initiated, has usually been granted to others, artists who were vetted by the system and had graduated from the official art academies. We argue instead that the slow turnabout in the official Chinese art establishment—from narrow socialist realist conventions of the 1970s to the more open, internationally-oriented approach to art that became mainstream in the early 1990s—was in fact begun by the daring young artists of *Blooming in the Shadows*, supported by a handful of equally brave elders who had briefly returned to positions of official influence in 1979.

Our great thanks go to Willow Hai Chang and Carolyn Hsu-Balcer for inviting us to develop *Blooming in the Shadows*. We are sincerely grateful to the artists Shi Zhenyu, Zhang Wei, Li Shan, Ma Kelu, Zheng Ziyan, Zheng Zigang, Wei Hai, Wang Aihe, Liu Shi, Tian Shuying, Du Xia, Huang Rui, Ma Desheng, Wang Keping, Qu Leilei, Yan Li, Li Shuang, Ai Weiwei, Qiu Deshu, Chen Jialing, Jiang Depu, and Chen Juyuan for patiently submitting to our interviews, for providing us with precious first-hand material, and for lending us their work. On behalf of the Wuming group, Wang Aihe and Zheng Ziyan have been extraordinarily helpful. With them, we mourn the passing of Wei Hai. Yan Li has gone to extraordinary lengths to assist our research on the Xingxing group, including loaning us rare publications. Wang Keping and Huang Rui have both responded to our constant questions with generosity and patience. All have lent work of enormous art historical value. Qiu Deshu of the Caocao group has provided us with rare primary documents of their ill-fated exhibition along with helpful print materials. In addition to the artists, we would like to thank Carolyn Hsu-Balcer and René Balcer, Ethan Cohen, Joan Lebold Cohen and Jerome A. Cohen, Fred Gordon, Cees Hendriske, Michael Micketti, Loretta Law, and other lenders to the exhibition for the great trouble to which they have gone to satisfy our requests.

To those who have endeavored to document these artistic groups despite all difficulties, we owe a debt as well. Gao Minglu's pioneering work on the Wuming group provided useful information. Wang Aihe, working with extraordinary perseverance and diplomacy, produced an important compilation of the creative output of thirteen of the Wuming artists. Chang Tsong-zung provided us with his extremely perceptive catalogue,

The Stars: Ten Years, and long-standing collegial support. Tabata Yukihito generously gave us his excellent catalogue, *Demand for Artistic Freedom,* produced for the twentieth anniversary of the Xingxing. We are grateful to Yan Li, Huang Rui, Wang Keping, and Qu Leilei for invaluable recent publications. Joan Lebold Cohen has shared her wisdom and all manner of help, including the generous loan of her early slides. Her book *The New Chinese Painting* was for many years the only source on the Caocao group. Denis Mair brought us news of the artist-poets on his 2007 visit to Columbus. Perry Link lent us slides of the second Xingxing show. Lesley Ma and Yanfei Zhu transcribed audio and video interviews with the artists. Zhang Qing provided invaluable help, as did Carolyn Hsu-Balcer and René Balcer. Joseph Chang has been a ready source of intellectual exchange. We are immensely grateful as well to Jane DeBevoise for her constant support and to the staff of the Asia Art Archive, particularly Ali Van, for great help in obtaining materials. We would also like to express our thanks to our respective institutions for their generous support through a University of California Academic Senate Research Grant and an Ohio State University Arts & Humanities Research Enhancement Grant.

Finally, we would like to thank Beth Eisenstaedt of China Institute for her good cheer, effectiveness, and patience in managing the production of the catalogue and the exhibition, to J. May Lee Barrett for her skillful editing of the catalogue and labels, to Peter Lukic for his elegant design of this publication, and to Perry Hu for his exhibition design.

Julia F. Andrews and Kuiyi Shen

Chronology

Major Art and Political Events of China 1949–2006*

1949

July 2	All-China Congress of Literary and Arts Workers held
July 2–16	**First National Art Exhibition held in Beijing, promotes revolutionary art**
July 19	China Federation of Literary and Arts Circles (FLAC) established
July 21	**All-China Art Workers Association established; Xu Beihong is chairman; Jiang Feng and Ye Qianyu are vice-chairmen**
October 1	Mao Zedong proclaims establishment of the People's Republic of China (PRC) at Tian'anmen

1950

April 1	**Central Academy of Fine Arts (CAFA) created by merging Beiping Art Academy and North China University's Third Division; Xu Beihong is director**
June 25	Korean War begins
November 7	**National Hangzhou College of Arts renamed East China Campus of CAFA**

1952

January	"Three-anti" and "five-anti" campaigns against corruption launched nationwide
September	**Reorganization of higher education. East China Academy of Arts created in Wuxi by merging the Shanghai Art Academy, Suzhou Academy of Art, and Shandong University Fine Arts Department; Liu Haisu is director**

1953

July 27	Korean War ends
October 4	**Chinese Artists Association (CAA) founded with Qi Baishi as chairman and Hua Junwu as first secretary**
December 12	**Jiang Feng is appointed director of CAFA**

1954

January 15	**Official art journal *Meishu* (Art) is founded**

1955

February 19	**Soviet art expert Konstantin M. Maximov arrives at CAFA to teach a two-year oil painting course**
March 27–May 15	**Second National Art Exhibition, Beijing**

1956

September 10	**Shanghai Institute of Chinese Painting (Shanghai Zhongguo huayuan) established**

1957

May 14	**Beijing Institute of Chinese Painting (Beijing Zhongguo huayuan) established, followed soon thereafter by a Nanjing and a Xi'an Institute**
June 8	Mao Zedong launches the anti-rightist campaign
November 1	**Central Academy of Arts and Crafts established in Beijing**
November 5	***Russian Paintings of the 18th–20th Centuries* opens at Beijing Exhibition Hall (Beijing zhanlanguan)**

1958

Spring	Mao Zedong launches the Great Leap Forward, a radical economic centralization of the country
June	**East China Campus of the CAFA is renamed Zhejiang Academy of Fine Arts (ZAFA)**
July 8	**Exhibition of current Soviet art opens in Beijing**
(1958–59)	Construction begins of "Ten Major Buildings" in Beijing to celebrate the tenth anniversary of the PRC, including Great Hall of the People, Museum of Revolutionary History, Chinese National Art Gallery, National Museum of History, and Beijing Train Station

1959

April 17	Liu Shaoqi is elected chairman of the PRC
December 5	**Pan Tianshou is appointed director of ZAFA**
(1959–61)	Three-year famine, a result of the Great Leap Forward

1960

June 17	**Third National Art Exhibition opens in Beijing**
July 16	Break with USSR made public
October	**Romanian artist Eugen Popa teaches oil painting training course at ZAFA**

1964

September 26	**First part of Fourth National Art Exhibition opens in Beijing, later parts continued throughout 1965**
December 15	***Rent Collection Courtyard* sculptural group exhibited in Beijing**

1966

May	Cultural Revolution begins. Liu Shaoqi, Deng Xiaoping, and most top administrators in government, party, military, education and culture are purged
August 18	Mao meets and praises the Red Guard at Tian'anmen
(1966–68)	**Red Guard art movement begins and continues until roughly 1968**

* Art events are distinguished in bold type

Blooming in the Shadows: Unofficial Chinese Art, 1974-1985

1968

(1968–76) Eight-year movement to send educated urban youth to the countryside

1971

(1971–73) **Zhou Enlai rehabilitates some artists condemned by the Cultural Revolution; he encourages landscape and bird-and-flower paintings suitable for interior decoration and foreign sale**

September 13 Death of Lin Biao

1972

February US President Richard Nixon visits China

April 23–July 23 **National Art Exhibition to Celebrate 30th Anniversary of Mao's "Yan'an Talks"**

1973

March Deng Xiaoping returns to administrative work to assist cancer-stricken Zhou Enlai

November **Central May Seventh University of Arts established in Beijing with Jiang Qing as president, and students recruited by recommendation; CAFA faculty return from countryside**

1974

January Launch of "Criticize Lin Biao, Criticize Confucius Campaign," aimed in part at Zhou Enlai

February 15 **"Black painting exhibition" held in Beijing and viewed by Wuming artists**

March **"Black painting exhibitions" in Shanghai, Xi'an, and elsewhere**

October 1 **National Art Exhibition in Celebration of the Twenty-fifth Anniversary of the Founding of the PRC, Beijing**

December 31 **Wuming underground art exhibition held at Zhang Wei's apartment[1]**

1976

January 8 Death of Zhou Enlai

March 25 **Official art journal *Meishu* resumes publication**

April 5 Spontaneous commemoration of Zhou Enlai and demonstration against Cultural Revolution leaders at Tian'anmen Square; **Xingxing and Wuming participate**

April 7 Hua Guofeng becomes prime minister and party vice-chairman, and Deng Xiaoping dismissed from all positions; the Tian'anmen Incident is declared counterrevolutionary

July 28 Tangshan earthquake hits Tianjin and Beijing

September 9 Death of Mao Zedong

October 6 Arrest of the Gang of Four (Jiang Qing, Zhang Chunqiao, Wang Hongwen, and Yao Wenyuan)

November 23 ***Ardently Celebrate Comrade Hua Guofeng's Appointment as Central Party Chairman and Smashing the "Gang of Four's" Plot to Usurp the Party and Take Power* exhibition opens at Shanghai Art Gallery and continues to January 12, 1977**

1977

February 7 Hua Guofeng promulgates the "two whatevers" policy, affirming the correctness of all Mao's policies

February 18–April 17 ***National Art Exhibition to Ardently Celebrate Comrade Hua Guofeng's Appointment as Central Party Chairman and Chairman of the Central Military Committee and Ardently Celebrate the Great Victory of Smashing the "Gang of Four's" Plot to Usurp the Party and Take Power* held at Chinese National Art Gallery, Beijing**

March Hu Yaobang becomes head of the Chinese Communist Party (CCP) Organization Department

May 23–June 30 ***Exhibition to Commemorate the 35th Anniversary of Mao's "Yan'an Talks,"* Chinese National Art Gallery, Beijing**

July Deng Xiaoping reemerges in public

August Hua Guofeng becomes chairman of the CCP and announces that the Cultural Revolution is over

August 1–October 5 ***Exhibition in Celebration of the Fiftieth Anniversary of the People's Liberation Army,* Chinese National Art Gallery, Beijing**

November *People's Literature* (Renmin wenxue) publishes Liu Xinwu's short story "Banzhuren," the first literary work to criticize the Cultural Revolution

December College entrance examinations resumed

1978

January Hua Guofeng's article "Uphold Mao Zedong's Revolutionary Line in Literature and the Arts" is published in *Meishu*

February ***Meishu congkan* (Art anthology), the first journal to publish modernist art, begins publication in Shanghai**

March 25 **"Studies" exhibition opens at Luwan District Cultural Center, Shanghai, showing more than 300 apolitical works by old and young artists; Qiu Deshu is organizer**

March **Opening of *Nineteenth-Century French Rural Landscape Painting Exhibition* in Beijing and on April 25 in Shanghai**

May 12 *People's Daily* publishes "Practice is the Only Measure of Truth," a challenge to the infallibility of Mao Zedong thought

May 16 **Shanghai branch of the CAA resumes activity**

August 11 *Shanghai Wenhui Bao* newspaper publishes Lu Xinhua's short story, "Scar," initiating a literary movement exposing the Cultural Revolution

November Rehabilitation of rightists by the CCP Organization Department begins; **Convictions of Jiang Feng and Liu Xun overturned**

Mid-November Condemnation of the April 5, 1976, demonstrators reversed

Autumn "Democracy Wall," at Xidan Street becomes a site for spontaneously posted citizen's complaints

December 5 Wei Jingsheng posts an essay, "The Fifth Modernization," on Democracy Wall, demanding that democracy be added to the "four modernizations" promoted by Deng Xiaoping

December 18 & 22	Third Central Committee meeting of the Eleventh Party Congress overturns the "two whatevers"; Deng Xiaoping appointed to leadership roles in party, military, and civilian government and assumes control of China
December 23	**Literary journal *Today* (*Jintian*) is founded by Huang Rui, Bei Dao, and Mang Ke and posted on Democracy Wall; Qu Leilei, Ma Desheng, and Huang Rui provide illustrations and design**
December–January	Underground journals of literature and political philosophy *Exploration*, *April Fifth Forum*, *Beijing Spring*, and *Fertile Soil* begin to appear on Democracy Wall

1979

January 1	Diplomatic relations between the US and the PRC are normalized
February	***New Spring* exhibition in Beijing's Zhongshan Park; preface to exhibition written by Jiang Feng**
February 11–18	**The *Twelve-Man Painting Exhibition* at Huangpu District Children's Palace, Shanghai, shows modernist painting**
March	**The CAA resumes activity**
April 8	**The first *Today* poetry recital held**
May	**Wu Guanzhong challenges socialist realism by suggesting in *Meishu* that formal beauty in art is as important as subject matter**
June	***World Art* (*Shijie meishu*) begins publication**
July 7	**Wuming exhibition opens for "internal" showing at Huafangzhai, and Liu Haisu visits on July 9; open for public viewing July 13–29**
August	*Serial Pictures Monthly* (*Lianhuanhua bao*) publishes an illustrated version of "Maple," based on a "scar" short story by Zheng Yi
September 27	**Outdoor Xingxing (Stars) exhibition with 23 participants opens in the garden of Chinese National Art Gallery**
September 29	**Xingxing exhibition closed by the police; airport mural project unveiled, and Yuan Yunsheng's "Water Splashing Festival" provokes controversy about nudity in art**
Autumn	**Caocao Society organized in Shanghai by Qiu Deshu and Chen Jialing**
October 1	National Day, 30th anniversary of PRC; **Xingxing protest march moves from Xidan Democracy Wall to Beijing Municipal Party Committee Headquarters**
October 31	National Congress of Literary and Art Circles opens. Officials express both praise and criticism of the Xingxing
November 3	**Jiang Feng becomes Chairman of the CAA**
November 23– December 2	**First Xingxing exhibition resumes indoors at Huafangzhai, Beihai Park**
December 6	Democracy Wall is closed

1980

February	Former chairman of the PRC Liu Shaoqi is posthumously rehabilitated; Hu Yaobang becomes secretary general of the CCP
February 16	**First Caocao exhibition, *Art for the '80s*, opens at the Luwan District Cultural Center, Shanghai; scheduled until March 9, it was prematurely closed and criticized by the authorities as a product of bourgeois liberalism**
March	**Li Xianting publishes "Guanyu Xingxing meizhan," a favorable review of the Xingxing show in *Meishu*; Li later fired from editorial job for this ideological error**
July 16	**The *Contemporaries* (Tongdairen) exhibition held in Beijing**
Summer	**Xingxing Painting Group formally established**
August 20– September 7	**Second Xingxing exhibition held at Chinese National Art Gallery**
August 26	Four special economic zones, Shenzhen, Zhuhai, Shantou, and Xiamen, are established
September	Zhao Ziyang appointed prime minister
October	**Wu Guanzhong's article "The Beauty of Abstraction" is published in *Meishu***
November	Hua Guofeng dismissed as chairman of the CCP
December	Hu Yaobang conclusively condemns the Cultural Revolution in CCP meeting; **works by Xingxing artists published in *Meishu***

1981

January	*Meishu* publishes realist works: Chen Danqing's *Tibet Series* and Luo Zhongli's *Father*. On 16th, Luo Zhongli's *Father* awarded first prize at the Second Youth Art Exhibition
July 7–14	Wuming exhibition at Huafangzhai
October 20– November 19	**Museum of Fine Arts, Boston, exhibits 70 American paintings at Shanghai Museum, including a Jackson Pollack and a few abstract works**
December	**Chinese Artists Association condemns bourgeois liberalism**

1982

January 25	Trial of the Gang of Four begins
May 19– September 12	***Painting the Chinese Dream* exhibition is held at Smith College, subsequently at Boston City Hall and Brooklyn Museum**
June	Deng Xiaoping becomes chairman of the Central Military Committee; Hu Yaobang becomes chairman of the CCP
September 13	Jiang Feng dies
(1982–83)	**Zhang Wei organizes an abstract painting group**

Blooming in the Shadows: Unofficial Chinese Art, 1974-1985

1983

(1983)	*Five-Person Show* at the home of the poet Hui Wa with work by Zhao Wenliang, Yang Yushu, Shi Zhenyu, Tian Shuying, and Liu Shi
August 14-19	Exhibition by Huang Rui, Wang Keping, and Ma Desheng held at Jixing Elementary School, Beijing, closed two days early by the authorities
September	Experimental painting exhibition at Fudan University in Shanghai closed after four days
September 19	The Parisian abstract expressionist Zao Wou-ki (Zhao Wuji) holds a solo exhibition at the Chinese National Art Gallery, Beijing
October	"Anti-spiritual pollution" campaign begins
December	**Chinese Artists Association condemns spiritual pollution**

1984

July	*Shanghai Literature* (*Shanghai wenxue*) publishes Zhong Acheng's short story "King of Chess"
November 16	Scheduled *Three Man (Yan Li, Yang Yiping, Ma Desheng) Recent Oil and Ink Painting Exhibition* at Beijing Workers Cultural Palace cancelled one day before the opening
December 11–January 10, 1985	**Selections from the Sixth National Art Exhibition held at Chinese National Art Gallery juried to avoid works with "spiritual pollution"**

1985

April 21	Huangshan Conference on Oil Painting establishes critical justification for avant-garde art in the official sphere
May	Fourth Congress of the Chinese Artists Association calls for "creative freedom"; '85 avant-garde movement begins
July	Peoples Communes abolished
Autumn	*Graffiti Exhibition* organized by Zhang Wei, Feng Guodong, and Zhu Jinshi with Ma Kelu, Ma Desheng, Yang Yiping, Qin Yufen, Gu Dexin, Wang Luyan, and Tang Pinggang; closed by police before the opening
October	Zhang Wei, Feng Guodong, Zhu Jinshi, Ma Kelu, Qin Yufen, Gu Dexin, and Wang Luyan hold informal exhibition at apartment of Marlowe Hood, and Robert Rauschenberg attends

1986

September	Wang Keping solo show at Beijing Concert Hall Gallery cancelled by the authorities
July 24-August 30	*Avant-garde Chinese Art* at City Gallery, New York, shows Ai Weiwei, Li Shuang, Ma Desheng, Yan Li, Zhang Wei, Xing Fei, Yang Yiping, Yin Guanzhong, Zhao Gang, and Zhu Jinshi; held at Vassar College Nov. 7–Dec. 8
December 30	Deng Xiaoping initiates "anti-bourgeois liberalism" campaign

1987

January	Hu Yaobang resigns; Zhao Ziyang becomes secretary general CCP
(1987)	*Six Stars* exhibition at Art Waves Gallery, New York

1989

January 1–February 19	*The Stars: Ten Years* held at Hanart 2 Gallery, Hong Kong
February 5-19	*China-Avant Garde* exhibition at the Chinese National Art Gallery concludes the '85 avant-garde movement
April 15	Hu Yaobang dies; demonstrations against corruption begin in Beijing and continue through June 4th
May 17	Zhao Ziyang resigns
June 4	Tragic end to demonstrations at Tian'anmen Square

1990

(1990-92)	Political, economic, and cultural freeze

1993

(1993)	Deng Xiaoping, who had conducted an inspection tour of southern China in January, 1992, reopens China's economy, relaxes travel restrictions; *Fifteen Years of the Stars* exhibition held at Tokyo Gallery
January–February	Hong Kong exhibition *China's New Art, Post-1989* introduces cynical realism and political pop

2000

March 13-April 1	*Demand for Artistic Freedom: The Stars 20 Years* exhibition at Tokyo Gallery

2002

(2002)	Huang Rui returns to Beijing and begins development of the 798 Art District

2006

(2006-2007)	*No-Name Group Retrospective*, Beijing, Guangzhou, Shanghai

NOTE

1. In the absence of written documentation, some uncertainty remains among exhibitors about the precise date of this event.

Blooming in the Shadows

Map

Wuming, Xingxing, and Caocao Artists in China

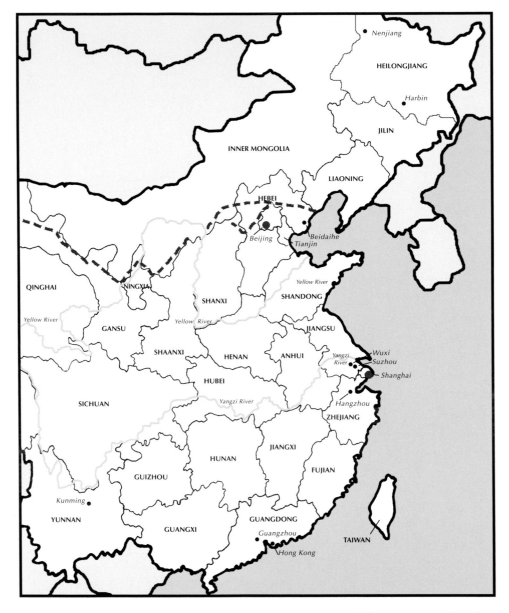

The Wuming and Xingxing artists were centered in Beijing, and the Caocao in Shanghai. During the Cultural Revolution many of these artists were sent in their youth to such far off places as Heilongjiang in the northeast, Xinjiang in the west, and Yunnan in the southwest. Those who remained in Beijing travelled illegally to scenic places like Beidaihe and the Great Wall to paint.

- - - Great Wall
- Major centers for the artist' groups
- Other art centers and places of interest to the artists

A Time of Trouble, A Time of Hope

Julia F. Andrews and Kuiyi Shen

In the decade after the Cultural Revolution (1966–76), idealists within China's cultural world led Chinese art out of the closed aesthetic and political system of socialist realism toward a realm in which the practice of art would be rooted in human dignity and personal freedom. Within this new paradigm, artists would seek truth in the authenticity of individual desire, pain, and dreams. The modernization of recent decades has made it difficult to remember the impoverished cities of the 1970s; even more unimaginable today is the unseen fear that gripped Chinese society. The dangers faced by path-breaking artists in that perilous period cannot easily be understood by those who did not experience them, and their sacrifices on behalf of artistic freedom have been largely overlooked by the generations that followed.

The purpose of this exhibition is to reconsider the artistic and conceptual contributions made by two generations of unofficial artists who were active between 1975 and 1985. Despite their near absence from the official narrative of contemporary art history, they broke conceptual, stylistic, and thematic ground for systematic changes in the Chinese art world of the 1980s and thus, at least indirectly, for its emergence as a global force in the late twentieth century. The system they opposed tried, in some cases successfully, to crush them as individuals but could not erase their artistic and conceptual legacies. Each of the three groups that we will consider made its mark on Chinese art history with a controversial exhibition organized in 1979. Their approaches to art were different, but they shared the aim of overthrowing the falsity of socialist realism and replacing it with an art that spoke the truth. By 1985, their goals had been adopted by art students at the official academies, and the establishment would never again be the same.

The works exhibited in *Blooming in the Shadows* were created quietly, sometimes secretly, during a repressive decade that spanned the latter half of the Cultural Revolution (1971–76) and the years immediately following the death of Mao Zedong in 1976.[1] In the political and cultural ferment of 1979 and 1980, as Deng Xiaoping consolidated support for his post-Mao regime, the three unofficial groups of artists that are the subject of the present exhibition—the Wuming (No Names), the Xingxing (Stars), and the Caocao (Grass) groups*—were able for the first time to exhibit their works openly, thus bringing into public view approaches to art and subject matter that had been banned for three decades. These young artists had defined themselves by their own chosen identities, not by the status they had been assigned by the state. They developed outside the mainstream of China's official art world during a period of spiritual desperation, a time when all human activity in China was tightly controlled. Despite rather different approaches to art, they shared a deeply-rooted opposition to the entrenched institutions of propaganda, an idealistic vision, and a passionate desire to express themselves freely.

The invisible force behind the art of this generation, the oppression against which they rebelled, was the pattern of brutality, narrow-mindedness, falsity, and irrationality that

* Wuming is pronounced as it would be in English. Caocao and Xingxing are pronounced "tsao-tsao" and "sheeng-sheeng."

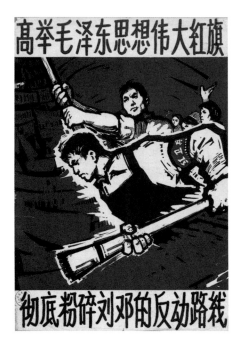

高举毛泽东思想伟大红旗

彻底粉碎刘邓的反动路线

Fig. 1. Anonymous, *Hold High the Great Red Flag of Mao Zedong's Thought: Thoroughly Smash the Reactionary Line of Liu and Deng*, ca. 1966. Poster, ink on paper; 77 x 54 cm. Landsberger Collection (E15/183). From Stefan R. Landsberger, Marien Van der Heijden, and Kuiyi Shen, *Chinese Posters: The IISH-Landsberger Collections* (Munich: Prestel, 2009), p. 139. Image courtesy of the Collection International Institute of Social History, Amsterdam

was most fully institutionalized in the Great Proletarian Cultural Revolution. As Xingxing artist Qu Leilei inscribed on a drawing in 1983, "I grew up in a time when morality ruled, but without principles; right-and-wrong prevailed, but without standards; and behavior had no rules."[2] The generation that came to maturity in China during the Cultural Revolution, roughly the same age as the American baby-boom generation, experienced a succession of hardships, traumas, and shocks that forged a particular understanding of the meaning of human life and the purpose of individual expression. For most of the artists in this exhibition, the art they made during this decade had existential significance—at crucial moments it defined their only purpose for surviving on this earth.

Launched by Mao Zedong in May of 1966 and couched in patriotic and idealistic terms, the Cultural Revolution was actually aimed at Mao's rivals and enemies within the party. He mobilized students at campuses all over China to seize, denounce, and humiliate their elders and to dismantle the party bureaucracy that Mao believed had thwarted his wishes. The young people, a cohort that that been indoctrinated since childhood in optimistic values of cooperation, hard work, self-sacrifice, and patriotism, eagerly followed his call to crusade against enemies of the revolution. They proudly took the name Red Guard and unwittingly assisted Mao in reestablishing his leadership in the form of a totalitarian dictatorship. Over the next two years, the search for "enemies of the people" spread to all quarters of the nation. Not only former capitalists, but veterans of the Communist revolution became targets (fig. 1). Private homes were repeatedly raided and vandalized in searches for "evidence" and to destroy "the four olds." Christian churches and Buddhist temples were stripped of their "feudal" contents, which the Red Guard enthusiastically destroyed. The children of intellectuals and officials were often the most idealistic, but many of them soon saw their own mothers or fathers condemned, marched around in dunce caps to the ridicule of spectators, or incarcerated for prolonged periods in make-shift unofficial jails called "ox-sheds." The ardor of future Xingxing artists Wang Keping and Qu Leilei was extinguished by the irrational suffering to which their fathers were subjected. Elderly family members were sometimes frightened or beaten to death. Many young people witnessed their neighbors, teachers, or relatives badly abused or even murdered by the mob. Wang Aihe, who was in fifth grade in 1966, remembers vividly the sight of her favorite art and music teacher, Miss Li, leaving the school in humiliation after having had her head publicly shaven. She had been condemned by a mass meeting at the school for her bourgeois family background and was never seen by her student again.[3] Describing a traumatizing event of 1968, Wei Hai remembers hearing shouts one afternoon in the courtyard where his family lived. "The Institute of Painting has arrested a counter-revolutionary!" When he and the other children rushed to the Institute, they saw adults holding down a struggling man and chanting slogans against the "counter revolutionary clique."

> The man raised his head with great effort to yell, "I am not a counter-revolutionary! I am not a…" To my shock, I saw that the man was my father's good friend Liu Xun…Soon after, we heard that he was sent to prison for having criticized [Mao's wife] Jiang Qing.[4]

Wei Hai's father was an ink painter at the Beijing Institute of Chinese Painting. His friend, Liu Xun, was to play a significant role in the history of the Wuming group after his release from prison.

Even within the Red Guard movement itself, factionalism erupted everywhere, and battles between members in the name of Maoist orthodoxy raged. Those initially swept away by the exhilaration of revolutionary fervor began to sober. With the party apparatus paralyzed and his enemies vanquished, Mao brought a halt to the Red Guard movement in 1968. Overnight, those Mao had anointed to carry out his mission, the students, were cast aside and replaced in his favor by the workers. Then, at Mao's behest, over the next eight years sixteen million young people, or a tenth of China's urban population, were exiled to the countryside or industrial facilities for reeducation by the peasants and workers. This policy was applied to virtually all urban middle and high school graduates, regardless of whether or not they had participated in the Red Guard and whether or not they came from elite family backgrounds. Virtually all of the artists in this exhibition suffered this fate, an experience with powerful effects on their lives and art. The "old three classes" (the middle and high school classes that should have graduated in 1966, 1967, and 1968), none of whom had received job assignments after schools were dismissed in 1966, went first. The sixteen-year-old Zheng Zigang, among the youngest of the rusticated youth, was sent in 1969 to a state-run farm in Manchuria, specifically to Heilongjiang province on China's Siberian border. Wang Keping, four years older, was sent to a similar farm in Heilongjiang the same year, and, like Zheng, worked in conditions one of his biographers has likened to a concentration camp.[5] The policy was still in effect in 1976 when the nineteen-year-old Li Shuang left Beijing to begin her life as a peasant at a farm outside the city. Among those who remained, Wang Aihe saw her brother sent away, then each of her parents. Like millions of urban children of the period, she lived for a long time in a parentless house.[6] She was assigned to work in a plastics factory amidst the dizzying fumes of chemical production. Oddly, despite their harshly regulated lives on the farm and in the factory and the totalitarian limitations on expression and behavior, this was the time when the young artists came to understand themselves as individuals.

In mid-September of 1971, Lin Biao, a military man who was Mao's chosen successor and the architect of the Maoist personality cult, died mysteriously while fleeing with his family by air in the direction of the Soviet Union. The matter was kept secret for almost a month, but the "educated youth" who had been rusticated to the northern border regions of Heilongjiang or Mongolia heard the shocking news on shortwave radio broadcasts from the USSR. Word of the deadly power struggle between Mao and Lin spread rapidly, and if the difficult conditions they encountered in the countryside had not already raised doubts, this affair instantly dissolved the faith, trust, and political idealism of an entire generation. Mao disappeared from public view, and the official explanations of how Marshall Lin, his "closest comrade-in-arms," had been transformed in a matter of weeks into the leader of an "anti-party counterrevolutionary clique" were impossible to believe. Among his alleged crimes was his criticism of sending young people down to the countryside, particularly his comment that the rusticated youth were undergoing not reeducation, but rather the hard labor of convicted criminals. Because some of the sent-down students were actually living in prison camps, this supposed "crime" seemed to them like truth-telling. Now stuck in whatever remote or desperate place Mao's policies had left them, with little hope for change, they began to look at the future in much bleaker and more skeptical terms. At the same time, with Lin Biao's death the highly militarized system of social control that forced all citizens to fill their leisure time with mandatory ideological training meetings

partially collapsed, leaving exhausted workers a modicum of personal time every day. Some young people turned to art or poetry as refuge from the enforced conformity and dreary labor that occupied their everyday lives and stymied their future prospects.

One of the distinguishing features of Mao Zedong's regime was a belief in the extraordinary power of art and cultural production. It was for this reason that art was tightly controlled. At the same time, Mao's doctrine stipulated that China's new art should be an art for the people. As a result, many opportunities were established throughout Mao's thirty years in power for ordinary people to learn to draw and paint, but with the caveat that they would paint politically approved subjects in the approved propaganda style. This system for promoting popular culture was implemented through a nationwide system of Children's Palaces, Youth Palaces, and Workers Cultural Palaces. The first offered classes for school children, the second served students and young people in any line of work, and the last was reserved for factory workers. With normal educational channels closed during the Cultural Revolution, these classes provided the only formal art education received by many young artists.

Some artists in this exhibition, such as Qiu Deshu in Shanghai and Wei Hai in Beijing, had attended after-school art classes at a Children's Palace before the Cultural Revolution. A remarkable number of the most creative artists of their generation attended such a program in childhood. Many of the instructors were highly talented artists and teachers with significant accomplishments in the pre-Liberation period. Because their ideological or artistic approaches were considered unsuitable for those in a leadership role after 1949, many such elder artists were given jobs that made use of their manual or technical skills, such as teaching ink painting or seal carving to school children. Despite efforts to contain their non-Maoist instincts and ways of expression, these teachers affected the sensibilities of many of their students. Similarly, classes at Workers Cultural Palaces would have a strong impact on young artists during the Cultural Revolution, particularly because access to any other kind of formal instruction was extremely limited. Core members of the Wuming and Caocao groups would first meet at such worker institutions.

During the Cultural Revolution, aspiring young people relied on other unconventional means for their artistic training. Many, for example, were highly skilled practitioners of the blackboard newspaper (*heibanbao*), which they learned as children. Each urban elementary school, like most work units, maintained blackboards for news and propaganda that were elaborately decorated by the children. Their most important function was to transcribe texts provided by the teachers, who were themselves responding to ideological instructions from above, but students decided the layout, design, and decoration. This was a high-status task, and students vied to be recognized as artistically talented and reliable enough to be given such assignments. Elaborately decorated in polychromatic chalk, the low-tech blackboard newspaper was an immediate and powerful form of visual communication that also served as a useful training ground for many young artists. After the Cultural Revolution began, student skills in lettering, drawing, coloring, and graphic design were easily translatable to other forms of art. When the "red sea campaign" (*hong haiyang*), in which all public surfaces were painted red, swept the nation in 1967 and 1968, many young people were well-prepared to cover walls with skillfully brushed slogans, portraits of Chairman Mao, and the sunbursts that symbolized Mao as the "great sun in all our hearts." Ma Kelu was impressed by the power of such painting after watching his schoolmate Wei Hai cover an entire wall of the school sports field with a gigantic propaganda painting in 1968.[7]

After Lin Biao's death, efforts were made to reestablish key elements of the state bureaucracy, most of which had been shut down during the early chaotic years of the Cultural Revolution. This shift in political and bureaucratic structure had yielded very evident changes in art. The art of the Red Guard period, between 1966 and 1968, is best known from surviving posters, Red Guard newspapers, and propaganda magazines, although a great deal of it, such as wall paintings, was completely ephemeral.[8] This art often focused on the rapidly changing policies of the early phase of the movement and their now arcane slogans, as well as images of the Red Guard themselves implementing Mao's policies. In general, the students took their designs directly to the printing house for publication, and the process was unmediated by censorship or editorial modification beyond the Red Guard group itself. Art of the "red sea" was similarly of local inspiration, although all painters sought orthodoxy and took their cues from approved models. After 1971, however, the state set standards and a reestablished exhibition system served as the primary patron and public venue for visual arts. Red Guard art was replaced between 1971 and 1976 with art of the workers, peasants, and soldiers (fig. 2).

In 1972, the central government reasserted its role in organizing national exhibitions by seeking submissions from local art centers. The purpose of its 1972 exhibition was to celebrate the thirtieth anniversary of Mao Zedong's "Talks at the Yan'an Forum on Literature and Art," the document that served as the basis for all arts policies in the Peoples Republic of China and was a doctrinal catechism throughout the Cultural Revolution.[9] While perhaps conceived to further promote domestic ideological uniformity, the exhibitions were also displayed to foreign guests during Mao Zedong and Zhou Enlai's post-Lin Biao diplomatic initiatives. American president Richard Nixon, who visited China in February of 1972, and many foreign visitors over the next four years were treated to art displays in which examples of this highly contrived "people's art" dominated.[10] Domestically, the exhibitions were important in creating and disseminating a uniform national style of art. They set a narrow standard for acceptable style and political content. Subject matter was almost entirely figurative, and the artist was supposed to represent the revolutionary virtue of people of his or her own class. Thus, a worker at a shoe factory might represent a dancer in one of the model theatrical works wearing shoes produced at her factory. A rusticated youth at a military farm on the Soviet border might represent fellow soldiers as heroic Chinese border guards. A youth

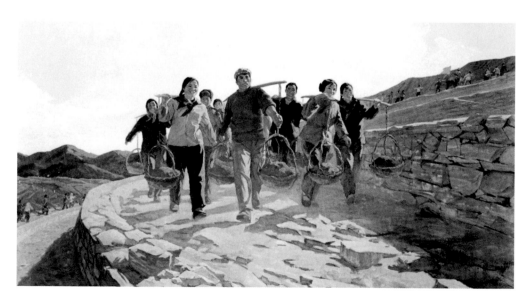

Fig. 2. Creation Group, Beijing Art Company, *Ten Thousand Miles, A Thousand Loads, to Build a Field*, 1972. Poster. The Ann Tompkins (Tang Fandi) and Lincoln Cushing Chinese Poster Collection, C.V. Starr East Asian Library, University of California Berkeley. Also published in Lincoln Cushing and Ann Tompkins, *Chinese Posters: Art from the Great Proletarian Cultural Revolution* (San Francisco: Chronicle Books, 2007). Digital image courtesy of Lincoln Cushing/Docs Populi

sent down to a dairy farm might represent a fellow farmer milking cows.[11] Images of Mao, but no other leader, were acceptable, although the dangers of accidental iconographic or stylistic error made this a high stakes choice of topic. Compositions had to follow the "three prominences" developed for model opera: in figures, artists emphasize the positive; in positive figures, they emphasize the heroic; and in heroic characters, they emphasize the central figure. Application of pigment was standardized in terms later mocked as "red, shiny, and bright"; cool tonalities were generally taboo. Any real or perceived deviation from the acceptable canons of representation, of which the final arbiter was Madame Mao, could be interpreted as a political crime and punished accordingly. Painting for pleasure, as the Wuming artists did, was a potentially dangerous act of dissent against this system.

Many rusticated youth with artistic abilities were required by their work units to produce visual propaganda, regardless of whatever loss of faith in the system and its hollow ideals they may have privately experienced. Some actively sought the opportunity to paint politically clichéd images for the national exhibitions. Such was the only path to a professional career as an artist and to a possible return to the city. Failing such success, art was also a temporary way to escape the hard labor to which they had been condemned. Because the young people were now considered to be peasants, workers, or soldiers rather than students, they were welcome to participate under their new, presumably permanent identities. Those favored with permission to paint would be given painting materials and space to make art. Most importantly, they would often be temporarily transferred from farm labor or factory work to special studios in which they could concentrate on making a work for the exhibition. They would thus, for a time, enjoy decent food, a less physically strenuous assignment, and a generally more comfortable life. The lucky ones were eventually transferred permanently to art or propaganda departments, becoming professional artists rather than laborers. In 1972, a small number of "worker-peasant-soldier" students were taken out of their work units and sent for a year to the Central Academy of Fine Arts (CAFA), then called the May Seventh Art School, to be trained in techniques they could use for propaganda. Between 1973 and 1976, an extremely limited number of worker-peasant-soldier students were admitted, based primarily on party recommendation, to CAFA for a three-year undergraduate course. Such benefits, or reductions of hardship, were attractions afforded by the system to talented individuals who cooperated. The frequent national exhibitions thus stimulated a large-scale production of socialist realist paintings in the Cultural Revolution style and established a canon of rosy-faced, ever-smiling workers, peasants, soldiers, and rusticated youth that artists could consult for acceptable thematic and stylistic approaches.

These two artistic movements, Red Guard art and worker-peasant-soldier art, along with the peculiar terrors of Cultural Revolution-era life itself, were the mainstream trends experienced in their formative years by the artists in the present exhibition. Yet, within this oppressive system were the seeds of rebellion against it, and those denied an education, a social life, and sometimes even a family by the system began to construct their own secret, alternative worlds in art. This underground activity was both inspired by and made briefly possible by the administrative vacuum following Lin Biao's death. The more moderate Premier Zhou Enlai took over many of Lin's responsibilities, but put his priorities on restarting the economy and restoring international relations rather than maintaining leftist thought reform campaigns.

In 1972, unbeknownst to his fellow citizens, Zhou began treatment for prostate cancer. The following year, the remarkable announcement was made nationwide that Deng Xiaoping, the number two national target of the Cultural Revolution (and, although not known at the

time, the highest ranking victim to survive) had been brought back into government and would serve as second-in-command in all areas administered by Zhou Enlai—the premier's office, the central military committee, and the central party—as well as fill the vacant position of military chief of staff. It is now evident that his primary role in 1973 was to aid the ailing premier, but at the time his rehabilitation suggested to everyone that the government might be stepping back from some of the results of the early Cultural Revolution. Some colleges and art schools were reopened, although their curricula and entrance procedures remained badly compromised. As part of the economic push, urban factories reopened, giving a small number of young people a chance to leave the worst rural conditions.

This brief relaxation of ideological pressure may hardly be called a period of liberalization—it might be better characterized as one of neglect—but it was a moment when young people began to read and to experiment with poetry, art, and a range of forbidden mental pleasures. Most important, by the time further crackdowns came in 1974, free thinking had become a habit among many in the Red Guard generation, even if its expression remained severely circumscribed. When Jiang Qing organized the "black-painting" exhibition in early 1974 to provide models of evil art for condemnation, members of the Wuming group attended in order to enjoy the works of art by famous masters exhibited as negative examples. The slogans brought forth in the new campaign, now against Confucius and Lin Biao (but intended to target Zhou Enlai), might be memorized and recited, as required, but to many who uttered them they seemed absurd.

Artists represented in *Blooming in the Shadows* come from different social backgrounds, two different generations, and two different cities and had endured varied experiences during the Cultural Revolution, but by its end they all shared the same desperate desire for change. The small, tentative flickers of hope that appeared in those otherwise bleak years were almost snuffed out in January of 1976, when Premier Zhou Enlai, the man generally considered to be the only moderating voice in the Cultural Revolution government, succumbed to cancer. To the further distress of Zhou's many sympathizers, Mao failed to attend his funeral, and the protocol established for his memorial was widely perceived as perfunctory. During the days leading up to the Qingming Festival, the spring holiday on which Chinese traditionally sweep family graves, crowds of Beijing residents seemingly spontaneously flocked to the Monument to the People's Heroes in Tian'anmen Square to lay out wreathes and commemorative inscriptions in Zhou's memory. Every night the authorities removed them, and the following day an even larger number would appear. Mao himself, or those close to him, correctly interpreted this outpouring of sentiment as a complaint against the surviving Cultural Revolution leaders, and on the evening of the festival itself, which fell on April 5, 1976, mourners on the square were beaten, threatened, or arrested by the police. Two days later the Tian'anmen event of 1976 was declared a counterrevolutionary incident. Those arrested are believed to number in the hundreds. This expression of popular opinion, crystallized by its harsh suppression, became known as the April fifth movement. Deng Xiaoping, who had given the eulogy at his mentor's funeral, was blamed and sacked from his job.

The tyranny of the Cultural Revolution did not wane until the death of its architect, Mao Zedong, on September 9, 1976. Bypassing men and women of greater talent or ambition, such as Deng Xiaoping and Jiang Qing, Mao had left as his successor an inconspicuous follower named Hua Guofeng, whom he had promoted to the post of minister of public security in 1975. After the April fifth event, Hua became premier and the first vice-chairman of the Communist Party. Although Hua Guofeng loyally maintained Mao's policies and

personnel, he collaborated with security forces to block any possibility of a coup by associates of Mao's ambitious wife. Cultural Revolution leaders Jiang Qing, Zhang Chunqiao, Yao Wenyuan, and Wang Hongwen were arrested on Hua's orders on October 6, 1976, only four weeks after Mao died.[12] Within a few weeks, Hua Guofeng ordered a much-welcome campaign of criticism against the so-called Gang of Four, but at the same time made clear that uttering words against Mao, the Cultural Revolution, or even the April fifth event remained forbidden. Formalizing this continuity of Maoist ideology and practice, a policy referred to in slogans as the "two whatevers" was published in major party organs in February 1977:

> Whatever decisions were made by Chairman Mao, we will resolutely defend. Whatever instructions were given by Chairman Mao, we must unwaveringly follow forever.[13]

This policy, which was maintained until the end of 1978, guaranteed that, despite the arrest of the Gang of Four, the Cultural Revolution itself would not be openly criticized. Even though a great many people were completely disgusted with the status quo, few changes could take place in art or culture, and expression of personal opinion remained forbidden. The national exhibition was postponed after the death of Mao, and when it opened in Beijing on February 18, 1977, it bore the unwieldy but politically explicit title, "National Art Exhibition to Ardently Celebrate Comrade Hua Guofeng's Appointment as Central Party Chairman and Chairman of the Central Military Committee and Ardently Celebrate the Great Victory of Smashing the 'Gang of Four's' Plot to Usurp the Party and Take Power." Six months later a similar exhibition was mounted in celebration of the fiftieth anniversary of the People's Liberation Army. Portraits of worthy political leaders dominated the events. The iconography of the socialist realist works was updated, but there was almost no change in artistic style or concept.

Maneuvering behind the scenes, however, was Deng Xiaoping. In May of 1978, an opinion piece submitted to the least dogmatic of the national newspapers, *Guangming Daily (Guangming ribao),* by a philosophy and politics professor at Nanjing University was published instead in the internal journal of the party school in Beijing. The piece was titled "Practice is the Only Measure of Truth." The following day, *Guangming Daily* reprinted it, an arcane strategy devised to avoid seeking permission from the Ministry of Propaganda. One day later, on May 12, the party organs *People's Daily (Renmin ribao)* and *Liberation Army Gazette (Jiefangjun bao)* also reprinted it. This article, published anonymously, was a direct challenge to Hua Guofeng and his attachment to Mao's ideological directives and was a signal to everyone that the forces of change had emerged. Over the course of the next six months, debate intensified, and the overturn of the "two whatevers" was secured at the Third Central Committee meeting of the Eleventh Party Congress, held between December 18 and 22, 1978. Deng Xiaoping regained positions in the military and civilian government as vice-chairman of the Chinese Communist Party, vice-chairman of the Central Military Committee, and vice-premier. Although Hua Guofeng retained his many increasingly empty titles until June of 1981, Deng was already installed in the positions he needed to take power.

The power struggle itself was of less interest to the general populace than what its effects would be on their lives. A younger protégé of Zhou Enlai and Deng Xiaoping, party school director Hu Yaobang, was believed to have been responsible for the decision to publish the article "Practice is the Only Measure of Truth." In March of 1977 he had been appointed chief of the Organization Department, a key party personnel post responsible for evaluating and recommending candidates to head government ministries, provinces, and municipalities.

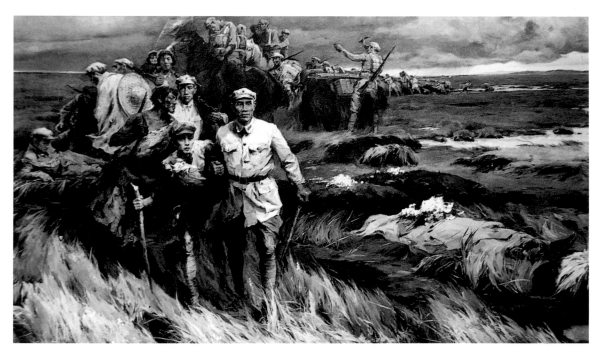

Fig. 3. Lin Gang and Pang Tao,
The Eventful Years, 1979.
Oil on canvas; 166 x 296 cm.
Museum of the Chinese Revolution, Beijing.
Courtesy of Pang Tao and Lin Gang

He had the power to restore a disgraced party member to high position and played a crucial role in investigating and rehabilitating those condemned in the Cultural Revolution.

This process was necessary in order to restaff the institutions that had been gutted during the purges and to begin rebuilding the economy and society. In the official art world, these events may be traced in both the roster of artists who were returned to their studios and the subject matter of their paintings—a flood of portraits of recently rehabilitated historical figures. Lin Gang and Pang Tao's 1979 painting of General Zhu De leading the Red Army across the snowy grasslands is one such example (fig. 3). This painting for the Museum of Revolutionary History marks the rehabilitation of the two artists, who were restored to their teaching positions at CAFA. Equally important is that it celebrates the return of the Red Army founder to the historical narrative; he is here given rightful credit for heroic contributions during the Long March in the mid-1930s. It also commemorates the many unnamed soldiers who died in that terrible retreat and seems determined to revise the exclusive association of this historic event with the name of Mao Zedong.

College entrance examinations were reinstated in 1977; art schools accepted their first post-Mao classes in 1978. Two thousand hopefuls applied for fifty-four places in the graduate program of CAFA in Beijing. The school admitted only fifty-five undergraduate students. Although a rejection of the art of the Cultural Revolution was total, the mainstream to which the academy returned was that of 1949 to 1966 and its legacy of socialist realism. Although individual faculty members and students were sympathetic to alternative forms of art, the academy as a whole, while still reconstituting its staff and curriculum, maintained technical standards based on academic rendering and a thematic emphasis on correct content. It could not yet provide leadership in new directions.

In overturning the "two whatevers" in December of 1978, the Party Central Committee went beyond simply criticizing the Cultural Revolution. It suggested that the party's entire history be reconsidered, from the Yan'an rectification to the anti-rightist campaign. In this spirit, Hu Yaobang's process of exonerating those condemned for political reasons started with victims of the Cultural Revolution and was extended to those of the 1957 anti-rightist campaign, even to the few survivors of the 1942 Yan'an rectification. In this process of restoring the civil rights, party membership, and employment status of hundreds of thousands of the unjustly condemned, two arts leaders who would be crucial to the emergence of unofficial art groups, Jiang Feng (1910–1982) and Liu Xun (1923–2007), were rehabilitated and restored to their leadership roles after more than twenty years in the wilderness. Although those within the Chinese Communist Party who launched this massive house-cleaning may have intended it to be internal to the party, it looked to everyone else as though the party was admitting its errors and correcting its mistakes. This extraordinary process stimulated ordinary citizens to anticipate the next step to be correcting injustices in society at large. Moreover, the rhetoric of democracy, aimed to pry power in the party away from Hua Guofeng, gave birth in the hearts of many Chinese to great hope and the expectation of a transition to a freer and more democratic society.

Each of the artists represented in this exhibition came together for public exhibition in 1979 and early 1980 in a context, the informal art group, that had been for all practical purposes illegal in the previous three decades. Despite rhetoric to the contrary, the idea of private individuals forming truly voluntary associations was considered treasonous (often under the rubric "counter-revolutionary faction") from the earliest days of the PRC. For the purpose of their exhibitions in 1979, however, the young arts activists were asked to take a name, and it is by those 1979 labels—the Wuming, Xingxing, and Caocao—that we know them today. The Wuming exhibition opened on July 7, 1979, at the Huafangzhai gallery of the Beijing Artists Association; the Xingxing hung their first exhibition on the fence around the National Art Gallery in Beijing on September 27, 1979; the Caocao artists succeeded in holding their first exhibition at the Luwan District Cultural Center in Shanghai's old French concession from February 16 to March 9, 1980. Although each of these key exhibitions and associated artistic groups directly confronted socialist realist norms, each did so in its own way. Similarly composed of idealistic young unofficial artists, the three groups differed from one another in the character of their membership, in their internal relationships, and in their connections to the art world and society of the day.

How was it possible that what had been banned for thirty years received government sponsorship in 1979? From a larger perspective, the temporary liberalization of culture was part of Deng Xiaoping's strategy to garner sufficient support to wrest political power from Mao's successor, Hua Guofeng, and assume the leadership himself. Deng Xiaoping's highly pragmatic bent and focus on economic matters, however, left the art world in an unpredictable state. With his youthful experience as a foreign student in Paris and a daughter who went to art school, he may have understood the world of visual art better than did Mao Zedong. It is clear, nevertheless, that he considered art and culture far less significant to the nation than did Mao, and his policies seem even more idiosyncratic. It appears that he loosened central control of the arts when it served his strategic purposes and tightened it again when a concession to hardliners in the party leadership was needed in exchange for their support in more critical political arenas. In general, arts policy was left in the hands of party arts leaders—conservatives and

reformers, those more loyal to Mao and Hua and those more supportive of Deng—
who fought their own battles. The careers of artists and arts leaders would rise and
fall arbitrarily in the wake of unforeseen events.

Two independent-minded Communist arts administrators, Jiang Feng and Liu Xun,
courageously gave the official assistance that made possible emergence of the unofficial
artists' groups who exhibited in 1979. Neither man is likely to be described as a close
follower of Deng or as an opponent of Mao. Both are best characterized by independence
of disposition, extraordinary idealism, and a great sympathy for young artists of similarly
creative approach. Born into a working class family in Shanghai, Jiang Feng (original name,
Zhou Xi) was determined to become an artist.[14] While working in a factory, he began taking
painting lessons at night, and in 1931 was chosen by the esteemed modern writer Lu Xun for
an intensive tutorial in woodblock printmaking. From this time forward he was a printmaker;
in this period he also joined the Communist Party and began to engage in labor organizing.
Jiang Feng and several left-wing friends, including the French-educated poet Ai Qing, were
arrested in 1932 when their Esperanto class at the White Swan Painting Studio was raided by
the police. They were incarcerated on political charges for three years. Not long after their
release the second Sino-Japanese War erupted. Jiang Feng made his way to the Communist
base camp in Yan'an in 1938 and threw himself into propaganda work. There, he became
head of the art department of the Lu Xun Academy of Literature and Arts in 1939.

In 1942 and 1943, Jiang Feng was caught up in the Yan'an "rectification movement,"
a brainwashing campaign conducted within the Communist Party. Promoted as a necessary
step to purify ideology and to rid urban intellectuals of their selfish attachment to such
impulses as personal expression and art for art's sake, it proved in hindsight to be the
moment at which Mao effectively consolidated his hold on power. Jiang, like the thousands
of party members subjected to rectification, underwent "mandatory self-criticism and forced
confessions" and had to '"draw a line" between themselves and "non-Maoist thoughts and
factions, which would be eliminated through intimidation and terror."[15] After 1949 he
vigorously led the party's program to reform Chinese art in accordance with Maoist principles
and, despite his own youthful experiments in modernist art, adopted an uncompromising
approach in banning both modernism and traditionalism in favor of socialist realism.

In 1957, despite all efforts to toe the line, Jiang Feng was purged on the spurious
charge of "rightism" in a nationwide rectification campaign directed, at Mao's orders, by Deng
Xiaoping. The movement identified and punished many non-Communists who had complaints
against the Communist Party, along with many innocent people implicated to fulfill a quota
system in which each work unit was expected to identify a fixed percentage of "rightists."
Along with Jiang Feng, the anti-rightist campaign also purged, on flimsy or fabricated charges,
many loyal members of the Communist Party. Stripped of his party membership and
responsibilities, it was only twenty-two years later, after Mao had died, that Jiang Feng was
exonerated, his party membership reinstated, and his position restored as chairman of the
Chinese Artists Association. His feistiness was abundantly evident upon his return to the art
scene at the age of seventy-nine, and he made particularly effective use of his administrative
power to assist other newly exonerated rightists and young artists who resembled his own
passionate younger self. The injustices he had suffered seemed to have restored the liberal
foundations of his thought, making him willing to offer official support to young people
engaged in pushing the boundaries of the status quo. They sensed in him a genuine
sympathy. Between his return to power in 1979 and his death in 1982, Jiang encouraged

young artists who sought to restore to the art world the passion, idealism, and some of the pluralism of the 1930s. His actions suggest that for him the golden age of revolutionary art was the time of his mentor Lu Xun, who died in 1936, and perhaps not that of Mao Zedong.

The equally idealistic Liu Xun was almost a generation younger than Jiang Feng, but having a full head of gray hair, he was perceived by the young artists in 1979 as an old man. Born in Nanjing, he had been a loyal party member since the age of fifteen, joining during the Sino-Japanese War while a refugee in Chengdu. His party credentials were impeccable until the anti-rightist campaign. In the early years of the PRC he served as editor of the propaganda magazine *China Pictorial* (*Renmin huabao*) and led several art magazines, including the party mouthpiece *People's Art* (*Renmin meishu*) and later *Serial Pictures Monthly* (*Lianhuanhua bao*). In 1956 he was part of the administrative team that established the Beijing Institute of Chinese Painting. In 1957, like Jiang Feng, he was unjustly condemned as a rightist. He entered a long period of hardship that culminated in his 1968 arrest during the Cultural Revolution and a ten-year prison sentence as a counter-revolutionary. This was the arrest that Wei Hai had described witnessing as a child. It was not until 1977, following the death of Mao and arrest of the Gang of Four, that he was exonerated and released. The following year he was appointed deputy director of the Beijing Artists Association and in 1979 became permanent secretary of the national Chinese Artists Association. Liu Xun sought to make up for his twenty lost years in many ways, not least of which was by encouraging young artists to break out of Maoist shackles. Jiang Feng and Liu Xun were not the only members of their generation of revolutionaries to have emerged from their experiences as they did, but their response—action—was crucial at this sensitive moment in time.

It is in this context that the three unofficial painting groups, the Wuming, the Xingxing, and the Caocao, pushed their way briefly into the limelight. The Wuming had been painting together secretly in Beijing since 1972 and was the earliest of the three groups to have developed a sense of identity, even if they did not dare adopt a name. On December 31, 1974, during the still extremely repressive late years of the Cultural Revolution, they held a private, and therefore illegal, group art exhibition at the home of Zhang Wei, one of the group's artists. Although "forming associations" was a treasonous move in the context of Cultural Revolution China, the individual painters who participated in the exhibition felt a similar sense of artistic and personal identification with the group from this time forward. It was thus completely natural that when permitted they would enthusiastically hold a public group exhibition in 1979. Their paintings have personal qualities, certainly, but the group character of their imagery and style is far more evident than the artistic dominance of any individual, and we might readily refer to them as the Wuming school. Instead of the required art of socialist realism, with its artificially optimistic images of ever-smiling workers and peasants, they sought a realm of freedom in the beauty of nature. Such subject matter was entirely apolitical, but in a repressive era, what one refused to say was far more conspicuous than what one said. To be apolitical was to dissent. It was perhaps only in this very peculiar environment that a lyrical landscape could and would be read as a courageous, even foolhardy, attack on the dictator and his art. The Wuming came together during this time of difficulty and disbanded when it was finished. The public exhibitions of the Wuming in 1979 and 1981 were a retrospective of its group activities in the Cultural Revolution era.

The Xingxing, or "Stars," were brought together for the purposes of a politically and artistically provocative exhibition in 1979 and became notorious for having hung their exhibition on the fence outside the Chinese National Art Gallery on September 27, 1979.

Although many of them had been involved in underground poetry and literary work during the Cultural Revolution and had formed circles of literary friends, their existence as an art group lasted for only two years, 1979 and 1980. The Xingxing was thus a loose collection of individuals, and the varied nature of their art reflects the diverse ways in which creative people bent on liberating art from its shackles might bring it into being. Both the Wuming and the Xingxing might be seen as inheritors of the New Culture movement of the 1910s, when reformist writers who considered modernization and Westernization to be two sides of the same coin sought to liberate China from its feudal past. These two Beijing groups rather naturally gravitated to Western cultural forms, such as free verse poetry, classical music, film, and theater, but particularly to oil painting, as well as to prints and sculpture. The third group, the Caocao, adopted a hybrid view of modernity that seems to have had its roots in cosmopolitan Shanghai of the second quarter of the twentieth century. For them, there was no doubt that the art of ink painting had every right to claim the mantle of modernity, and it was in this belief that they pursued their experiments in abstraction. Their group, at least as a formal organization, lasted for only a few months, being thoroughly crushed by the authorities before their first and only show was even concluded. Its core artists continued their project with some success as discrete individuals, and their efforts in abstract ink eventually gave way to a much larger experimental ink movement that flourishes today.

The bombastic, artificially sweet form of socialist realism that came to define the official art of the Cultural Revolution was rejected, along with its bloodshed and psychological trauma, by artists in the early post-Mao period. Art theorists tried to articulate the problem. Shao Dazhen, the Soviet-trained editor-in-chief of the new journal *World Art* (*Shijie meishu*) published a series of articles on Western modernism. Wu Guanzhong, who was educated at the modernist National Art Academy before embarking on his studies in France, had a solo show in 1979 that prompted him to publish an article in the May issue of the official art journal *Meishu* (Art) in which he suggested that formal beauty was as important as subject matter.[16] Indeed, the opposition to socialist realism emerged as a debate about the relationship between form and content. Rejecting Mao's requirement that political content be primary and artistic standards only secondary, the official press began to argue tentatively that formal beauty and theme were *equally* important elements in art. In short order, artists sought to sever the Maoist connection between politically correct content and appropriate artistic form and began dismantling socialist realism.

The Wuming group had years earlier already put into practice their belief that formal beauty was the *only* important thing in art. They experimented with color and brushwork, pushing beyond the bounds of realism, but for them beauty was still linked to optical experience, and art was a transformation of what was perceived with the eye and felt with the heart. By 1979, the idea that artistic form need not be representational or even beautiful was taken up by the Xingxing, along with the idea that political expression need not be praise. They went even farther, by commenting objectively, as well as critically, on the society they knew. Western modernism, including surrealism and quasi-abstract styles, were their preferred vocabulary. Finally, in Shanghai, the Caocao group took up the challenge of formal experimentation. If form could be severed from content, what forms should art take? How could abstraction fulfill the standard of formal beauty? And most challenging, how could these goals be realized with ink and Chinese paper?

Many students and faculty from the art academies attended these unofficial exhibitions. Although their responses were not all laudatory, there was substantial sympathy,

particularly among some students and young faculty, for what they were trying to do. Still, in 1979 and 1980, the faculty and students of the art academies generally could not or would not implement such ideas in their art.[17]

The year 1985, when modernist art was first widely promoted by young critics within the official Chinese art establishment, is commonly seen as the beginning of a formative epoch for contemporary Chinese art, the time when young artists began to break out of China's previous isolation and prepared to emerge onto the international scene. What this story omits is the essential role played by artists outside the official art world and academies more than half a decade earlier. The unofficial artists, who had so much less to lose, were not hobbled by the conventions of academic training or fear of punishment. They opened the door to formalism, abstraction, and uncensored social commentary. Although their artistic movements were completely crushed and the artists themselves swept aside by political repression in the early 1980s, once unleashed these artistic impulses could not be restrained. Indeed, their ideas lived on and reemerged within the art academies in the ferment of the mid-1980s. The works exhibited in *Blooming in the Shadows* tell a story that has been almost forgotten in the course of China's rapid rise to international economic power. The art of the post-Mao era all began here.

Art Underground: The Wuming (No Name), 1972–1982

During the latter half of the Cultural Revolution, young artists who would later call themselves the Wuming engaged in what was then highly dangerous behavior when they formed an illicit group.[18] Their gatherings and association, like their art, were unauthorized. Over the previous two decades, many other Chinese had gone to prison for less; if their activities had been reported to the authorities, they could well have been condemned and punished as counterrevolutionary plotters. Rather than a counterrevolutionary plot, however, the communal activity of painting fulfilled for the Wuming basic human needs—artistic, personal, and social aspirations—that the abnormal society of Cultural Revolution China tried to suppress. While the group's coming together was almost accidental, it was at the same time driven by psychological forces that were almost irresistible.

The Wuming was composed of two generations of artists who came from different social classes, occupations, and educational backgrounds. What they had in common, besides art, was that each had been condemned to the bottom ranks of society on the basis of their "bad class backgrounds." That is to say, their parents fell into social or vocational groups considered to be the enemies of the Chinese Communist project: capitalists, intellectuals, rightists, disgraced cadres, people with relatives abroad, and citizens who had worked in government under the previous Nationalist regime. On this basis, socio-economic distinctions among them that might have existed before the Cultural Revolution, or might matter in Chinese society today, did not exist.

Friendships and Painting in Dangerous Times

The majority of the Wuming artists, ten of whom are represented in the present exhibition, were born in the 1950s, too young to have participated in the Red Guard movement but old enough to have seen what happened during what they refer to as the "red terror" of the Cultural Revolution. All had discovered art as an escape from the bleakness of life, but it gradually became much more; the pursuit of art gave meaning to their lives. As teenagers in the 1970s, they began painting out-of-doors in pairs and trios of artistically inclined friends who knew one another as neighbors, classmates, or co-workers. Ma Kelu and Wei Hai had been friends at the No. 23 Middle School. Zhang Wei and Li Shan had both attended the No. 41 Middle School, although it was Li Shan's older cousin who had known Zhang Wei in school. Four of the future Wuming painters, Zheng Ziyan, her brother Zheng Zigang, Shi Xixi, and Bao Le'an, all lived in the No. 203 Apartment Compound, where families of Ministry of Culture staff had lodgings. The boys Zheng Zigang and Shi Xixi were childhood friends.

Higher education, both high school and college level, had ceased, and they were employed as laborers, working the equivalent of six full-day shifts every week in a factory or other state enterprise. A few of them worked as staff artists or designers, which required them to paint propaganda but gave them privileged access to art supplies. In about 1972, these small groups of friends began to intersect. On a snowy day in that year, Ma Kelu was

painting at Wumen in the Forbidden City when a person stopped to watch and give him advice (see p. 37, pl. 10). That person was Zhang Wei, who would become a friend. In the same year Ma Kelu met Shi Xixi, bringing Ma into the network of the No. 203 Apartment Complex. Ma Kelu then introduced his classmate Wei Hai to his new friend Zhang Wei, and Zhang brought Li Shan into the expanding circle of young painting friends. Liu Shi met Ma Kelu in 1973 when they were both doing propaganda posters. That year Zheng Ziyan was dispatched to the Beijing Workers Cultural Palace to decorate a parade truck. While there she met Wang Aihe and Ma Kelu, who were taking a workers amateur art class. Ma Kelu then brought Zhang Wei and Wei Hai to see Zheng Ziyan's paintings. Indeed, Zheng Ziyan, Wang Aihe, Ma Kelu, and Liu Shi, along with future Xingxing artist Ma Desheng, developed their friendship while participating in activities at the Workers Cultural Palace. They also began to paint together. Zhang Wei had a sympathetic older work colleague who would drive him and his friends to the Ming tombs in the company truck. Later Zheng Ziyan, Li Shan, and Wei Hai would join him in these painting expeditions. With this critical mass, the younger artists began meeting, seemingly accidentally but usually with some sort of prearrangement, at isolated parks in the suburbs. There they painted the beauties of the natural world and coalesced as a group.

One of the many unconventional aspects of the Wuming group when it came together in 1972 was the large number of young women. Since 1949, art in China had been primarily the business of men. Although some female veterans of the revolution (quite a few were named as rightists in 1957) continued to work, as did some leaders of feminist movements in the 1930s, their impact on the art world of the 1950s, 1960s, and 1970s was very limited. Female students and faculty members in the art academies were vastly outnumbered by male colleagues and almost never occupied positions of power or reputation. The 1985 New Wave movement and China's art world today remain male-dominated. In each of the small circles that coalesced into the larger Wuming was one strong young woman: Zheng Ziyan, from the No. 203 Apartment Compound on the east side of town; the young Li Shan, from the west; and Wang Aihe, living close to Wangfujing nearer the center of town. Later, they were joined by Du Xia and Tian Shuying. From the very beginning and to the very end, female artists were at the core of the Wuming.

The demographic character of the group changed in 1973 and 1974 after Zhang Wei introduced Ma Kelu to an older artist he had met in the park, Zhao Wenliang (b. 1937). Zhao and his long-time circle of male painting friends, Shi Zhenyu (b. 1946), Yang Yushu (b. 1944), and Zhang Da'an (b. 1941), had acquired a certain underground reputation in Beijing based on their *plein air* painting. At about the same time, with Zhang Wei's introduction, Shi Xixi invited Zhao Wenliang, Shi Zhenyu, and Yang Yushu to his home in the Ministry of Culture apartment complex.

During the Cultural Revolution, the Ministry of Culture staff had been sent to labor camp, and many of their children, including those of the Zheng and Shi families, were left home alone. In the absence of parental supervision, Shi Xixi and Zheng Zigang broke into a huge hoard of books that had been stored in their compound in preparation for recycling. After these late night raids they and their friends would enjoy the forbidden fruit—art books, translated novels, Western philosophy—further stimulating their painting experiments and unapproved mental wanderings. Zheng Ziyan first met Zhao Wenliang at Shi Xixi's home. On that occasion, she had brought her father's precious art reproduction books about Ilya Repin (1844-1930) and Soviet museums to show a dozen of their painting friends.

From this time forward, the older artists, then in their thirties, and the younger, in

their teens or early twenties, painted and developed their art together, each individual contributing his or her own talents and personality to the group. While the experience was naturally more of a formative one for the teenagers, the role of the older artists in mentoring their young friends gave them a sense of social worth they had previously been denied. Wang Aihe reminisces:

> The elders naturally took more of a lead, more responsibility, and shared their experience. The young reciprocated by affirming the elders' causes, rejuvenating their art, and giving *Wuming* vibrant energy. The experienced and tactful protected their group from trouble with police and neighborhood committees. The innocent refreshed our eyes with their child-like visions. The women contributed to the diversity and richness of *Wuming* art with views and experiences that were distinct from the men's. The studious brought in *History of Impressionism* and *Rodin on Art.* The eloquent debated theory and politics. The literary circulated Hugo, Tolstoy, and Pushkin. The philosophical discussed Nietzsche and Sartre. The musical shared Beethoven and Debussy. And the sociable connected the group with other groups and friends to provide further resources and opportunities. Most importantly, the loyalty and friendship each person dedicated to the group ensured our common safety and freedom. Within this community, we dared say the taboo words, think the dangerous thoughts, experiment with forbidden art, [and] read the banned books. Together we ventured distances that nobody could reach alone. Above all, the magnet binding us was the space of freedom in a time not free, cultural nourishment during cultural famine, and a solidarity sustaining us in an age of unprecedented alienation. *Wuming* was where we pursued truth and lived out our true selves without having to pretend as in all other social circumstances. It gave us our most important identity. In a world where spiritual life was smothered, *Wuming* was the spiritual home we created.[19]

The four older artists, one of whom is represented in *Blooming in the Shadows,* were friends before the Cultural Revolution. All had hoped to attend CAFA but had been rejected. So, in the late 1950s and early 1960s, they took art lessons at the Xihua Art Tutorial School.[20] Zhao Wenliang, the eldest of the four and organizer of many of their activities, moved to Beijing from Harbin with his family when his father was hired to translate Russian for the Ministry of Petroleum. Formation of his personal style was strongly affected by an exhibition of Russian painting he had seen in Beijing in 1957. Zhao met the fifteen-year-old Yang Yushu at an art class in 1959. Shi Zhenyu met Zhao and Yang in 1962. By 1962 or 1963, the four friends had begun regularly painting at parks around Beijing. Their works were quite personal in subject– portraits of one another, self-portraits, landscape images of the parks in which they gathered to paint—and expressive in style, emphasizing the bold effects of color. In the Chinese art world of the day, their works would have been considered "studies," not the higher-status "creative works," which required a significant political theme and the intellectual arrangement of pictorial elements in service of the message. Unable or unwilling to paint such political work, but simply crazy about art, this group of friends painted their subjective responses to what they saw.

When the Cultural Revolution broke out all four suffered enormously. During the "red terror" from August 18 to early September of 1966, Shi Zhenyu's courtyard home was ransacked repeatedly by the Red Guards; he was traumatized to see his neighbor murdered. Zhao Wenliang's father was forced to return to Liaoning, where he no longer had a home.

Yang Yushu's mother was condemned and forced to leave the city, and Yang himself was incarcerated for a time. Not until October did the old friends dare to make contact, and then only in the most secret way.

Nevertheless, it was friendship and art that sustained them in this terrible time. Shi Zhenyu, who had worked at a machinery factory under the Ministry of Light Industry since 1964, had learned carpentry there, and he carefully made tiny painting boxes that could be hidden in a bookbag. They began travelling far outside the city to paint in remote places, such as near the Great Wall, Ming Tombs, or Fragrant Hills. Shi asked to work the night shift so that he could paint by daylight, and sometimes he would feign illness to have more time for art. He recalls:

> The pleasure of painting in the open air diluted the pain and discrimination I suffered in a chaotic society. Painting led me to a peaceful new world, where there was no slaughter, no conspiracy, and no informants. As I painted, I felt so blessed and delighted to successfully represent nature. Occasionally, I would also feel regret for my powerlessness.[21]

Nevertheless, they had a number of frightening encounters with soldiers and peasants who suspected, in the paranoid mentality of the time, that their painting was a cover for some nefarious undertaking.

After Lin Biao's demise in 1971, the intensity of persecution somewhat waned, and they felt safe to resume painting in parks within the city of Beijing. Among their favorite spots were Yuyuantan (Deep Jade Pond) Park (see p. 27, pl. 1), the Beijing Zoo, and the Purple Bamboo Garden (Zizhuyuan). At about this time, in 1973, they met the enthusiastic young painters Ma Kelu, Wang Aihe, Zhang Wei, Zheng Ziyan, Wei Hai, Li Shan, and Bao Le'an, and the group began painting together almost every day. The decade-long experience of the elder painters and passionate enthusiasm of the younger came together in a mutually supportive alternative society to the oppressive reality of late Cultural Revolution Beijing. Their passion, in this ugly time, was to paint as beautifully as possible. The older artists, particularly Zhao Wenliang, offered advice and encouragement to everyone in the group. For some of the younger artists, Zhao Wenliang, Yang Yushu, and Shi Zhenyu assumed the roles of informal teachers. The group continued to grow. Du Xia met Shi Zhenyu when she was painting at Yuyuantan in 1974 and was soon brought into the group.

The younger Wuming followed Shi Zhenyu's example, making small painting boxes so that they could carry ordinary bookbags to the factory and go painting directly after work. Art supplies were difficult to obtain; they barely had money for food, and such materials were expensive. For this reason, they rarely painted on canvas or even on standard oil painting paper, but instead prepared their own homemade painting paper from whatever supplies they could find. Many of their paintings were executed on scrap cardboard. Liu Shi was particularly thrilled to have acquired a cache of the stiff cardboard used for shoe boxes. Other works were painted on homemade oil painting paper. Each artist prepared the paper in his or her own slightly different way, generally by gluing cheesecloth to large sheets of regular paper and then brushing the surface with laboriously concocted gesso. Once the paper had dried, the sheets would be trimmed into small panels that would fit precisely inside their painting boxes.

A routine gradually developed in which the Wuming lived double lives—in their work unit, where they spent six days a week, and outside, where they spent precious hours painting or talking about art, music, literature, or philosophy with fellow Wuming artists. Daily life in

society was harsh, but they sought to live in a world of nature and the spirit, seeing beauty where it could be found (fig. 4). Because they feared discovery and their work units were in scattered locations, members of the group would travel individually to whatever spot they had designated as their next meeting place. If trees were in bloom at a certain park, the word would spread secretly but effectively, and all would converge on the site of this fragile beauty.

Fig. 4. Wang Aihe painting after work, Beijing, 1974. Courtesy of Wang Aihe. Originally published in the *Wuming (No Name) Painting Catalogue*, vol. 7 (Hong Kong: The Hong Kong University Press, 2010)

Besides their outdoor painting excursions, the group often met at the homes of Shi Xixi, Zhang Wei, or Shi Zhenyu. Occasionally they listened to records at the home of Li Shan or visited Zhao Wenliang, Yang Yushu, or Wang Aihe. Zhang Wei lived with his mother and sisters in Apartment 305, in the Fusuijing Building (see p. 40, pl. 13), which, because of its many doors and dark corridors, was somewhat less accessible to the prying eyes of suspicious busybodies. It was close to favorite painting spots such as the Purple Bamboo Garden and Yuyuantan Park, and the apartment windows provided a lovely aerial view of the White Pagoda, very suitable for painting (see p. 32, pl. 6). Most importantly, the family was so kind and welcoming that their home was to all the Wuming a warm social space, so rare in their cold world. Given the difficulties already suffered by the family, Zhang Wei's mother was not only generous and hospitable, but also extremely courageous to welcome such gatherings into her home.

Late in 1974, Bao Le'an made the audacious suggestion to Zhao Wenliang that they hold an underground exhibition.[22] By then Zhang Wei's home served as their informal social center and group studio, so it was there that they held the group show. Perfectly aware of the dangers they were incurring, the exhibiting artists carried their works to Zhang Wei's home in the Fusuijing Building with utmost discretion.[23] Zhao Wenliang invited Wei Hai to join the exhibition at the very last minute, and Wei Hai was thrilled. Regarding this as a turning point in his life and artistic path, he writes:

> I felt the chill wind along the dark and silent corridors inside the Fusuijing Building. I finally reached the door to no. 305, on the third floor, with two paintings in hand and my excited heart beating in my chest. I knocked according to our secret code. Warm orange light spilled out as the door opened. The room was filled with people, strangers and friends who greeted me with a smile. Our small oil paintings were displayed on every possible surface—walls, chairs, and tables. The artists earnestly explained them as the room buzzed with discussions of foreign painters and writers…People were mainly criticizing the Cultural Revolution and ridiculing politically themed provincial Chinese oil paintings and the second rate USSR style. Someone read poems out loud, and then someone else mentioned that I could sing. Suddenly everyone was encouraging me to sing. I chose the Italian song "O Sole Mio." This small exhibition was like a manifesto that gave our group new meaning and generated a strong sense of affirmation. My heart was thumping, and I saw the same excitement in my friends' eyes. I don't really know what brought us all together, but from that moment on, I was no longer alone … From then on, I was with friends who shared the same dream; we went into nature together to paint natural scenery,

and stood apart from the revolution ... Our pursuit of art was absolutely pure ... We were not landscapists; we turned to landscape painting in reaction to the artistic criteria of the time, when portraiture was corrupted into a tool of propaganda.[24]

The exhilarating exhibition and the perils they survived in mounting it were critical in confirming the group identity of the Wuming. Each artist recognized the growing unity of the group in different ways and at different moments, but this underground exhibition was profoundly memorable to all who participated. For many, it was the first exhibition in which they had shown their works. Most importantly, it confirmed for each participant his or her personal identity as an artist. This sense of self was secret, invisible to all but this close circle of friends, and was outside the institutions that controlled China's populace. Although "forming associations" was a treasonous move in the context of Cultural Revolution China, the participants all felt a similar sense of artistic and personal identification with the group from this time forward. They looked to Zhao Wenliang's "affirmation that art cannot be taught by academies or teachers, but must be discovered within oneself."[25] This confidence that human value existed in places where the state failed to see it was the thinking of those who would survive.

The Wuming did not paint political art. Their work was lyrical, colorful, and filled with beauty. As they all acknowledge today, this art, as well as this lifestyle, resisted in various ways the domination of society by politics during the Cultural Revolution. However, in the context of their time, the very apolitical character of their art and their quest for complete spiritual freedom were rooted in an implicitly political position. In February of 1974 the Wuming all attended a "black-painting" exhibition held in Beijing as part of a campaign against landscape painting and classical music. The Wuming did not go to criticize the famous artists, but to appreciate their work. Subsequently, however, Wei Hai was explicitly criticized in the same negative terms for his bourgeois art, and his friends at CAFA were told to stay away from him.

In an even more profoundly significant event, thirteen members of this illegal and therefore officially nonexistent group travelled together to the coastal resort of Beidaihe for four days over the national day holiday, from September 30 to October 4, 1975, to paint the sea (fig. 5).[26] A few months earlier, in a smaller experiment, four of the Wuming artists, Zhao Wenliang, Zhang Wei, Shi Zhenyu, and Zheng Ziyan, made the same journey. Zheng Zigang, who was laboring in Heilongjiang, joined them.

In the highly restrictive society of the Cultural Revolution, when workers served the revolution like soulless ants, the idea of low-level workers independently planning a short vacation with their friends at the beach was completely outside acceptable norms of behavior. Such a trip might have been described in one of the decadent works of foreign literature that were circulating underground, but it was certainly not in keeping with revolutionary ideology. Moreover, in that period travel in China was restricted; it was expected that anyone leaving the city of his or her residence registry would only do so on official business or with official permission. Young people, particularly those with artistic skill, sometimes side-stepped such restrictions by the risky tactic of counterfeiting travel documents. For this occasion, someone forged a letter of introduction that enabled them to pass the public security bureau inspection and then to check into a hostel at the beach. Shi Xixi paid for Yang Yushu's train ticket. Others mailed their tickets back to Beijing, so that Li Shan, who was only a high school student with no money, could alter the date and use it again. The transportation ruse worked, but in the evening she was questioned and sent away by security agents at the hostel for her lack of an introduction letter. She was stranded

overnight at a remote train station with no return ticket and nowhere to go; Zhang Wei caught up with her the next morning, giving up his trip to accompany her back to Beijing.

For most of the Wuming artists, including the elder Yang Yushu, it was the first time they had seen the sea, with its changing moods. It was an extraordinary visual and spiritual experience that meant not only new visions and inspiring surroundings, but temporary liberation from the network of spies and gossips in Beijing who watched their every move. All the artists returned with many new paintings and images in their minds of an alternative mental and physical space. The trust and collective ingenuity required for a dozen people to do as they pleased in these dangerous times further solidified their group identity and friendships. In Wang Aihe's words, it was a "utopian commune."[27]

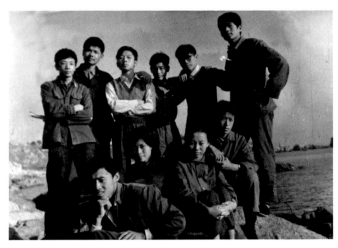

Fig. 5. Wuming artists at Beidaihe, September 1975. Front row, from left: Zhang Wei, Li Shan, Wang Aihe, and Zheng Ziyan. Back row: Liu Shi, Shao Xiaogang, Wei Hai, Shi Xixi, Ma Kelu, and Zhao Rugang. Courtesy of Wang Aihe. Originally published in the *Wuming (No Name) Painting Catalogue*, vol. 7 (Hong Kong: The Hong Kong University Press, 2010)

The Beidaihe trips were only the first of many, as Wuming artists, alone, in pairs, or in small groups began to travel all over China and eventually to paint all over the world.

For Wuming artists as individuals and for the nation as a whole, the year 1976 was a particularly eventful one, beginning with the death of Zhou Enlai, and the regime's failure to adequately commemorate him. Wang Aihe, whose home was adjacent to the Peking Union Medical College Hospital and not far from Tian'anmen Square, could not stay away from the demonstrations at the Monument to the People's Heroes. On April 2 and 3, alongside Zhao Wenliang, she photographed the wreaths and poems on the Monument with a rented camera. The next day she stopped by again to read the new poems and then, after painting all day in the park, narrowly missed arrest when she returned to the square on the evening of April 5. Zhang Wei, Zheng Ziyan, and Wei Hai all joined the communal commemoration on that dismal rainy day and barely escaped the crackdown, but the police identified Wei Hai and arrested him at his home the next day. Zheng Ziyan rushed to tell Zhang Wei that Wei Hai had been arrested, and he fled to Suzhou for about three months.

In the same year, veteran leader Zhu De died on July 6, and on July 28 the Beijing-Tianjin area was hit with a massive earthquake. Fearful of aftershocks, Beijing residents lived outdoors, and the Wuming painted for a period of time in tents. Part of the crowded home where Wang Aihe lived with her family had collapsed, but her Wuming friends brought building supplies and helped her construct a small studio from the rubble.

The solidarity of the Wuming was to a great extent born of the oppression they all suffered. After the arrest of the Gang of Four, the young artists began exploring the new opportunities that began to appear; many changed to more suitable jobs. Still, in the uncertainty of the post-Mao transition, the Wuming artists remained grounded in their art and their friendship.

The Formal Wuming Exhibitions

From January 26 to February 24, 1979, the first independently organized exhibition since the start of the Cultural Revolution, the *New Spring*, was held in Beijing's Zhongshan Park. Most remarkably, Chinese Artists Association chairman Jiang Feng's preface for the exhibition reads as a manifesto for a radically new view of the art world. He writes, in part:

> The "right to form organizations" is a lawful entitlement of the citizens, as expressly stipulated in our country's constitution. Furthermore, such an organization is beneficial to the advancement of art. It can (1) promote creativity; (2) increase styles, forms, and themes of artworks; (3) encourage artists to learn from each other, compete with one another, and improve together; (4) provide more opportunities to bring artworks to the masses and hear comments and criticism from them; (5) solve artists' economic problems by pricing the works for sale ... (6) these kinds of exhibitions could eventually become economically independent events without subsidy from the government.[28]

Among the exhibited artists was Liu Xun, just exonerated and released after many years in prison. Wei Hai's father, Wei Jiangfan (b. 1922), a painter at the Beijing Institute of Chinese Painting, was Liu Xun's friend, and the father and son went to visit Liu Xun at his office in Beihai Park's Huafangzhai galleries soon after Liu's return. They learned that he was to be formally appointed vice-chairman of the Beijing Artists Association. Accord to Wei Hai, Liu Xun was quite interested in hearing the story of the Wuming and about their secret 1974 exhibition, and he asked to see their paintings. Wei Hai introduced him to the three older artists, and a viewing of Wuming works was held for him at Shi Zhenyu's house. He was very eager and immediately expressed his intention to hold an exhibition for the Wuming at Huafangzhai. Persuading his more conservative colleagues in the artists association to go along with this idea was more difficult, but he was adamant about holding the exhibition and fought until he won the day, saying that he didn't care if they sent him back to jail for sponsoring it.

Before the show was finally permitted, however, the group was required to formally organize and give the exhibition a title. They felt somewhat resistant to an overly grandiose or optimistic name, but finally came up with Wuming. Their name represented a utopian absolute freedom of the spirit. The group, which had existed without a name since 1972, was now officially the Wuming, or "No Name."

Liu Xun, then fifty-six years old, had just returned to a position of responsibility after spending twenty-two years in disgrace. Rather than playing it safe, he put his own bureaucratic career on the line by making this important decision: to bring unofficial artists who had resisted the state into an official art gallery. When the artists association suggested removing from the exhibition one of Zhang Wei's most deeply expressive paintings, a truthful and sympathetic image of a fellow factory worker's sad state, Zhao Wenliang tried to persuade Zhang Wei to go along for the good of the entire group. For Zhang Wei, such a compromise would violate the artistic principles he and the group had always followed; he was dismayed that any fellow Wuming would withhold support. He refused to join the show under such conditions, and Liu Xun took up his cause, insisting that the Cultural Revolution's patterns of bureaucratic interference be broken and that all the works must be shown. Although the results of this negotiation were favorable, in the end the process began to strain the informal dynamics of the group. It was the first of the generational, educational, and class divides among the Wuming that would take its

members in many different directions and mark the two official Wuming shows of 1979 and 1981 as a conclusion to their movement.

The venue for the 1979 exhibition, the Huafangzhai, was originally built as part of the imperial garden at Beihai and had several small pavilions, four of which were dedicated to this exhibition. Displayed in the main hall, the works of Zhao Wenliang, Yang Yushu, and Shi Zhenyu were given priority. Those of Ma Kelu, Zhang Wei, Wei Hai, Liu Shi, Wang Aihe, and Zheng Ziyan were hung in the front hall. Paintings by Tian Shuying, Li Shan, Zheng Zigang, and Wang Zhiping were among those exhibited in the east and west buildings.[29]

The first week of the show, which opened on July 7, 1979, was designated for "internal viewing," which meant that only invited guests could attend. Testing the waters, the artists association gave many important people in the art world the first opportunity to voice their opinions. On July 9, a living legend, the newly rehabilitated "rightist" Liu Haisu, came to see the exhibition. He was himself a landscape painter, and he was not a Communist. A founder of the private Shanghai Art Academy in 1913 and a leader in educational reform movements in the art world during the 1920s and 1930s, he was a long-time supporter of informal art groups. Enthusiastic about the event, he brushed two calligraphic inscriptions—"beauty is here" and "Wuming Painting Society"—in appreciation of the Wuming effort. The exhibition, which was open to the public from July 13 to July 29, drew an average of 2,700 visitors a day.[30]

As a public display in an official space, the Wuming exhibition made several points. First, this show demonstrated the principle that art and politics could be separated, and it thus took a position on the theoretical debate initiated by Wu Guanzhong in the May issue of *Meishu* about the proper relationship between form and content. The Maoist belief that art must serve politics was set aside, and personal paintings of completely apolitical subject matter and intent were presented as alternatives. Second, the show validated painting that differed from the academic norm in style, methods, techniques, and aesthetic approach. Diversity and experimentation in composition and style were thus encouraged. Third, putting the Wuming on display restored the rights of private individuals to express themselves in art. The Wuming, as outsiders, dared to say what everyone wanted to hear, and in 1979 Liu Xun validated their years of courageous work by official recognition.

The Wuming exhibitions were promoted by activists within the Communist Party and the Chinese art world to set a larger precedent. Comparatively innocuous in subject matter and unchallenging in style, the art of the Wuming was the perfect tool for art world reformers to unlock the gates of the Maoist prison that the Chinese art world had become. Although these liberating principles would be worked out in debates and even institutional battles in succeeding years, once the border had been crossed into this realm of artistic freedom there was no turning back.

By the time the Wuming group held its second exhibition at Huafangzhai in 1981,[31] the social and economic reorganization that took place during the reform period began to offer new opportunities for individuals. There was no longer need for the secrecy and mutual protection of the Wuming era, and the naive communal dreams born of their isolation were only partially suitable to the new era. The official policy that Jiang Feng had proposed in 1979, that art would become economically self-sufficient, slowly began to affect the lives and thinking of its practitioners. By 1981, someone had drawn up a formal charter for the Wuming, putting the elders in charge and requiring regular attendance at monthly meetings and monthly dues. According to the new rules, the Wuming Painting Society would earn a five to ten percent commission on any sales that took place at Wuming exhibitions.[32] Needless to

say, the free-spirited young artists did not conform to new rules any better than they conformed to the old. This misbegotten attempt at formalization would mark the end of the Wuming as a coherent group.

In the years following their two formal exhibitions, Wuming members established new artistic friendships and professional contacts. Although mutual regard among the individuals continues to the present day and friendships endure, their lives took different directions. Three of the older artists, Zhao Wenliang, Yang Yushu, and Shi Zhenyu, along with Liu Shi and Tian Shuying, held a five-person exhibition at the home of the poet Hui Wa (b. 1927) in 1983. The following year, Liu Shi, Zhao Wenliang, and Yang Yushu were hired by the Beijing Women's Federation as editors, moving from the status of "worker" to that of "intellectual." In December of 1984, missing only Shi Zhenyu, they had a four-man show at the home of a German friend.

The others, as we shall see, also went their own ways. Wei Hai applied again to take the entrance examination for CAFA in 1977, but was denied a test slot, probably because of the political black marks in his file. In 1979, he and Zheng Ziyan married. Zhang Wei and Li Shan married in 1980. The Wuming was no longer a single unitary group.

The Wuming in Retrospect

Artists of the Wuming, who painted together for almost a decade, were a diverse group with varying goals, but they emerged from that experience with a recognizable group approach to art. Founded primarily in Russian styles, their approach was developed in a completely closed system in which they learned from old reproduction books with only the further input of their own individual and collective artistic experiences in 1970s Beijing. The first official exhibition of their work in 1979 amidst the blossoming lotuses of Beihai Park both recognized the uniqueness of this art group and proposed their resistance to political art as a direction for the future. The impact of this group's stubborn attachment to apolitical art in a period that sought to abolish it and the official recognition of the rightness of their project was profound. Despite the almost total neglect of art historians over the subsequent three decades, the group must now be recognized for laying part of the groundwork for what followed in the three decades after Mao.

In 2006 and 2007, the Wuming artists reunited for the first time since 1981 in an exhibition that travelled to Beijing, Guangzhou, and Shanghai. An accompanying compilation of essays and interviews with Wuming artists was the first attempt at a retrospective look at the movement.[33] Reevaluating the Wuming artists' efforts of three and a half decades ago is an opportunity to reconsider the interpretations created by young critics in the 1980s and 1990s and to rethink the prevailing scholarly narratives that have been based upon them.[34]

Excavation of the history of the Wuming thus makes possible an important reassessment of how Chinese art developed in the post-Mao period. We have previously argued that the '85 New Wave movement, despite its vicissitudes in the political strife of the late 1980s, was to a large degree a reformist project supported by the official institutions of the Chinese art world.[35] Put in slightly oversimplified terms, the critical emergence of the Chinese new wave, as well as of internationally oriented Chinese art, corresponds with its move into the official art world and its infiltration of the art academies in the mid-1980s. We would argue that underground artists, including those represented in *Blooming in the Shadows*, were essential in building the foundation on which this edifice was constructed.

A look at the history of these three groups, beginning with the Wuming, make clear that it was the passions of private individuals who worked in the unofficial sphere, despite

the dangers, that enabled art to survive in the era of propaganda. The Wuming thus served a historical function that was greater than that of any individual within the group. Their unselfconscious pursuit of freedom in art and insistence on dreaming their own dreams was an inspiration to others during the late years of the Cultural Revolution. More importantly, they were briefly brought into the open at a time when the official cultural world did not know otherwise how to undo the damage Maoism had done to art. Displayed as a specimen of the long-castigated concept of pure art, or art-for-art's sake, the official Wuming exhibitions gave others in the art world, amateurs and official artists alike, the license to pursue their own experiments.

The Wuming Artists

Shi Zhenyu (b. 1946; pls. 1–3). Born in Beijing, Shi Zhenyu entered Fuxue Hutong Elementary School in 1952 and No. 21 Middle School in 1958. An enthusiastic art student at the middle school, Shi Zhenyu studied with a teacher named Gao Lan and hoped to enter the attached middle school of CAFA. Unfortunately, this path was blocked by his "bad family background": his father had been a school principal before 1949 and died as a victim of the "expanded suppression of counter-revolutionaries" campaign when Shi Zhenyu was four.[36] It was under these circumstances that in 1962 he attended an amateurs painting class at the Youth Continuing Education School for the Arts at Guozijian and met Zhao Wenliang, Yang Yushu, and Zhang Da'an. Unlike his close friends Zhao Wenliang and Yang Yushu, Shi Zhenyu maintained stable employment from the time of his first job assignment in 1964, working as a carpenter, foundry worker, and electrician at a machinery plant under the Bureau of Light Industry. He lived with his mother, aunt, wife, and little son in a small courtyard at Beixinqiao, where he frequently welcomed his young friends during the Wuming period.[37] The earliest work in the exhibition, *Yuyuantan Landscape* (pl. 1), by Shi Zhenyu, depicts one of the favorite painting spots of the Wuming artists. He participated in the 1974 underground show at Zhang Wei's home and in the 1979 and 1981 Wuming group exhibitions.

After the Cultural Revolution the government moved to restore China's stalled economy, transferring some talented and competent people to jobs previously occupied by those whose only qualification had been loyalty to Mao. Of the older artists, Shi Zhenyu was the most effective in making a personal and professional transition to the reform era. In 1976, he was appointed a technician in the Household Appliances Research Center of the Bureau of Light Industry, and from that point on his career focused on industrial design. In 1983 he became deputy chair of the industrial design program of the Beijing School of Arts and Crafts, and in 1987 he became a faculty member of the Central Academy of Arts and Crafts (CAAC) in Beijing. After CAAC became the Academy of Arts and Design of Tsinghua University in 1999, he taught as an associate professor in the Department of Industrial Design. He has won a number of awards and after his retirement in 2007 set up a design studio, sometimes collaborating with his old Wuming friends on projects.

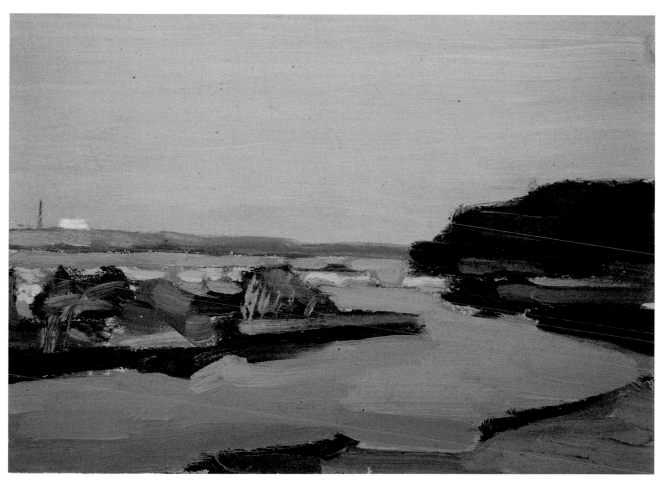

Plate 1. Shi Zhenyu (b. 1946), *Yuyuantan Landscape*, 1965.
Oil on paperboard; 15 x 20 cm (unframed), 40 x 50 cm (framed).
Collection of the artist

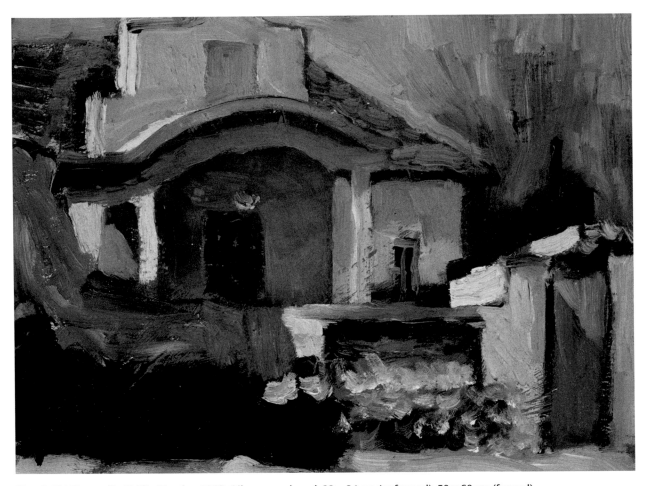

Plate 2. Shi Zhenyu (b. 1946), *Qingdao*, 1973. Oil on paperboard; 22 x 34 cm (unframed), 50 x 60 cm (framed).
Collection of the artist

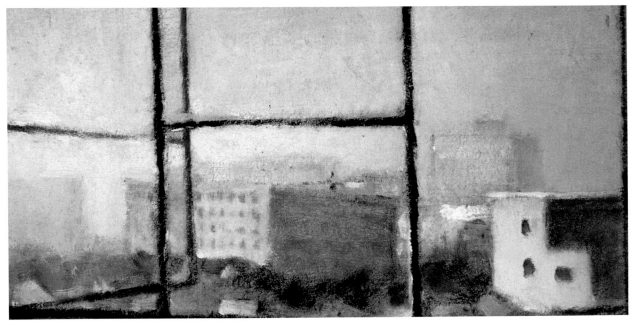

Plate 3. Shi Zhenyu (b. 1946), *Outside the Office Window*, 1976. Oil on paperboard; 13 x 26 cm (unframed), 45 x 55 cm (framed).
Collection of the artist

Zhang Wei (b. 1952; pls. 4-6). Born in Beijing, Zhang Wei grew up in the old-style courtyard home of his paternal grandfather, a wealthy businessman.[38] Zhang Wei, his siblings, and his parents lived in the west side of the compound; the east side was the dining room, and his grandparents lived in the northern and southern sections. Later his grandfather, who was a great opera fan, lent the rooms on the east side to an actor-friend in the Peking opera. During the Cultural Revolution the Red Guard destroyed the courtyard, which had moon-shaped doors, refined woodwork, and an elegant northern garden, and even dug up the brick paving. His grandmother was beaten to death, and their furniture and antiques burned in the courtyard for several days. By this time Zhang Wei, his mother, and his sisters were living elsewhere. Zhang Wei's mother was a Russian teacher at the affiliated middle school of Beijing Normal University; his father had never worked. They divorced in 1963, and in 1964 his father was arrested on charges that he was planning to flee to Taiwan. He died in prison in 1968.

Zhang Wei began his studies in 1959 at the Baozi Hutong Elementary School and in 1962 transferred to Shifuma Boulevard No. 2 Elementary School. From 1965 to 1968 he was enrolled at the Beijing No. 41 Middle School and in 1968 was sent to work and live in a village in Lingqi county, Shanxi. He was able to return to Beijing due to a leg injury in 1970 and began to paint in the next year. Some time around 1972 he met Ma Kelu, who introduced him to others who would become members of the Wuming group. Through these friends he met Zhao Wenliang, Yang Yushu, and Shi Zhenyu, whom he regarded as teachers. *White Pagoda* (pl. 6) represents the view from his balcony in the Fusuijing Building, a vista that served as a frequent subject for his Wuming friends, who would gather at his home to paint. It was in Zhang Wei's apartment, on December 31, 1974, that he and his painting friends held their underground painting exhibition.

In 1973 he was assigned to work in the West City District as a loader at the No. 2 Automobile Plant. Many of his fellow workers were very interesting old men who had been condemned to this arduous work because of their bad backgrounds. One such friend at the plant often gave him and his friends Li Shan, Wei Hai, and Zheng Ziyan rides to the Ming Tombs in the factory's dilapidated old truck. The driver was a graduate of the Catholic Furen University and had worked as an actor and businessman, but right before 1949 he had served as an official in the Nationalist government. Under the Communists he was assigned to work as a loader. Zhang Wei's controversial painting at the first official Wuming exhibition in 1979 recalls his feelings for the condemned men with whom he had worked in the factory.

When the Cultural Revolution concluded, Zhang was transferred to a more desirable job as a stage designer with the Beijing Kun Opera Troupe. Although he participated in the 1979 Wuming exhibition, he was very hurt by the attempt to censor his painting. He and Li Shan, who were so central to the Wuming, dropped out of the group's activities following the 1979 exhibition and took their artistic pursuits in a new but still unofficial direction. Adopting an artistic position that once again was far ahead of what the art establishment could accept, Zhang Wei organized an abstract painting group that flourished in 1982 and 1983. Its members included Ma Kelu, Li Shan, Zhu Jingshi, Qin Yufen, Gu Dexin, Wang Luyan, and Feng Guoding. The year 1983 saw exhibitions at the Chinese National Art Gallery by both the Parisian abstract expressionist oil painter and printmaker Zao Wou-ki (Zhao Wuji) and the modernist ink painter Liu Guosong, then teaching in Hong Kong. Once the debate about abstraction had been opened, the door could not be closed. Zhang Wei and his friends were at the vanguard.

As Zhang Wei initiated new circles of art, Li Shan assumed the role of warm and welcoming hostess to the new underground. Zhang's advocacy of abstract art in the early 1980s

was not quite as dangerous as their Wuming activities had been, but it was still a career-killing move for any artist. As China returned to a comparatively repressive situation between 1982 and 1984, their habits of operating quasi-secretly still proved useful. In addition to the salons they hosted at their home, they would hold exhibitions several times a year. They also made many friends in Beijing's student, diplomatic, and journalistic communities, from whom they learned more about the world beyond China. Still, they remained outsiders in the Chinese art world.

In the fall of 1985, as the cultural climate in Beijing warmed, Zhang Wei, Feng Guodong, and Zhu Jinshi organized the *Graffiti Exhibition* with Ma Kelu and Xingxing members Ma Desheng, Yang Yiping, Qin Yufen, Gu Dexin, Wang Luyan, and Tang Pinggang. The police closed it down even before the opening because of its emphasis on the still forbidden art of abstraction and possibly also because of the participation of artists who had been banned or investigated in recent crackdowns. But they were not so easily deterred. Soon after, in October 1985, on the occasion of Robert Rauschenberg's exhibition in Beijing, their journalist friend Marlowe Hood organized an informal exhibition and dialogue between the American artist and seven artists from their group: Zhang Wei, Feng Guodong, Zhu Jinshi, Ma Kelu, Qin Yufen, Gu Dexin, and Wang Luyan. With Zhang Wei and Rauschenberg each taking offense at the other's brashness, the conversation was not altogether successful. Nevertheless, it was important as a first encounter with the American art world.

In November of 1986, at the invitation of Michael Murray from Vassar College, Zhang Wei travelled to New York to participate in the exhibition *Avant-garde Chinese Art*, one of the first exhibitions in the US to include artists of the Wuming group and also perhaps the first to focus exclusively on art that was oppositional in its approach.[39] While in the US, Zhang became involved with an artists' political group that, after years of protests and lawsuits, succeeded in obtaining the right for artists to sell or display art on the streets of New York. In 2005 he returned to Beijing, where he has a studio in Suojiacun. He continues to exhibit and to advocate for the rights of artists.

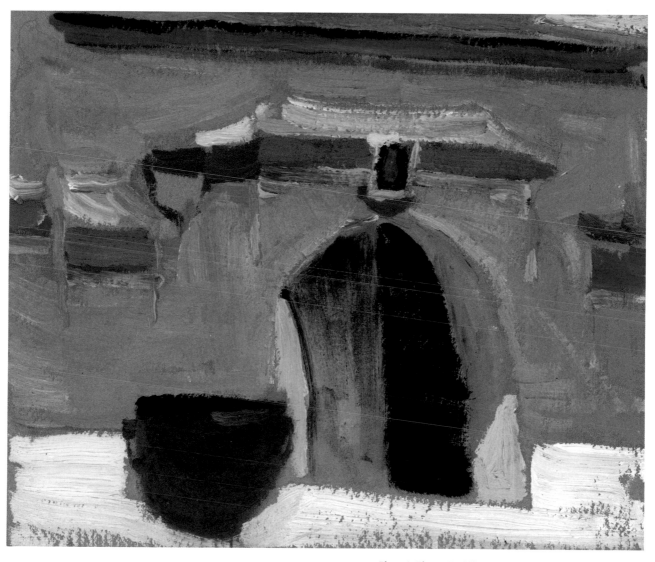

Plate 4. Zhang Wei (b. 1952), *Temple of Heaven 1*, 1976.
Oil on paperboard; 20.5 x 25 cm (unframed), 42 x 51.5 cm (framed).
Collection of the artist

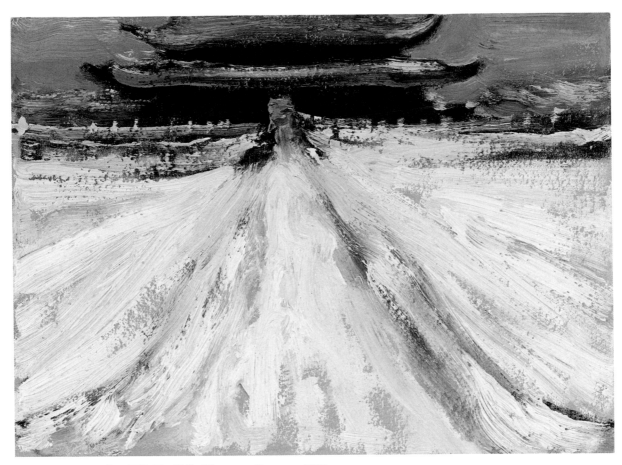

Plate 5. Zhang Wei (b. 1952), *The Hall of Supreme Harmony*, 1976.
Oil on paperboard; 18.7 x 25.6 cm (framed). Collection of Carolyn Hsu-Balcer and René Balcer

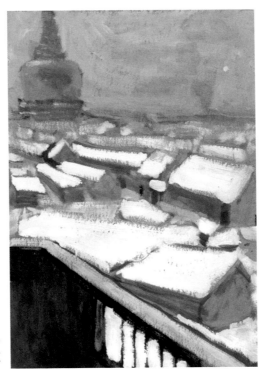

Plate 6. Zhang Wei (b. 1952), *White Pagoda*, 1976.
Oil on paperboard; 30.5 x 26.5 cm (framed).
Collection of Carolyn Hsu-Balcer and René Balcer

Li Shan (b. 1957; pls. 7–9). The youngest artist in the group, Li Shan comes from a well-educated family. Her father, a virologist, graduated from Beijing Medical University, and her mother, a graduate of Jiaotong University in Shanghai, was a metallurgist.[40] Both paternal grandparents were college graduates; her grandmother was a doctor. Li Shan attended Fusuijing Elementary School and then entered No. 41 Middle School in 1971. In that year, she began painting *en plein air* with her older cousin Xie Yali. She vividly recalls her first expedition and the beauty of the Purple Bamboo Garden. Although it was very cold on that November day, she was thrilled to paint alongside the mentor she so admired. In the evenings, the two girls would make drawings of plaster casts, which Xie Yali insisted was essential training. Then her cousin was sent down to Yunnan. Before leaving she introduced Li Shan in 1973 to some of her middle school painting friends, notably Zhang Wei and Ma Kelu. Zhang Wei soon introduced her to the other young artists of the Wuming group. She got to know Zhang Wenliang, Yang Yushu, and Shi Zhenyu in 1974.

Once the Wuming group came together, Li Shan went out every day or two to paint with someone from the group, missing school three or four days a week. She needed a letter from home as an excuse for her absences, so she successfully forged notes from her mother. Since she was truant, however, she could hardly ask her parents for bus money. Instead, she learned from her friends how to paint counterfeit monthly bus passes. She was very afraid of getting caught, so her bus tickets were very faithfully copied, much more accurately, in her opinion, than those of Zhang Wei. To look as though she had some legitimate business travelling around the city she always wore one of her mother's work uniforms, and she never got caught. Since funds were short, members of the group made their own art supplies. She painted on cardboard or oil painting paper that she had prepared herself. Her homemade painting box must have been slightly larger than others, as she recalls making her own bookbag to accommodate it. The box would hold three or four pieces of homemade paper and some brushes. Their favorite places for painting were Yuyuantan Park (Diaoyutai) and Purple Bamboo Garden, which were not too far from her home, as well as the Beijing Zoo, the Old Palace (see pl. 8), Zhongshan Park, the Workers Cultural Palace, Temple of Heaven, the Fragrant Hills, and the Ming Tombs.

Li Shan participated in the group's 1974 underground show, and she desperately wanted to accompany the group to Beidaihe in 1975. Such a trip would be impossible without the acquiescence of her parents. Zhang Wei took her to visit his classmate, the son of painting professor Wu Guanzhong, and brought several of her paintings along to show the respected senior artist. Wu Guanzhong commented that her paintings had very nice color. She immediately reported to her parents that Wu Guanzhong had praised her work, and they agreed to let her go to paint at Beidaihe. Despite her closeness to Zhang Wei in that period, her Wuming friends recognized in her work a sense of innocence that was all her own. She framed the world from her own angle, enlivened it with quirky details, and rendered it with clean color and clear light.

After graduating from high school in 1977, she worked at a bakery as a designer. She participated in the first Wuming group exhibition in 1979. In 1986 she moved to New York and then returned to Beijing in 1992. She remains active as an artist and designer in Beijing, holding several of her own solo shows and participating in many group exhibitions.

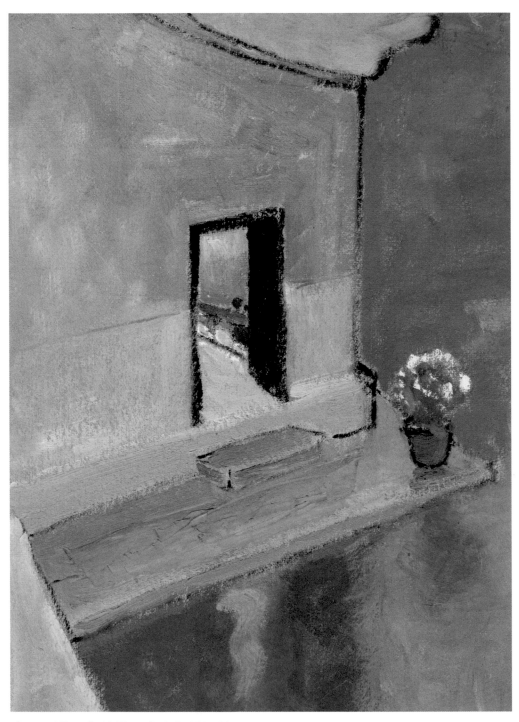

Plate 7. Li Shan (b. 1957), *In the Rain*, 1974–78.
Oil on paperboard; 28 x 20.2 cm (unframed),
55 x 48 cm (framed). Collection of the artist

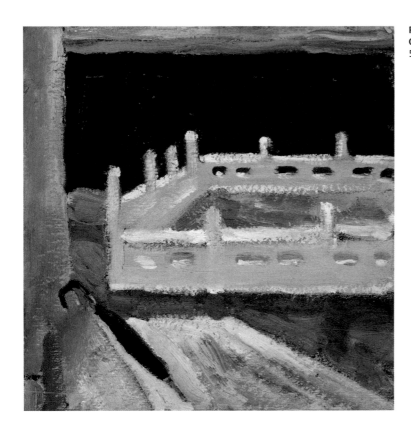

Plate 8. Li Shan (b. 1957), *Untitled*, 1974–78.
Oil on paperboard; 19 x 18 cm (unframed),
50 x 50 cm (framed). Collection of the artist

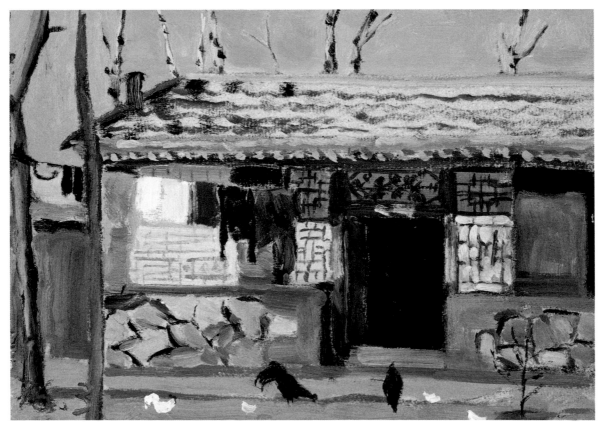

Plate 9. Li Shan (b. 1957), *Dormitory*, 1976.
Oil on paperboard; 19.5 x 27 cm (unframed), 55 x 48 cm (framed). Collection of the artist

Ma Kelu (b. 1954; pls. 10-12). Along with Zhang Wei, Ma Kelu was an essential node in the Wuming network. Ma was born in Shanghai, but moved to Beijing at the age of six with his father. He started elementary school the following year, in 1961, and went on in 1968 to the No. 23 Middle School. During his middle school years he studied with Chen Fosheng, an ink painter, and started outdoor drawing. In 1969 he met fellow students Wei Hai and Zhou Maiyou, with whom he shared an interest in art. Between 1970 and 1972 he was sent down to the countryside in Pinggu, about sixty kilometers northeast of Beijing, but he returned to the city in 1972 with a job assignment in a small restaurant at Chaoyangmennei run by the East City District Food Service Company. Over the course of 1972 and 1973 he met and, along with Wei Hai, began painting with Zhang Wei, Liu Shi, Zheng Ziyan, Wang Aihe, Shi Xixi, and Bao Le'an. Ma Kelu's home was near the Drum Tower and Bell Tower, to the north of the old palace, and he painted many images of such neighborhood landmarks, including Yingding Bridge (pl. 12) and Shishahai. He was then transferred to work in the company's mechanical repair facility. During those years he had the opportunity to study painting briefly at the Beijing Workers Cultural Palace, where he made other young artist friends. Meeting Zhao Wenliang, Yang Yushu, and Shi Zhenyu in 1974 had a strong effect on his painting style, as it had for many of the young artists in the group.

Ma Kelu, who loves literature as well as art, has written compellingly of the old city's attraction—the desolate ruins of the ancient city walls of the Yuan capital, the Ming-Qing city of Beijing, the Forbidden City (see pl. 10), the Great Wall and Ming Tombs, the Fragrant Hills, the Eight Great Sites, the Summer Palace, the Yuanmingyuan's ruined places, the five lakes, Zhongnanhai, Beihai, Shishahai, Houhai, and Kushuitan—to the young artists. Beijing in those days gave them a feeling of desolate melancholy. After having travelled in Europe and attended art school in the United States, Ma writes in his 2009 "Self Statement":

> In the early 1970s, when we began painting from nature, we haunted the streets of Beijing and Diaoyutai…By 1974, our circle of friends had grown, friendships deepened, and we came to rely on and influence one another. Every spring, we would climb the Fragrant Hills and Eight Great Sites and travel together the lilac-lined roads to Biyun Temple…The lake at Yuyuantan had a broad surface coursing through long forests and along changing hillsides. In Purple Bamboo Park were even more dirt roads, lakes, lotuses, creeks, and high hillsides where grass grew to one's waist and all the way to the river's edge—a stretch of natural charm…[41]

On the unclassifiable nature of their art, he reflects:

> In those paintings, one could see the influence of poetry and literature; they revealed a kind of natural wisdom. Looking at them today, they fall squarely into the realm of classical aesthetics, full of the natural and frugal beauty discussed by Kant, and the dignified aestheticism of Hegel. These were totally different from modernism, post-modernism, deconstruction.[42]

In 1976 Ma Kelu and Zheng Ziyan, along with Wei Hai and Zhang Wei, counterfeited train tickets and travelled to Shanghai, Hangzhou, and other southern cities to visit the sites and people of their early lives. In Shanghai Ma Kelu visited his mother and siblings, whom he had not seen for sixteen years; Zheng Ziyan, who lost her father in 1972, visited relatives in Hangzhou,

where she had been born. Now a young adult, Ma Kelu painted a picture of the Shanghai *lilong* (alleyway) home of his childhood.

After participating in the three Wuming exhibitions, in 1974, 1979, and 1981, Ma Kelu turned his attention to other forms of art, including lithography. He joined Zhang Wei in his pursuit of abstraction and participated in the series of experimental exhibitions of the early and mid-1980s. In 1984 he resigned his job to become a professional artist. Along with Zhang Wei, Zhu Jinshi, Wang Luyan, and others, he participated in the 1985 apartment exhibition visited by Robert Rauschenberg. In 1988, after traveling to Germany, Sweden, and Denmark, he moved to the US. He studied on scholarship at Skowhegan School of Painting and Sculpture and then at Empire State College, SUNY, before settling in New York City. His studio work was exhibited in galleries in North America and Europe, and he also sold art, including framed photographs of his Wuming paintings, on the streets of New York. In 2006 he returned to Beijing, where he has a studio, and has participated in many exhibitions.

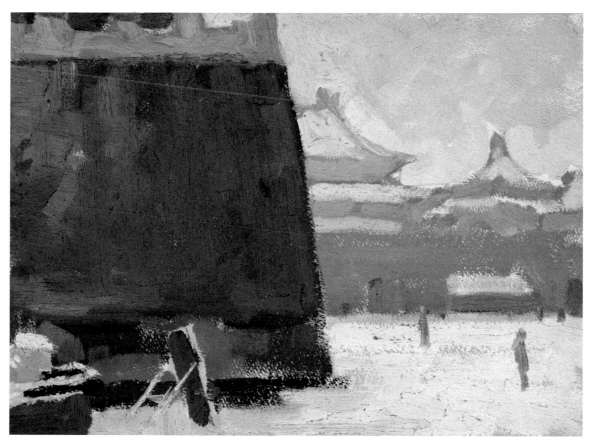

Plate 10. Ma Kelu (b. 1954), *Snow at Wumen Gate*, 1974.
Oil on paperboard; 19.5 x 26 cm (framed).
Collection of Carolyn Hsu-Balcer and René Balcer

Plate 11. Ma Kelu (b. 1954),
Chrysanthemum and Blue Pot,
1974. Oil on paperboard;
39 x 31 cm (unframed).
Collection of the artist

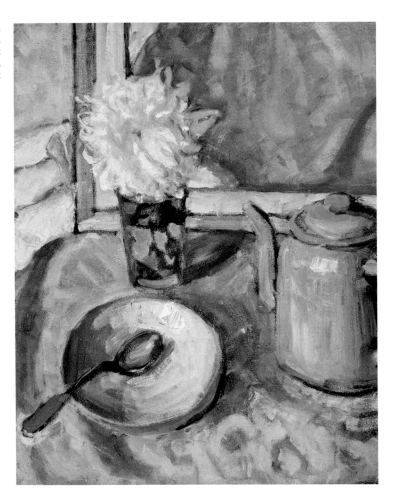

Plate 12. Ma Kelu (b. 1954),
Yinding Bridge, 1980.
Oil on paperboard;
31 x 41 cm (unframed).
Collection of the artist

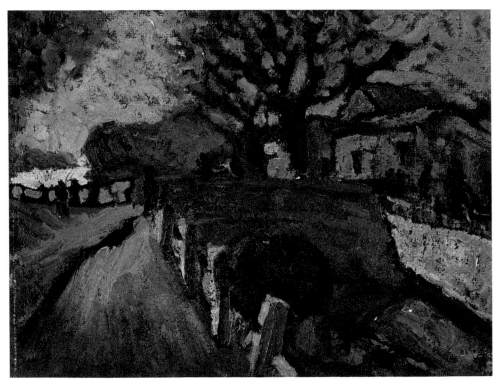

Zheng Ziyan (b. 1951; pls. 13-15). Zheng Ziyan was born in Hangzhou, where her father, Zheng Yefu, worked as a professor at the East China Campus of CAFA.[43] One of thirteen art students in a woodcut training class organized by the writer Lu Xun and taught by Uchiyama Kakichi in August of 1931, the father was a pioneer of the new Chinese woodcut movement and one of its key organizers. Zheng Yefu participated in many of the small woodcut groups that came together in Shanghai in the 1930s and were banned, one after the other, by censors of the Nationalist government. During the Sino-Japanese War he continued their work, for a time running a small mail order factory in his hometown in Zhejiang that distributed printmaking supplies and instructional materials all over China. In 1953 he was chosen as a vice-chairman of the Chinese Artists Association and reassigned to a post in Beijing. Over the next four years he organized national and international exhibitions, assisted arts leader Jiang Feng in establishing the Central Academy of Arts and Crafts, and assumed editorship of a new journal, *Printmaking (Banhua)*. Along with Jiang Feng, a fellow student in the 1931 printmaking class, he was named a rightist in 1957, stripped of his job and party membership, and assigned to hard labor. The two old friends were transferred back to the city in 1960 to work in the storage and conservation department of the newly constructed Chinese National Art Gallery.

With the father's demotion, the family lost their housing in a lovely courtyard house owned by the Artists Association. Zheng Ziyan was one of four children. Her mother was forced by the political circumstances to move the growing family into much smaller quarters in the housing of the Ministry of Culture, where she worked. At the beginning of the Cultural Revolution they lived in No. 203 Apartment Compound. Like the households of most cadres and intellectuals, their family life was broken by the Cultural Revolution. Her father was publicly abused in 1966 and then condemned to labor camp in Hubei. Her younger brother Zigang was sent to the Heilongjiang countryside in 1969.

Zheng Ziyan began middle school in 1964. With her father's encouragement, she had already begun making woodcuts and paintings as a child and participated in many children's art exhibitions. She entered the work force in 1971 after being assigned to the "commerce" sector of the state employment system. Her initial job assignment was at a day care center that served workers in retail trade units. The administration recognized her artistic talent and began giving her special design assignments for temporary exhibitions or parades. In 1972, encouraged by her father's friend Li Hua, a printmaking professor at the newly reopened Central Academy of Fine Arts, she applied there for admission. In the end she was told that "political background" was the main admission criterion, and she did not qualify. Deprived of the opportunity to go to art school, she participated in amateur art classes at the East City Culture Center on Yanle Hutong. In addition, her father, who had been sent home on medical leave, devoted himself to teaching her drawing and painting. Some of his favorite art books, those on Kathe Kollwitz, Iri Maruki, and Toshiko Akamatsu, had been returned, and he urged her to study them. After her father died of liver cancer in 1973, Li Hua took it upon himself to give her weekly art classes at his home. At that time, she began painting outdoors with the Wuming group, and Wuming activity became a center of her life.

In 1973, Zheng Ziyan met Wang Aihe and Ma Kelu at art class, and Ma Kelu brought Zhang Wei and Wei Hai to see her paintings. Her brother's friend Shi Xixi, who was living alone in the same apartment compound, also began making new friends who shared his love of literature, music, and art. His home became a gathering place for them all. Zheng Ziyan's first meeting with the older artists Zhao Wenliang, Yang Yushu, and Shi Zhenyu was at Shi

Xixi's initiative. Each small circle of friends mutually solved practical problems. Zheng Ziyan remembers their handmade palette knives and how Wei Hai constructed painting boxes for Wang Aihe, Zheng Zigang, and herself. Zheng Ziyan subsequently joined in the underground exhibition at Zhang Wei's home. Her generally optimistic disposition is conveyed in her works, such as the clean snow on grimy buildings below Zhang Wei's balcony (pl. 13) or the vividly painted locust leaves offering hope of new life to dusty courtyard houses (pl. 14). Yet senior art critic Wang Zhaowen, who saw her paintings at the 1979 Huafangzhai exhibition, commented that they had a melancholy flavor. Perhaps the critic saw the authenticity of her feelings, sorrow and disappointment, in that troubled time. She has written that her father left her with a commitment to seek "true art."[44]

As efforts were launched to revive the consumer economy, Zheng Ziyan was reassigned by her employment sector to work as a designer in a department store. *Autumn in the Great Northern Wilderness* was painted when she and Wei Hai visited her brother in Heilongjiang shortly before Zheng Zigang moved back to Beijing in 1979 (pl. 15). In that year, Wei Hai and Zheng Ziyan married. They both participated in the 1981 Wuming exhibition, and in 1984 their dreams of attending art school were finally realized when they enrolled at the Central Academy of Arts and Crafts. After graduating in 1988 from the Interior Design Department of the academy, she worked as an art editor for a magazine publisher and retired in 2006. She is now also practicing Chinese ink painting.

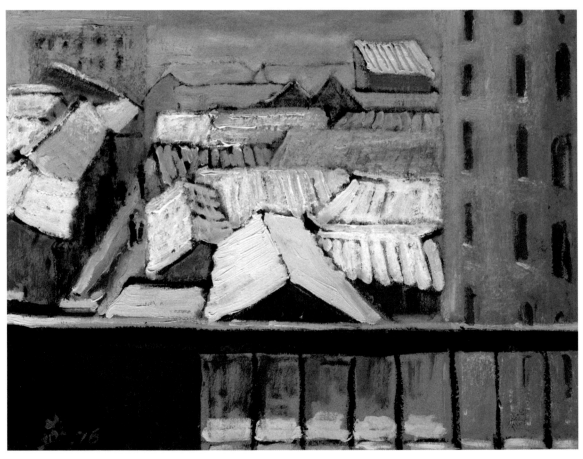

Plate 13. Zheng Ziyan (b. 1951), *Winter View from Fusuijing Building,* **1976.**
Oil on paperboard; 30 x 38 cm (unframed), 50 x 63 cm (framed).
Collection of the artist

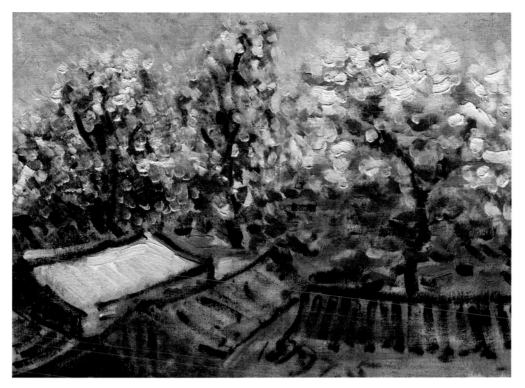

Plate 14. Zheng Ziyan (b. 1951), *Fragrance of Locust Tree Flowers in Beijing*, 1977.
Oil on paperboard; 25.5 x 35 cm (framed). Collection of the artist

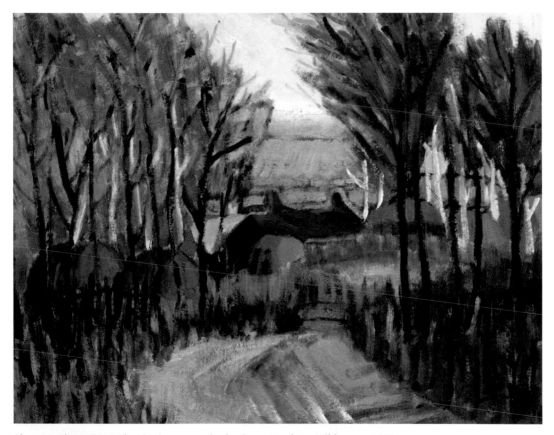

Plate 15. Zheng Ziyan (b. 1951), *Autumn in the Great Northern Wilderness*, 1979.
Oil on paperboard; 30.8 x 37.8 cm (framed). Collection of the artist

Zheng Zigang (b. 1953; pls. 16–18). Rather than the picturesque sites of Beijing, many of the Wuming era landscapes of Zheng Zigang depict the terrain and seasonal changes of Manchuria, where he lived as a worker on the Shanhe state farm in Nenjiang, Heilongjiang, from 1969 to 1979. Zheng Zigang was born in Shanghai and moved to Beijing with his family when he was a child. From 1960 to 1969 he studied at the Beijing Jingshan School, which had an intensive curriculum designed to take students from first grade through senior high in ten years. Having received this accelerated education, he was sent to the countryside at the relatively young age of sixteen. During his home visits his sister Zheng Ziyan and his friend Shi Xixi introduced him to the Wuming group, and when he returned to the farm they sent him off with painting supplies. Beginning in 1972 he painted images of the vast and desolate landscapes of China's agricultural northeast and would send them back to his sister and her friends in Beijing for comment. *Sunset over the Farm* sets the young workers' simple dormitories against the spectacular evening sky (pl. 16). *Clean Winter* is a painterly exploration of white on white that was refused for several exhibitions, probably for its abstraction (pl. 17).[45] In a work from near the end of his ten-year exile, he explores the effects of light in the birch forest (pl. 18). He writes in his 2009 "Self-statement" that he particularly enjoyed his last years in Heilongjiang, when the others had gone back to the city and he could use the dormitory as his private painting studio.[46] His sister and Wei Hai visited him in 1978. Like his sister, Zheng Zigang participated in the 1979 and 1981 Wuming exhibitions.

As the post-Cultural Revolution regime struggled to rectify the many injustices of the prior decade, some sent-down youth were permitted to return to the city to replace a parent in his or her place of employment. In 1979, Zheng Zigang was hired by the Chinese Artists Association, where his father had worked. The following year, his father was posthumously rehabilitated. In addition, Zheng Zigang studied Chinese language and literature between 1980 and 1984 at the East City District Staff College for Continuing Education in preparation for a career in exhibition planning and catalogue editing. He worked at the Artists Association organizing painting exhibitions, compiling publications, and similar administrative duties until he took early retirement in 2003. Since then he has resumed landscape painting.

Plate 16. Zheng Zigang (b. 1953),
Sunset over the Farm Dormitory, 1973.
Oil on paperboard; 19.7 x 26.7 cm (framed).
Collection of Carolyn Hsu-Balcer
and René Balcer

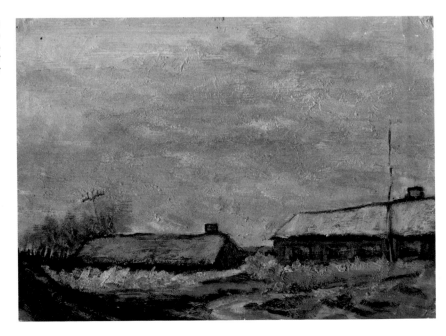

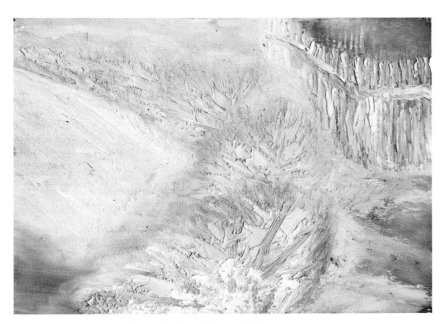

Plate 17. Zheng Zigang (b. 1953), *Clean Winter*, 1974.
Oil on paperboard; 19.7 x 27.5 cm (unframed),
56 x 50 cm (framed). Collection of the artist

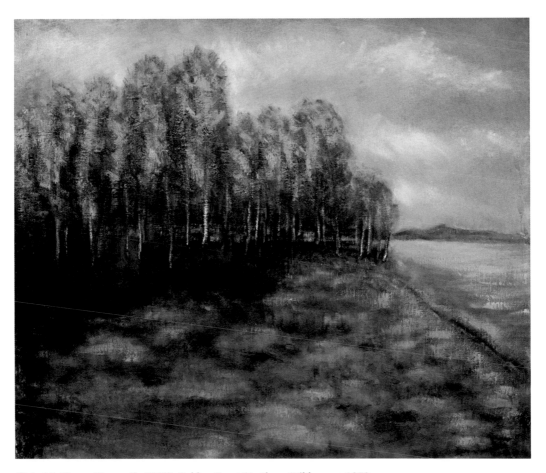

Plate 18. Zheng Zigang (b. 1953), *Golden Great Northern Wilderness*, 1978.
Oil on paperboard; 50 x 58 cm (unframed), 54 x 63 cm (framed).
Collection of the artist

Wei Hai (1952–2010; pls. 19–22). Born in Beijing, Wei Hai was the son of artists. Both his parents had graduated from the National Peking Art Institute (later, the Central Academy of Fine Arts), where his father, Wei Jiangfan, was a student of the Republican-era reformer Xu Beihong.[47] As testimony to the father's academic training, his oil painting, a copy of *The Feast of Bacchus* by Velasquez, hung in their home. Wei Jiangfan taught at the Central Academy until he was transferred to the Beijing Institute of Chinese Painting in 1960. He is known today for his *guohua*, or Chinese ink paintings.

Wei Hai's art studies began in fourth grade with his father's instruction in drawing. He was also enrolled in the *guohua* class at the Jingshan Children's Palace while a student at the Heizhima Hutong Elementary School. Moreover, the Beijing Institute librarian, known to him as Auntie Pu (she was the younger sister of the last emperor, Puyi), indulged his enthusiasm for studying art books, and his father sometimes brought reproduction books home for him. Wei Hai fully expected to attend the attached middle school of the Beijing Art Academy and to become an academy artist.

Although his family would largely escape persecution, his art school dream would become impossible with the outbreak of the Cultural Revolution. Instead he entered the No. 23 Middle School in 1967. During this period he created many blackboard newspapers and also painted pictures of Mao, but also got in trouble in that self-denying period for his pride and his passion for reading. In 1970 he was assigned to a job as a lathe worker in the Beijing Electron Tube Factory. During the period before he joined the Wuming in 1974 he worked very hard to master pencil drawing and oil portraiture while painting a few landscapes. When CAFA prepared to accept worker-peasant-soldier students, he took the entrance examination but did not meet the political requirements. In the end, it was the Wuming and not the academy that provided the artistic environment he craved. "Our group adhered to no artistic dogma," he writes.

> We had no spiritual leader or teacher, in fact we abhorred authority and power. We were never driven by commercial or venal motives nor did we seek personal benefit. Our pursuit of art was absolutely pure, and I have remained dedicated to that ideal. During an era that celebrated the cult of personality, our group stood in opposition and pursued freedom of thought, art, and personal expression. We were not landscapists; we turned to landscape painting in reaction to the artistic criteria of the time, when portraiture was corrupted into a tool of propaganda. Our common behavior reflected a common artistic mindset—to pursue absolute freedom of the spirit by going back to nature and our original selves, and trying to find the passion of creating pure art. Since each one of us painted to express our unique and individualized understanding of pure art, our styles of expression were not the same…
>
> Turning to landscapes didn't mean abandoning portraiture. We did still life and portraiture as well, using the same concepts as in our landscapes. I deliberately simplified figures in portraits, using strong and heavy colors to show powerful contrasts; through this form I tried to express my passion of pursuing spiritual freedom. We all emphasized the uniqueness of expressing individual thought; we objected to abundant narrative in painting, superficial artistic language, and pandering to popular tastes. Mainstream art education, which I received as a child, emphasized representing space and structure, and used portraiture as a means of conveying a person's identity. During the Cultural Revolution, portrait painting came to represent mainstream art; since portraits of the time [were required to emphasize social class] …, a few types of faces,

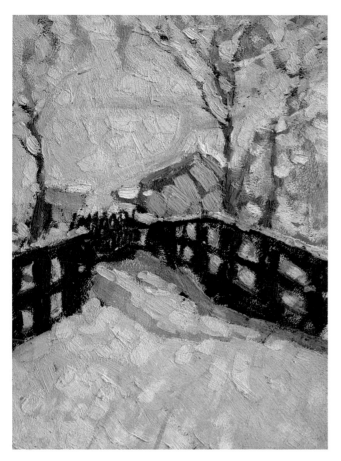

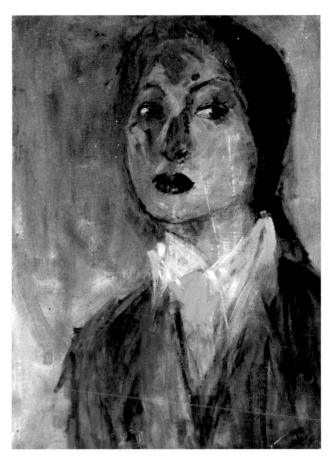

Plate 19. Wei Hai (1952–2010), *Small Red Bridge*, 1975.
Oil on paperboard; 27.8 x 19.8 cm (framed).
Collection of Carolyn Hsu-Balcer and René Balcer

Plate 20. Wei Hai (1952–2010), *Red Lips*, 1976.
Oil on paperboard; 56 x 40 cm (unframed),
85 x 68 cm (framed). Collection of the artist's estate

like masks, came to be used to portray all people, while strong, easily understood narratives and obvious themes were used to educate the public. Quite obviously, our paintings stood against the mainstream of that period.[48]

During this period Wei Hai continued to take formal classes: a friend of his father's allowed him to join the class on portraiture and drawing for middle school art teachers that he was teaching at CAFA. Wei Hai's drawing skills were considered particularly good. Nevertheless, after the "black-painting" exhibition in February 1974 and the subsequent condemnation of ideologically deviant artworks, his friends from CAFA came to tell him that someone had reported on him, and his paintings were being criticized. A work he did in class in 1976, *Red Lips*, painted in a sensual style tied to the boldness of the Wuming, was too far outside the polished academic and social norms of the time and was criticized by the professor conducting the class (pl. 20). Wei Hai apparently refused to accept the criticism and found himself not only humiliated on the spot but also condemned by the Beijing Institute of Chinese Painting, where his father worked and the family lived, as representing the "ideological tendency of the capitalist class." He believed that this painting marked him forever in the records of the academy as heterodox.

Even more serious was his political "crime" of April 1976. "On the day before the Qingming Festival," he recalls,

> Tian'anmen Square was filled with people carrying white flowers in mourning for Premier Zhou Enlai, who had died four months earlier. Under a gray sky, the crowd formed a dark block around the Monument to the People's Heroes, where they laid wreaths in honor of Premier Zhou. Some among the crowd eulogized him while others read parodies ridiculing the Gang of Four. The sound of voices reading poems and shouting slogans was continuous, like the distant thunder growling before a storm. In the early morning of the following day, April 5, water wagons appeared in the square. The trucks approached and used high-pressure jets to wash away the wreaths, slogans, and poems piled around the monument. People were incensed at seeing these expressions of their sincere feelings being thus trampled and debased. Those responsible had come from the small militia headquarters nearby. At midday, the people finally had enough—there was an uproar among the crowd and people rushed to the headquarters; a car was overturned and set on fire, part of the headquarters itself was soon ablaze. Zhang Wei and I dragged some bicycles from the west gate of the building and tossed them into the fire. The water trucks turned their high-pressure jets on us and forced the crowd back. Hundreds of militiamen without insignia or collar badges ran out of the building, and formed several circles around the building. The angry crowd surged forward like the tide. Flames, pressure jets, and soldiers—I could never forget the fear and confusion on the faces of the young soldiers. Zhang Wei and I ran out of the square hand in hand, warning each other to take care.[49]

Late that night the police arrested Wei Hai at his home. When they released him the following morning, he asked Zheng Ziyan to immediately warn Zhang Wei. After he was released Wei Hai's factory formed a special team to make him and the others from the April fifth event confess their crimes. Particularly difficult for him in the context of this and other Cultural Revolution political movements was that he was shunned by people he knew. But, he gradually realized that the authorities didn't know what he had done in Tian'anmen Square. After that, on his way home every day he'd drop in on Zheng Ziyan, who would help him write the "confession" to be turned in the following day.[50] Wei Hai participated in the 1974 underground Wuming exhibition and, with the help of his father's friend Liu Xun, facilitated their 1979 show at Huafangzhai. The following year he received a job transfer out of the factory. He participated in the second Wuming show in 1981 and in 1984 entered the Central Academy of Arts and Crafts to study graphic design. After he graduated in 1988, he worked at the Central Academy of Drama as a TV director. In the 1980s he, too, experimented with abstraction. He eventually became a member of the Chinese Artists Association. In 2000 he fell ill with a degenerative disease, the effects of which he translated into powerful painted images over the last decade of his life.

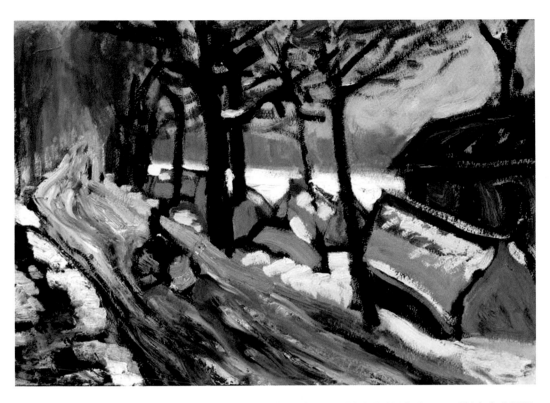

Plate 21. Wei Hai (1952–2010), *Snow at Shishahai*, 1978.
Oil on paperboard; 27 x 39 cm (unframed),
57 x 49 cm (framed). Collection of the artist's estate

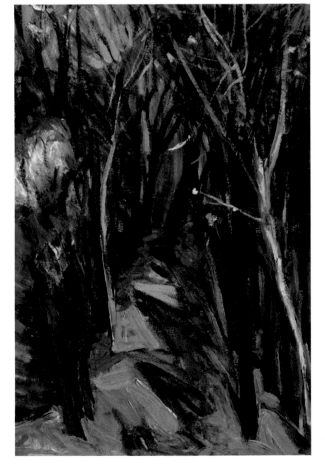

Plate 22. Wei Hai (1952–2010), *Golden Path*, 1975–77.
Oil on paperboard; 39 x 26.8 cm (unframed),
55 x 42 cm (framed). Collection of the artist's estate

Wang Aihe (b. 1953; pls. 23–25). Born in Beijing, Wang Aihe was the daughter of two pharmacologists.[51] Her father taught at Beijing University Medical School and her mother worked at the Peking Union Medical College Hospital. Her mother was condemned as a rightist in 1957. Wang Aihe entered Bamiancao Elementary School in 1961 and then Shuaifuyuan Secondary School in 1967. Her brother was sent to the countryside and her parents to separate labor camps, leaving the teenage Wang Aihe in an empty home. In 1971 she was assigned a job in the East City District No. 1 Plastics Factory, a neighborhood concern that produced plastic bags for chemical fertilizer and red covers for the writings of Chairman Mao. She had the job of pressing designs into the red plastic covers for Mao's works, producing as many as 3,000 covers in a night, a factory production record. After Lin Biao died the plant decided to diversify its products, and Wang Aihe became a product designer, a job she held until 1983. In 1972 the factory expanded her responsibilities to include supervision of new printing technologies that were even more toxic than the old ones. She, like all the workers, was frequently ill from the chemical exposure, and for the next decade her life alternated between diligent work, illness, and slow recuperation. As the child of a rightist, she was also frequently subjected to the pressures of ideological investigation and thought reform in the workplace.

In 1973 Wang Aihe was permitted to join an art class at the Workers Cultural Palace, formerly an ancestral shrine adjacent to the Forbidden City. It was here that she met Zheng Ziyan, who had been sent there to decorate a parade truck, as well as Ma Kelu, Zhong Ming, and Feng Guodong. Through them she met Shi Xixi, Zhang Wei, and Wei Hai and joined the Wuming group in their painting excursions, their salons, their 1974 secret exhibition, their trip to Beidaihe, and their public exhibitions in 1979 and 1981. Throughout that difficult decade, art and her Wuming friends became the center of her life.

Wang Aihe joined Zhao Wenliang in Tian'anmen Square during the April demonstrations of 1976. Then, on July 28, the kitchen of the ramshackle courtyard dwelling (see pl. 23) she shared with her parents and four brothers collapsed in the Tangshan earthquake. Her Wuming colleagues came to help her rebuild. Liu Shi, who worked at a restaurant near her home, picked up bricks and beams from the houses that had collapsed and brought them to her home on the restaurant's tricycle cart. Shi Xixi, a construction worker, quickly laid the bricks. Wei Hai, the carpenter, made windows and doors. Ma Kelu and Zhang Wei cemented the floor and plastered the walls. The room was finished by the Mid-Autumn Festival and became her studio. Wei Hai built her a large painting box. For the first time she had a place of her own to paint, and over the next five years expanded her art to include figure paintings.

In the Democracy Wall era, her paintings became more reflective of social reality and darker in mood. She stopped painting in 1981 to begin studying for college entrance examinations and was accepted for the graduate program at the Chinese Academy of Social Sciences in 1983. She was the first of the Wuming to become a full-time student. Three years later, in 1986, she went to Harvard, where in 1995 she completed a Ph.D. in East Asian Languages and Civilizations and Social Anthropology. Since then she has taught at Purdue University and at Hong Kong University. She edited *Wuming (No Name) Painting Catalogue*, the thirteen-volume historical series on the Wuming artists, published by Hong Kong University Press in 2009.

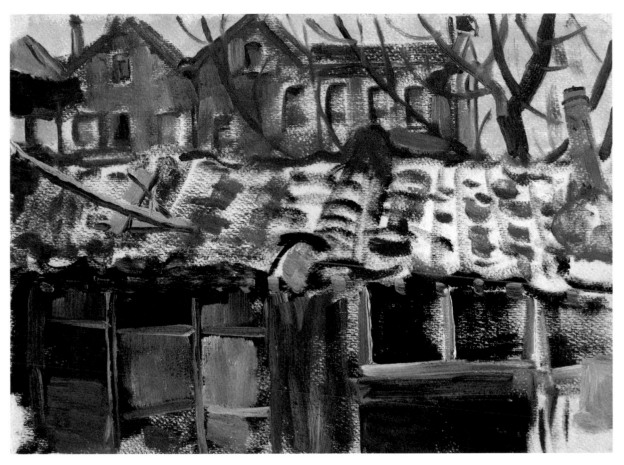

Plate 23. Wang Aihe (b. 1953), *Home*, 1973.
Oil on paperboard; 19.6 x 27 cm (unframed).
Collection of the artist

Tian Shuying (b. 1955; pls. 29-31). Tian Shuying was one of the last artists to join the group and one of the last to leave. Perhaps because of this, her painting style remained very distinctive. One of four daughters, she grew up in the east part of the city and attended Dongzhimen Elementary School from 1963 to 1969.[55] In 1969 she enrolled at Fanxiulu, or "Anti-Revisionist Road," Middle School (now Dongzhimen Middle School), which was next door to the Soviet embassy. Every day the students could see the demonstrations and vandalism at the embassy. In addition to making bricks and digging air raid shelters, they practiced the dances and routines they would perform in the twice annual Tian'anmen viewings by Chairman Mao. After months of practice, they performed flawless routines of choreographed slogans. Any error would show disloyalty to Chairman Mao and the Communist Party. Before she graduated, her family moved to housing near Wangfujing, where her father worked. After graduation in 1972, having learned little academically, she was sent to Liushui Village near Huairou in the countryside north of Beijing, where she worked cleaning out pigpens. It was not until 1975 that she was transferred back to the city and assigned to work as a cook at the Wangfujing Snack Shop in the East City District Food Service system. She met Liu Shi at work and began painting with him that year. He introduced her to Shao Xiaogang, Ma Kelu, Zhang Wenliang, Yang Yushu, Shi Zhenyu, Wang Aihe, Zhang Da'an, and Tian Yu. She too became addicted to painting. In addition to their days spent painting in the park, Liu Shi and Tian Shuying spent many hours at the home of Zhao Wenliang at No. 5 Dongmeichang in Shishahai. Her employer constantly pushed her to study political doctrines and join the Communist Party and criticized her for her lack of dedication. They even asked her father to criticize her, and her parents could never understand her passion for art. She painted and exhibited with the Wuming, joining their 1979 and 1981 exhibitions and the final five-person show in 1983 at the apartment home of the poet Hui Wa. Although she did not participate in the trips to Beidaihe, she travelled in that period to the beautiful Huangshan mountains in Anhui. In 1991 she transferred from the food service sector to the commerce sector of the state employment system, but still as a cook. From 1999 to 2003 she was posted to Hong Kong. She retired in 2005 and has returned to painting.

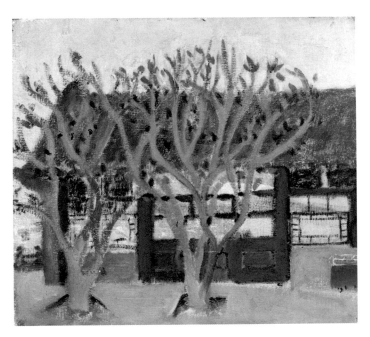

Plate 29. Tian Shuying (b. 1955),
Two White Crabapples in Blossom, 1977-78.
Oil on paper; 28.5 x 31.2 cm (unframed).
Collection of the artist

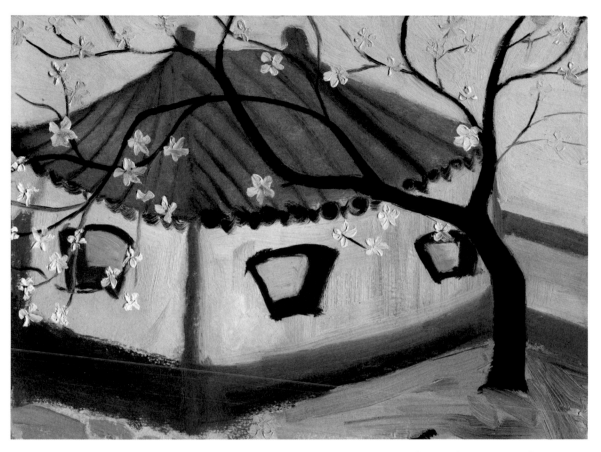

Plate 30. Tian Shuying (b. 1955), *Greenhouse*, 1977.
Oil on paperboard; 19.5 x 26.7 cm (unframed).
Collection of the artist

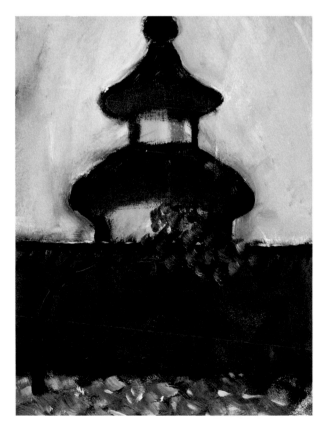

Plate 31. Tian Shuying (b. 1955), *Temple of Heaven*, 1979–80.
Oil on paper; 27 x 20 cm (unframed). Collection of the artist

Du Xia (b. 1951; pls. 32–34). Du Xia had a more episodic but no less intense involvement with the Wuming artists. Like some of the others, she grew up in residential quarters assigned to state cadres. She was born in Guiyang and moved to Beijing when her father was hired by the Ministry of Construction.[56] From 1958 to 1964 she studied at the elementary school of the Ministry of Construction and then entered Fengsheng Middle School (No. 9 Middle School for Girls). In 1966 her father was declared a "capitalist roader," subjected to endless criticism sessions, and then locked up. Beijing was in chaos and she stopped going to school. Late in 1968 she was sent to the Bianzitong Commune in the countryside of Suo county, Shanxi. About two years later her father came to visit her for three days, telling her that he was being sent to labor in an asbestos mine in Qinghai province and might not see her for a long time. After witnessing her life on the farm he urged her mother to enroll her at Datong Normal School, which was just beginning to recruit students.

While at school in 1972 Du Xia fell ill and was sent back to Beijing. During her recuperation she became interested in painting and was introduced to a young painter named Zhang Zhunli (b. 1950; later known as Mao Lizi), who became her tutor.[57] He taught her painting, introduced her to his painting friends, and took her to see the works of art professors at their homes. They discovered that they were only one year apart in age and their relationship blossomed into a romance. In the summer of 1973, however, he left to join the Performing Arts Troupe under the Political Bureau of the Air Force, a very high status job. She began painting landscapes and met Shi Zhenyu at Yuyuantan Park late in 1973. Soon after, early in 1974, while painting at nearby Bayi (August 1) Lake, Yang Yushu and Zheng Ziyan strolled by to chat and then introduced their friends Zhang Wei, Ma Kelu, Wei Hai, Shi Xixi, and Zhao Wenliang. From the time of this chance encounter in the park she painted with the Wuming. Later in the year Zhao Wenliang invited her to see their unofficial exhibition, and she was to join their salons as well. Those Wuming who loved music would visit her home to listen to her family's old record player. By the time Zhang Zhunli returned from his tour of duty, her aesthetic values had changed, and she was unable to praise his new work. They broke up during the Chinese New Year of 1976. Like her Wuming friends, she visited Tian'anmen Square in the first week of April 1976 to see the wreaths and poems laid there. In that same week she accompanied Wang Aihe, Liu Shi, and Tian Shuying to the Summer Palace to paint peach blossoms, only to learn from her father on the following day that people were being arrested at Tian'anmen.

In December 1976, Du Xia was assigned to teach at the School for Children of Datong Cement Factory Workers and was unable to return permanently to Beijing until about 1990. In 1979 she moved to a school for the children of mine workers in Ji county, Tianjin. Because she had studied outside Beijing, rules prohibited her reassignment to the city. In her absence, Liu Shi selected her paintings for the 1979 Wuming exhibition at Huafangzhai. She participated in the second show, as well, and in 1981 took her small son to see it at Huafangzhai.

In 1984 her father became ill with cancer, and in 1986 her parents moved into a courtyard house in the Wangfujing area. Her paintings during that period were somewhat bleak (see pl. 32). After her father's death an exception to policy was granted, and she was transferred to a job in Beijing at the China Construction Materials Company so as to care for her mother. Their courtyard home was demolished in 2002. During the move she found an impossibly moldy box of her old paintings, but later learned that Liu Shi had kept a box of her old paintings in good condition. She retired in 2006 from the China Architecture Industry Publishers and has resumed painting.

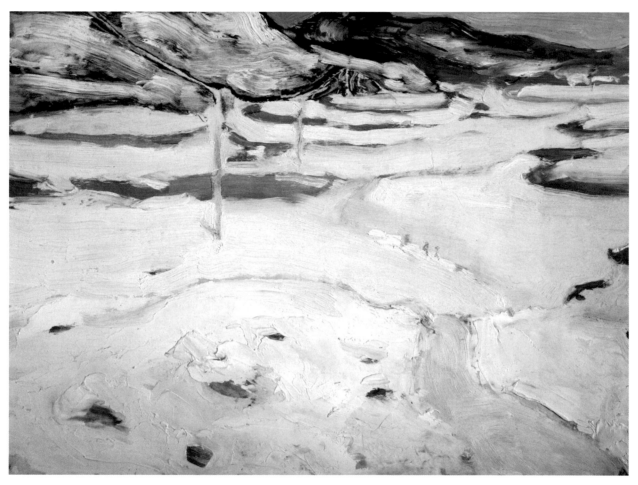

Plate 32. Du Xia (b. 1951), *Snow-Capped Terrace Field*, 1985.
Oil on paper; 17.8 x 25.7 cm (unframed), 56 x 63 cm (framed).
Collection of the artist

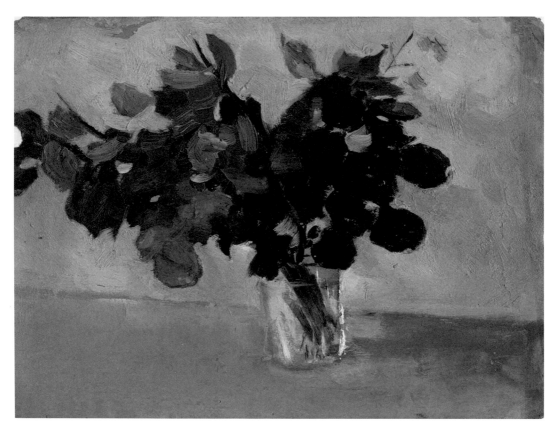

Plate 33. Du Xia (b. 1951), *Red Autumn Leaves*,
1973. Oil on paper; 20.8 x 26.8 cm (unframed),
60 x 65 cm (framed). Collection of the artist

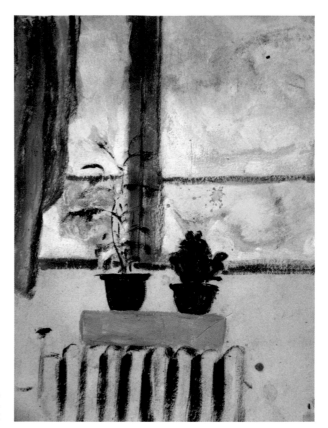

Plate 34. Du Xia (b. 1951), *Winter Outside the Window*, 1975.
Oil on paper; 25.7 x 18.2 cm (unframed), 64 x 56 cm (framed).
Collection of the artist

Art on the Fence: The Xingxing (Star-Star) Group

On September 27, 1979, after mimeographing admission tickets to the *Xingxing Open Air Art Exhibition*, a group of twenty-three young modernist artists hung 123 of their works on a fence outside the National Art Gallery, in a park adjacent to its east wing.[58] Their subversive action took place on the eve of the national exhibition, an official celebration of the thirtieth anniversary of the founding of the Peoples Republic of China.[59] Although the artists were hardly a unified group, what they did in 1979 and 1980 has made the name Xingxing a synonym for the pursuit of artistic freedom at all costs. Moreover, the enthusiastic cultivation of like-minded writers and foreign friends by core Xingxing members, as well as the persistence with which they pursued their artistic ideals, have earned them a central place in the narrative of dissident culture in China.

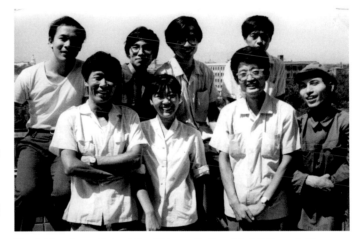

Fig. 6. Xingxing artists at the Chinese National Art Gallery, Beijing, August 1980. From left: Wang Keping, Qu Leilei, Yan Li, Li Shuang, Huang Rui, Zhong Acheng, Chen Yansheng, and Ma Desheng. Courtesy of Huang Rui

From the perspective of art, however, what may be even more important is the courage and effectiveness with which the Xingxing artists challenged both the artistic standards and taboos they had inherited. Most directly rejecting the art of the Cultural Revolution, the first Xingxing exhibition in actuality brought into question the entire cultural program of the PRC between 1949 and 1979. Their assault on the art establishment from outside its boundaries blazed the trail for those at the very center of the official art world—particularly students in the national art academies in Hangzhou and Beijing and young editors of official journals in Beijing and elsewhere—to begin the process of remaking Chinese art from within. The process of freeing Chinese art from socialist realism and internationalizing it has sometimes been presented as one that began in 1985 with the launching of an officially approved "new wave" or "avant-garde." Longtime observers, however, trace the origins of this movement to events of 1979 and particularly to the daring of the Xingxing artists.

Literature and Art during Beijing's Spring

Early photos suggest that the Xingxing was formed by a core group of five young men, Huang Rui, Ma Desheng, Yan Li, Qu Leilei, and Wang Keping, who were active in the underground poetry and literature movement. The writer Zhong Acheng played an important role, and the female painter Li Shuang was an early member. Eventually, as the group grew, each new member contributed suggestions from his own social network, and the roster swelled to more than thirty artists (fig. 6). From its earliest

inception, the Xingxing was both an offshoot of and a reaction against the unofficial literary movements that flourished at the end of the Cultural Revolution.

A new generation of writers took up their pens for their own intensely personal purposes during the latter half of the Cultural Revolution, inspired by the "desk drawer literature" or "hand-copied editions" of unofficial poetry that had circulated among rusticated youth in the late 1960s. The particularly personal and self-expressive writings penned between 1967 and 1969 by Guo Lusheng (b. 1948) were read by almost every underground writer. Much as the Wuming artists based their psychological survival on their practice of painting and on the secret social lives they led with their fellow painters, this group of literary friends wrote poetry because, in the words of one of the youngest members of the group, Yan Li, they had no other way to express their emotions. Their poet friends included Bei Dao (Zhao Zhenkai), Mang Ke (Jiang Shiwei), and Duo Duo (Li Shizheng). According to Yan Li, who vividly recalls first reading a hand-copied manuscript of Guo Lusheng's "Faith in the Future" in 1969, they wrote their thoughts on paper and locked them in a drawer or exchanged their words among these trusted friends.[60]

In mid-November 1978, the government reversed Mao's condemnation of the April 5, 1976, Tian'anmen demonstrations as counterrevolutionary and, in the official media, began calling for "socialist democracy and rule of law."[61] People soon began arriving in Beijing from various parts of China to seek redress for injustices suffered during the Cultural Revolution that could not be resolved locally. There were so many legitimate problems that it was impossible for them all to be considered, and petitioners began posting their appeals on walls where they might be seen by relevant authorities. Beijing people also began posting complaints, and by the end of 1978 these expressions of opinion were concentrated at a 250-meter long stretch of centrally located wall near the intersection of Xidan and Chang'an Boulevard, to the west of Tian'anmen Square.

The name by which this stretch was soon called, Democracy Wall, was not only a reflection of its grassroots origins, but also associated with the stunning essay posted on December 5, 1978, by Beijing worker Wei Jingsheng, who argued that the "four modernizations" slogan then promoted by Deng Xiaoping needed a fifth, namely democracy. Over the next year a number of underground political and literary journals appeared on the wall, including Wei Jingsheng's journal *Exploration* (*Tansuo*), along with *April Fifth Forum* (*Siwu luntan*), *Beijing Spring* (*Beijing zhi chun*), *Fertile Soil* (*Wotu*), and most important for present purposes, the literary magazine *Today* (*Jintian*). All were benignly ignored, or even encouraged, by the authorities during the transitional period, as Deng Xiaoping sought to solidify his power base through a comparatively tolerant policy that distanced him from the abuses of the Cultural Revolution. This was, in the end, only a temporary strategy. It was in this brief period of "Beijing Spring" that the Xingxing fought to realize their aesthetic, social, and political goals.

On December 23, 1978, a few weeks after Wei Jingsheng's sensational posting, copies of the mimeographed *Today*, one of the first unofficial literary magazines published in post-1949 China, appeared on walls and bulletin boards in a number of places in Beijing, including Democracy Wall. The magazine's founding editors were three friends, the poets Bei Dao and Mang Ke and the painter-writer Huang Rui. The editorial board stated their purpose as publishing works of high literary quality and emphasized diversity, freedom of the spirit, and openness to culture from beyond China's borders. Bei Dao, the magazine's leading figure, wrote in 1979, "Today, as the dawn rises from the bloodshed, what we need are colorful flowers, flowers that truly belong to nature, flowers that truly blossom in

people's hearts."[62] Eventually expanding its circulation to about 1,500 copies, the magazine published nine issues, each of which sold for ¥0.50. After the right to unregistered publication was withdrawn, they printed three supplements for "internal circulation" that were distributed for free. *Today* is best-known for championing experimental poetry, particularly a trend known as "misty" or "obscure" (*menglong*) poetry, for which founding editors Mang Ke and Bei Dao were themselves known.

From early in the run of *Today*, visual art was a part of its mission. Huang Rui, as art editor, designed the covers and took responsibility for layout, cutting stencils, writing art criticism, and other editorial work.[63] His covers for *Today* were striking by contemporary Chinese standards, rejecting the red of Maoism; beginning with issue two he printed the cover in a deep blue, a color rarely seen in design of the period and which was intended to represent the infinite freedom of the sky. Moreover, Huang Rui's rendering of figures on the cover similarly avoided Mao-era visual stereotypes, envisioning the magazine's audience, contributors, and subject matter as thinkers, members of the much maligned educated elite, and not as workers, peasants, or soldiers.

Ma Desheng joined the *Today* group as a writer with its first issue and later contributed as an illustrator. His short story "The Skinny Weakling" (Shouruo de ren) was published in December 1978, the inaugural issue. Zhong Acheng, who both wrote and illustrated, was the magazine's major critic beginning with its earliest issues. Qu Leilei published his drawings and illustrations in the third issue under the pseudonym Lu Shi and thereafter became the most regular artist for the magazine. Needless to say, the mimeograph reproductions of the drawings were of rather poor quality. Yan Li's poems also appeared in the early stages of *Today*. Additionally, the *Today* group published a separate literary series of poetry and stories by its key members known as *Jintian congshu*, which was also embellished with illustrations. In the end there were six *Today* writers who also painted, Yan Li, Qu Leilei, Huang Rui, Ma Desheng, Zhong Acheng, and the late Gan Shaocheng. All became Xingxing members. Acheng would later devote himself exclusively to writing.

The informal gatherings of these talented poets had a salon-like quality, but *Today* also organized three large public poetry readings. The first took place on April 8, 1979, in the park-like space that surrounded the ruins of the Qing emperors' European-style palace, the Yuanmingyuan, and the later readings were at Bayi Park near Yuyuantan. Stage backdrops were painted by Huang Rui using the only large-size fabric to be found, bed sheets, and one of their colleagues set up a sound system. The sensational events attracted large crowds, including some foreigners and the police, and featured foreign poetry in Chinese translation as well as Chinese experimental poetry. Actor and script-writer Wang Keping, who published in *Beijing Spring* and *Fertile Soil*, was notable for his talent at reciting the new poetry, and he was asked by some of the poets to perform their work at these poetry readings in 1979.[64]

The First Xingxing Exhibitions of 1979

The great excitement and popular success of the first experimental poetry reading at Yuanmingyuan left the painters feeling, by comparison, a certain lack of public exposure. Huang Rui resolved to organize an exhibition of like-minded artists that might fulfill for them the same purpose that the literary magazine and its poetry performances served for writers. He soon enlisted the support of Ma Desheng, and the two enthusiasts set about selecting works from within the core *Today* group while expanding the roster of artists beyond it. Zhong Acheng, recently returned from Yunnan, was involved from the very start.

Intersecting circles of painters and poets led Huang and Ma to the homes of many new acquaintances in search of objects for the show. Recently rehabilitated rightist Yuan Yunsheng, who had participated in the semi-official *New Spring* exhibition, introduced *Today* illustrator Qu Leilei to sculptor Wang Keping. The two young artists, Qu and Wang, worked in adjacent buildings within the Central Broadcasting complex but had not previously met. Upon seeing Wang's powerful sculpture, Huang Rui and Ma Desheng were thrilled at the prospect of exhibiting his work and persuaded him to join the show. Someone had also recommended to them a female painter named Li Shuang. But upon visiting her studio Huang and Ma were astonished to find it partially filled with the work of her boyfriend, Yan Li, who was previously known to them only for his poetry in *Today*. Qu Leilei also introduced his friends Mao Lizi (Zhang Zhunli) and Yang Yiping. The general curatorial premise of the Xingxing founders was quite parallel to that of the literary magazine: in addition to artistic quality, they implicitly sought authentic expression of individual emotion, and their guiding principal was diversity of content and form.

In the catalogue to the 1989 Hong Kong retrospective of the group's works, Ma Desheng writes:

> Every artist is a star [*xing*]. Even great artists are stars from the cosmic point of view. Ten years ago we called our group The Stars in order to emphasize our individuality. This was directed at the drab uniformity of the Cultural Revolution.[65]

Huang Rui's more recent explanation of the group's name makes clear their aim of restoring individual human dignity after the terrors of the Cultural Revolution.

> During the Cultural Revolution you could talk about the Stars, but you could not do it in public, because the Stars did not exist. The reason the Stars did not exist was because there was only one sun; that sun was Chairman Mao. The sun was the only thing that shone; Chairman Mao was the only one who gave light. It was like that because the Cultural Revolution only talked about political philosophy, not natural science. Also, the Stars only appeared at night, which seemed very natural at the time; the Stars shine independently; every single star shines alone; it can exist by itself and for itself.[66]

Unlike poetry, which can be easily reproduced and made accessible to all, painting and sculpture must be experienced in the original to enjoy their full effect. Having seen the quasi-official *New Spring* exhibition held at Zhongshan Park in February, Huang Rui and Ma Desheng endeavored to gain permission to use a public space for their exhibition. In particular, they sought out the Beijing Artists Association, which managed the Huafangzhai Gallery in Beihai Park. Its open-minded chairman, Liu Xun, visited Huang Rui's home to look at the work and was quite supportive, but he was unable to find a free spot on the exhibition calendar until the following year. Meanwhile, as they waited, many other exhibitions took place, including a series by older masters, such as Wu Guanzhong, Liu Haisu, Huang Xinbo, and Huang Yongyu, at the Chinese National Art Gallery and in July a showing at the Huafangzhai of paintings by young artists of the Wuming group. With the latter—an exhibition of outsiders like themselves—their own sense of urgency increased.

As the political atmosphere began to grow more restrictive, the artists decided they could afford no further delay, and if no gallery was available they would have to hold the

show outdoors. The three options they considered were Democracy Wall, the Yuanmingyuan, and in front of the centrally located complex where Wang Keping and Qu Leilei worked. Then, while visiting a show at the Chinese National Art Gallery, they noticed the little garden on its east side and decided that it would be an ideal exhibition space. Wang Keping recalls riding his bike past it every day, carefully examining the fence and planning how to install his sculpture. The day before the exhibition Yan Li and Wang Keping rode their bikes to the university district in the northwestern suburbs of the city to hang posters at all the major colleges as well as along the road. The night before, they moved their artworks to the dorm room of a nervous friend at the CAFA middle

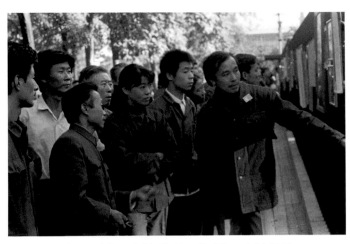

Fig. 7. Qu Leilei (2nd from left), Liu Xun (3rd from left), Li Shuang (5th from left), and spectators listen to Wang Keping (7th from left) talk about his work hanging on the fence at the Xingxing exhibition, September 27, 1979. Photo by and courtesy of Li Xiaobing

school, which was then located near the Chinese National Art Gallery.

Between 7:00 and 8:20 a.m. on the morning of September 27, modernist posters designed by Huang Rui to announce the exhibition were installed beside the art gallery, and the artists pinned badges with matching modernist logos to their jackets. They carefully hung about 120 works in a variety of styles and media—oil paintings, ink paintings, woodblock prints, pen-and-ink drawings and sculptures—on the fence around the art gallery garden and suspended from ropes in the trees. Some of the *Today* writers contributed poems that were installed beside the works. The artists were exhilarated with the exhibition's appearance, its reception by the crowd, and also the very act of their own daring rebellion. Their friends from the April Photography Society (Siyue yinghui), particularly Li Xiaobin, came to document the event. Quite a number of prominent figures from the official cultural world came to see the show. Most notably, the pioneering modernist printmaker and recently rehabilitated rightist Jiang Feng visited the exhibition and expressed his support for the young artists. He reportedly said to them, "This form of art exhibition, in the open-air, is pretty good. One can exhibit inside the art gallery, but one can also exhibit outside the gallery; artists can emerge from inside the art academy, but artists can also come from outside the art academy."[67] Having himself risen from just such a dangerous outsider position, he was extremely sympathetic to the young artists. He asked them if there was anything he could do to help, and when they requested assistance in finding a place to store the works at night, Jiang Feng instructed the Chinese National Art Gallery to provide a space.[68] In the afternoon Liu Xun arrived and is seen in Li Xiaobin's photographs thoughtfully looking at the works of Wang Keping, Li Shuang, and others and discussing them with the artists (fig. 7). His only expressed concern was that it would have looked better if they had waited until he could arrange a gallery space.

On the second day, just as Minister of Culture Huang Zhen was holding a major international press conference to announce the schedule for the coming National Congress of Literary and Art Workers and with it a new policy of creative freedom, the police took Huang Rui and Ma Desheng to the station for a discussion of their illegal exhibition. The two organizers were, after long discussions, released. The third day, September 29, the artists arrived to find their exhibition posters gone, back-dated proclamations posted that declared

a ban on the exhibition, and policemen everywhere. Gangs of thugs had been brought to the museum by truck to threaten and harass the artists and potential spectators. Police had gone into the museum and confiscated all their artworks. Their photographer friend Chi Xiaoning filmed the chaotic goings on. Later in the morning, Liu Xun appeared, took a look at the situation, and invited the artists to meet with him in the museum's VIP reception room. With his intervention, the works were released from police custody and the Beijing Party Committee agreed that the Xingxing exhibition should be properly exhibited, either immediately at a more appropriate outdoor site or indoors in a few weeks. The artists chose the latter option and proceeded to meet Liu Xun that afternoon at the Huafangzhai to plan for the exhibition. They were encouraged by Liu Xun's respectful reception and considered it a great victory to have finally been granted what they sought—an exhibition space to show their works publicly. After all, unofficial shows had rarely been permitted since 1949. In the meantime, their works would be stored in the Chinese National Art Gallery.

However, that evening, when the organizers of the Xingxing group met their friends from the unofficial journals, a bold suggestion was made that they should insist the police apologize for violating their artistic freedom. Otherwise, they should hold a protest demonstration. After some debate, a vote was held, and most of the artists agreed. Huang Rui, as the organizer of the Xingxing exhibition, believed that their goal of obtaining an exhibition venue had already been achieved. Having lost the vote, however, he accepted the more radical decision reached by the group and offered to lead the demonstration. A proclamation was drafted condemning the police for banning the exhibition and asking the Beijing Party Committee to correct the police misconduct; a deadline for response was given as 9:00 a.m. on October 1. If the authorities did not respond favorably, they would march.

They all recognized how dangerous a demonstration would be, and all readied themselves for possible arrest. Prepared for the worst on the morning of October 1, Wang Keping and Qu Leilei took off their wristwatches and left their identification, keys, and valuables at home. Ma Desheng joined them to first deliver their complaint to the Supreme People's Procuratorate in Dongjiaoming, asking that those who closed the exhibition be prosecuted. A copy of the document was also delivered to the Beijing Municipal Committee. Later, they went to check if the copy posted on Democracy Wall was still there and found that it had attracted a great crowd.

When they heard no response to their demands, Huang Rui, Qu Leilei, Ma Desheng, and Wang Keping, along with Bei Dao, Mang Ke, and other unofficial magazine editors, set out from Democracy Wall toward Tian'anmen Square with banners held high. Ma Desheng, on his crutches, fearlessly took a position at front and center. Qu Leilei and Wang Keping followed carrying signs—Wang's bearing the credit "*Fertile Soil*," the journal where fellow Xingxing member Li Yongcun (a.k.a. Bo Yun) served as art editor. Zhong Acheng took photographs from a distance. At Liubukou, suddenly a crowd of policemen appeared and instructed them not to walk past the government compound at Zhongnanhai or cross Tian'anmen. Their supporters melted away, but the small and very exposed band of protestors nonetheless turned south, making their way past Qianmen to their goal, the Municipal Party Committee building. Among the many curious people who followed were journalists, foreign students, and diplomatic personnel. A banner was carried on two tall poles by the demonstrators. Upon arrival, Wang Keping, with his theatrical training, erected it with one pole on either side of the entrance, forming an archway through which participants came in and out of the building. One side of the banner had a political slogan supplied by

their supporters in the underground magazines (fig. 8). The reverse side read "Demand Political Democracy, Demand Artistic Freedom," the cause for which the artists marched, and it was that slogan that Wang turned to face the crowd. Speeches were given by all the demonstration leaders, and the delegation took the petition inside the building. As the rest waited, Mang Ke led the crowd in singing revolutionary songs. In less than an hour, the delegates returned, having delivered their petition. Upon further discussion, it was decided that the goal of the demonstration had been reached and they could disband. They celebrated with a lunch of Western food and then agreed to meet later at Huang Rui's house to make sure no one had been arrested. The artists' fear of arrest was not misplaced. Only later did they learn that the Central Committee of the Chinese Communist Party Political Bureau had called an emergency meeting on the morning of October 1 to discuss how to handle the challenge. In a compromise between the hardliners and the more tolerant faction, a decision was made to permit the demonstration to take place, but to arrest participants if it continued for too long. They apparently came within minutes of that fateful hour.

About two weeks later, on October 16, Qu Leilei unexpectedly ended up in even bigger trouble than what they had feared after the Xingxing demonstration. By a coincidence of the work rotation system of China Central Television, Qu Leilei was assigned lighting duty for the trial of admired writer and democracy activist Wei Jingsheng. It was to be top secret—TV footage would only be broadcast, if ever, after the verdict and sentence had been decided. Qu Leilei casually mentioned this to his painting friend Ma Desheng, and that evening Wei Jingsheng's *Exploration* colleague Zhao Nan asked him to tape the proceedings with Wei's own recorder. Placing his open bag next to the audio speakers, Qu was successful at obtaining a good recording of Wei's statements at the trial and also managed to remove the tape recorder undetected. Once Qu Leilei turned it over to Wei's colleagues, it became history. They posted a transcription on Democracy Wall the following day, and distributed printed copies to supporters and foreign journalists there. To the shock and outrage of fellow activists, Wei received a fifteen-year sentence for having posted his "Fifth Modernization" essay on the Wall. One of the colleagues who distributed the trial transcript was sentenced to ten years in jail. The political atmosphere in Beijing became increasingly restrictive toward the end of 1979. Qu Leilei was investigated for quite some time, but was let off on the grounds that the court, still technologically behind the times, had not explicitly prohibited the use of tape recorders. Fortunate not to have been arrested for his role in the leak, Qu Leilei fell under heavy political pressure.

Not surprisingly, Huang Rui and Ma Desheng's subsequent efforts to meet with Liu Xun about the Huafangzhai exhibition were unsuccessful. They remained stubbornly optimistic, however. Huang Rui and Wang Keping were contacted by a journalist from the propaganda magazine *China Reconstructs* in the middle of October. The woman told

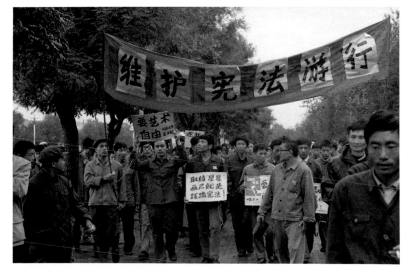

Fig. 8. Demonstration in support of the Xingxing artists; Wang Keping (front row, 4th from left) holding a poster "Demand Artistic Freedom," with Qu Leilei at center in second row, October 1, 1979. Photo by Wang Rui

them that they would like to photograph some works in order to run a story about the upcoming exhibition. Ai Weiwei's older sister worked in the storeroom of the Chinese National Art Gallery and was able to make arrangements for viewing the work in storage there. When the two reporters left the gallery after the interview, Wang Keping confided in Huang Rui some odd things he had noticed about the behavior of the photographer, who looked Chinese but did not say a word. The way she moved and handled her camera was different, very professional, but with an approach that they had not seen before in members of the Chinese media. Wang Keping concluded, to his great amusement, that the only explanation must be that she was actually a foreigner. On October 20, under the anonymous byline, "Special to the New York Times," a front-page article titled "Peking Permits Once-Banned Exhibition of New Art" and "China Allows Modern Art Show; Victory of Artistic Freedom Seen" appeared in the internationally influential newspaper. Quoting remarkably frank comments by the two artists, the article was illustrated by a photograph of Wang Keping with arms wrapped around his sculpture *Silent* (see p. 79, pl. 45) and a shot of Huang Rui's painting *New Woman*.[69] When the translation appeared in *Reference News* (*Cankao xiaoxi*) Wang Keping and Huang Rui were immediately summoned by the authorities and criticized. Not long after, Liu Xun told them that authority for such exhibitions had been taken out of his hands.

When the National Congress of Literary and Art Circles opened on October 31, 1979, mention of the Xingxing art exhibition was made by several of the official speakers. The screenwriter Xia Yan condemned them, particularly because their exhibition and demonstration distracted the foreign media from the important announcements being made by government leaders on the occasion of the Thirtieth Anniversary celebrations. This complaint—that they talked to too many foreigners—was one of the many official criticisms that the Xingxing artists would frequently hear and ignore. Party cultural theorist Zhou Yang, whose experiences during the Cultural Revolution had converted him from a hardliner to a liberal, heaped praise upon them. At the conclusion of the Congress Jiang Feng was named Chairman of the Chinese Artists Association.

To the surprise of the Xingxing artists, Liu Xun suddenly contacted Huang Rui on November 20 to tell them that their exhibition could resume at Huafangzhai from November 23 to December 2. Although announced in the official media, including the most important party organ, *People's Daily*, it was word of mouth that brought in most of the spectators, which swelled from about 500 the first day to more than 8,000 on the final day of the show.

In March of 1980, a young critic for the party organ *Meishu*, Li Xianting, published a favorable summary of the Huafangzhai show. He would later lose his job for this. Still, in June of 1980, *China Reconstructs* ran a three-page photo spread titled "'Star' Amateur Art Exhibition," featuring well-photographed images of an oil painting by Huang Rui depicting the ruins of Yuanmingyuan, drawings by Zhong Acheng and Qu Leilei, woodcuts by Ma Desheng and Gan Shaocheng, and a polychromatic work, *Summer*, by Cao Liwei. The brief text read, "The 'Star' Amateur Art Exhibition recently shown in Beijing's famous Beihai Park featured 163 Chinese traditional paintings, oils, engravings and wood carvings. Most of the 23 artists were young, experimenting boldly with content and form. There were over 33,000 visitors."[70]

The Second Xingxing Exhibition of 1980

In the summer of 1980, the Stars Painting Society (Xingxing huashe) was formally established and registered with the Beijing authorities. It had a somewhat expanded membership, with about a dozen core artists, including Huang Rui, Ma Desheng, Zhong Acheng, Li Yongcun, Qu Leilei, Wang Keping, Ai Weiwei, Yan Li, Mao Lizi (Zhang Zhunli), Yang Yiping, Li Shuang, Shao Fei, Zhu Jinshi, Gan Shaocheng, Yin Guangzhong, and Zhao Gang.[71] At Liu Xun's invitation, Huang Rui, Ma Desheng, and Wang Keping were inducted into the Beijing Artists Association; a part of the system, they were now considered professional artists rather than amateurs. Soon after, Jiang Feng visited their studios and agreed to hold a second Xingxing exhibition from August 20 to September 4 at the Chinese National Art Gallery. He advised them, however, not to exhibit works that were vulgar, offensive, or too abstract. With this opportunity, they would have completed their move from an illegal space into the most prestigious official art gallery.

Clearly not co-opted into a position of timidity by his membership in the artists association, Wang Keping exhibited his sensational birchwood sculpture *Idol* (see p. 79, pl. 44), which his colleagues had asked him not to bring to the first exhibition. Regardless of the artist's protestations that this was not really his intent, to virtually all observers it looked like a satirical portrait of Mao Zedong as a plump bodhisattva. Wang Keping acknowledges not unpacking the piece until most of the gallery staff had left. Some accounts suggest that he installed it in the gallery without approval of exhibition sponsor Jiang Feng. The artist himself, who kept a detailed diary in this period, remembers things quite otherwise—that he specifically asked Jiang Feng, before he approved their exhibition application, if it could be shown. He writes, "Jiang Feng stared at *Idol* for a long time, his expression stern…Who would have guessed that without disclosing any feelings or uttering a word, Jiang Feng simply turned around and walked away. We understood exactly what he was thinking about but didn't want to say."[72] Evidently, he had read Jiang Feng's stunned silence as agreement. Besides the controversy surrounding Wang Keping's sculpture, paintings by Qu Leilei and quite a few others depicted female nudes. Some of Huang Rui's were non-objective. Yan Li's were surrealist. All broke taboos. As a whole, they presented a strong argument for personal freedom and artistic diversity. About one hundred works were shown, and over the three weeks of the exhibition, more than 100,000 visitors viewed them.

Right after this second show, Bei Dao organized a special issue on the Xingxing in the mid-September issue of *New Observer* (Xin guancha), where he had recently become an editor.[73] Submissions came in from old and young, including one by the elderly writer Feng Yidai, who praised the Xingxing for retaining beauty in their souls despite the darkness of their period and lyrically compared their endurance to that of the solitary pine growing high above a rocky mountain path. Bei Dao published six pieces, including *Idol* and a painting by Huang Rui that was subsequently lost after an exhibition in France.

Unfortunately, Jiang Feng, who was on vacation when the exhibition opened, returned from the beach at Beidaihe to a hail of criticism from his rivals in the party. Liu Xun, Jiang Feng, and Yu Feng put their reputations and their careers on the line to help the young painters. According to Huang Rui, "We all owed a lot to Liu Xun and Jiang Feng. Jiang Feng agreed to and was directly in charge of the exhibition of 'The Stars' in the China Art Museum; this turned out to be his personal 'crime.'"[74] From this time forward, this elderly champion of the young was under constant pressure, relentlessly attacked by bureaucrats who used the Xingxing as a weapon against him. Jiang Feng died of a stroke while defending his position

at a party meeting in September 1982. Liu Xun is believed by Huang Rui to have been the person responsible for protecting the Xingxing artists after their 1979 demonstration.[75] None of the Xingxing were declared counter-revolutionaries for participating in the exhibitions or demonstration, and although other political dissidents were condemned to jail, partly for the crime of marching on behalf of the Xingxing on October 1, none of the artists were targeted for defending their right to exhibit. An attack on nudity in art was launched by hardliners in the fall of 1980, and Yuan Yunsheng's airport mural *Water Splashing Festival* (which may have partly inspired Qu Leilei's oil nudes) was soon covered over.

As cultural policies became increasingly tight, a ban on unregistered magazines forced *Today* to cease publication by the end of 1981. With repressive political campaigns between 1981 and 1984, first against "bourgeois liberalism" and then to eradicate "spiritual pollution," hardliners gained the upper hand. Xingxing members became a primary target in the art world. The three who had been invited into the system, Huang Rui, Ma Desheng, and Wang Keping, found the works they were required to submit for official exhibitions were immediately thrown into the trash. In the first half of 1981, Li Shuang was arrested and ultimately expelled from China. The charges were not about art or politics, but about her romantic relationship with a member of the French diplomatic corps. Huang Rui and Wang Keping married foreign girls and moved abroad in 1984. The three leaders of the Xingxing, Huang, Ma, and Wang, later learned that a directive prohibiting exhibition of their works had been issued. The group, like Democracy Wall, lasted less than two years, but had extraordinary impact.

Who were the Xingxing, or "Stars"?

Blooming in the Shadows discusses in particular seven artists of the Xingxing group—four leaders, Huang Rui, Ma Desheng, Wang Keping, and Qu Leilei, and three important but more junior painters, Li Shuang, Yan Li, and Ai Weiwei. Huang Rui, initiator of the Xingxing art exhibition, has characterized the group's members as coming from official or intellectual families. By virtue of an odd system in which translations of foreign books and other publications not available to the general public were circulated to cadres, they enjoyed a relatively privileged literary culture. They shared interests in Western classical music, fiction, drama, and poetry, as well as art. For them, artistic freedom would include the freedom to be fully cosmopolitan.

An even more important birthright that served the Xingxing members well was their networks of connections within the very establishment that they challenged, accompanied by their political savvy. Their instincts permitted them to make their voices heard, to properly time their challenge, and to successfully push the establishment to its very boundaries. Their rebellious attitudes were typical of their generation but expressed more sharply and more effectively. Many were the children of idealists who had overthrown the Nationalist government on behalf of a utopian Communist state and, whether by genetic disposition or family education, had similar uncompromising ideals. Zhong Acheng's father, the film scholar Zhong Dianfei, was a close friend of party art leader Jiang Feng, as was Ai Weiwei's father, the poet Ai Qing. Furthermore, like Jiang Feng, the two fathers were rightists, now trying to rectify the system to which they had devoted their lives. Ai Qing, who had, with Jiang Feng, participated in a similarly iconoclastic and cosmopolitan art society in Shanghai in the early 1930s, visited the Xingxing shows many times. His interest was undoubtedly most directly linked to the participation of his son, but at the same time, biographical

parallels between the old poet and the young rebels must have inspired his sympathy. Qu Leilei was close to the older Yuan Yunsheng, who in turn had a strong bond with Jiang Feng; the latter two men had undergone labor reform side-by-side after being condemned as rightists. Jiang Feng provided great encouragement and practical help to the Xingxing, and even, in the eyes of some members, may have been persecuted to death on their behalf. At the Huafangzhai exhibition in November of 1979, Liu Xun mentioned genially that his superior in the Beijing Municipal Committee knew Wang Keping's father and admired him for his participation in the 1935 Beijing student movement. With this positive impression in mind, the superior had reached a conclusion that accorded with Liu Xun's own, that the Xingxing exhibition showed good work. Qu Leilei's parents were also veteran revolutionaries, and his father a particularly well-known Communist writer. Yan Li's father was a prominent scientist and long-time party member who had recently been rehabilitated. These relationships may have provided a small measure of protection in the chaotic climate of the time. Li Shuang, by contrast, was the child of college professors and the granddaughter of an international antique dealer.

There is no evidence that any of the Xingxing consciously exploited their family ties as they emerged into the cultural world—indeed, having watched their parents abused by the Red Guard they had been taught to consider them something of a liability. Still, the networks of Communist administrators and intellectuals in which their parents' careers were conducted undoubtedly led certain individuals in positions of authority to assume the good intentions of these young people and give their experiments the benefit of the doubt. It was not until the party decided conclusively in 1983 to condemn the Xingxing that supporting them became impossible.

The Xingxing, seeking freedom of artistic expression, and in Ma Desheng's words, the freedom to live, were deemed by the authorities at large to have gone too far. By 1981 the group had largely disbanded, and in 1983 the three founders, Huang Rui, Ma Desheng, and Wang Keping, were secretly banned from exhibition in China. Partial retrospectives have been held abroad, one in Hong Kong in 1989 and others in Tokyo in 1993 and 2000. In 2007 the first such show was held in Beijing. Over the course of the several years that the group was active in Beijing it set a direction for the future of China's art.

The Xingxing Artists

Huang Rui (b. 1952; pls. 35–38). Along with his friends Bei Dao and Mang Ke, Huang Rui was a key figure in initiating the literary magazine *Today* in the fall of 1978 and in organizing the two Xingxing exhibitions in 1979 and 1980. The son of an engineer, he grew up in a typical old Beijing courtyard house on the west side of the city, in a neighborhood with many temples, and attended Huguosi Elementary School.[76] Right next to his house was Baochansi (Precious Meditation Temple), whose name was changed to the homophonous Precious Production Temple during the Cultural Revolution but which was later torn down. Huang vividly remembers a painting in the courtyard of their residence that caught his imagination as a kindergarten child—a Great Leap Forward mural depicting rockets, smokestacks, red flags, and trains. He began his artistic training at the age of nine by studying Chinese ink painting. When his teacher was later arrested, he switched to a more realistic style. In the early 1970s he emulated the nineteenth-century style of the Russians Vasily Surikov, Illya Repin, and Isaac Livitan.

The Cultural Revolution began when Huang Rui was thirteen. In his adolescent years he saw Chairman Mao four times. The third occasion, on August 18, 1966, was a momentous event for the nation, but left Huang Rui feeling cold. Upon receiving the Red Guard for the first time at Tian'anmen that day, Mao launched the greatest chaos of the Cultural Revolution. Huang was shocked to see people crying with irrational joy at the sight of Mao Zedong. Closer to home, he recalls the Red Guard raids on nearby temples, the expulsion of the monks and nuns, and the strange combination of excitement and fear these spectacles aroused. Huang Rui did not follow his older brothers' involvement with the movement, but largely withdrew into private exploration of classical music and literature, with a particular interest in European culture.

When the scheduled graduation date for his school, the No. 3 Middle School, arrived, Huang Rui, like all urban students, was sent to the countryside for "reeducation." He spent six years, between 1968 and 1974, laboring in Inner Mongolia. Despite his exile, he managed to return frequently enough to the city to maintain his cultural interests and expand his circle of literary friends.[77] In 1969 he became familiar with the underground poetry of Shizhi (Guo Lusheng).[78] He met the aspiring poet Bei Dao in 1970 and began painting in oils in 1971. From reading the 1972 obituary of Pablo Picasso in the internal-circulation newspaper *Reference News,* he learned for the first time about this artist and his painting *Guernica.* In 1972 he found a good painting teacher in Beijing, but when he returned to Mongolia he would rapidly run out of paint. During these periods without art he began writing poems. He met Mang Ke in the fall of 1973 and was dazzled by his poetry. He was finally able to return to the city in 1975, when he accepted a job at the Beijing Leather Factory. Upon his return from Mongolia that year, Huang did a work depicting a man in a small boat set against a cloudy sky and dwarfed by a vast stormy sea, a work he considers to be, for its self-expressive value, his first important painting.

In preparation for the April 5, 1976, memorial for Zhou Enlai at Tian'anmen, Huang Rui composed a poem, "The People's Grief," which he set up on a placard and also recited on the square. He was arrested two days later and incarcerated for almost four months, released only on July 28, after the Tangshan earthquake. When college admissions were restored, he took the fiercely competitive entrance examination for CAFA but was not one of the tiny number of students admitted. Although estranged from the academy after this disappointment, he nevertheless continued his studies independently, finding ways to see books on European art at both the Beijing Library and CAFA.[79]

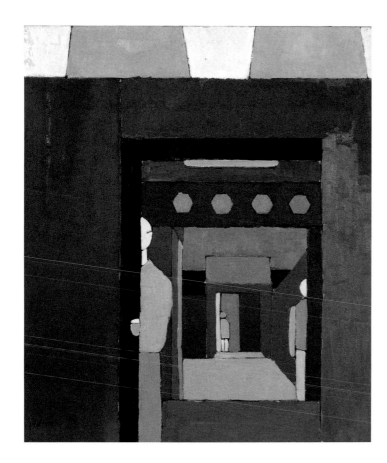

Plate 35. Huang Rui (b. 1952), *Forbidden City*, 1979.
Oil on canvas; 69 x 79 cm (unframed),
74.8 x 84.7 cm (framed). Collection of the artist

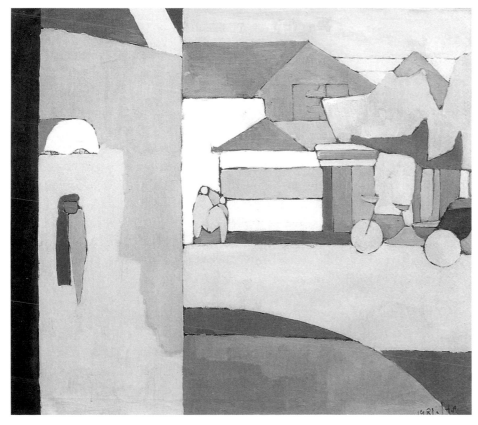

Plate 36. Huang Rui (b. 1952),
Childhood Memory, 1981.
Oil on canvas; 89.5 x 78.5 cm (unframed),
110 x 100 cm (framed).
Collection of Cees Hendriske

In the spring of 1978, Huang Rui, along with Chen Shaoping and Wang Luyan, studied painting under He Baosen (b. 1938) at the Beijing Workers Cultural Palace. Around this time he painted the highly realistic image of a solitary girl titled *The Interrogated*. Perhaps reflecting upon his experience in jail, this work deployed accepted academic techniques to represent a complaint against the state. This was typical of a trend that developed within the academies in 1979 and 1980 that is usually referred to as "scar art." Huang's painting was shown in an exhibition of workers art that travelled to Tianjin and Shanghai after Beijing. Soon after, he began an anguished political allegory, *April 5, 1976*, that would be exhibited in the first Xingxing exhibition. At about this time Huang's formerly counterrevolutionary poem, "The People's Grief," was published in an anthology of Tian'anmen poems by the People's Publishing House (Renmin chubanshe).

Although the purpose of the workers' art program was to train workers in academic painting techniques, he became increasingly interested in modernist art—particularly that of Wassily Kandinsky, Paul Klee, Henri Matisse, and Pablo Picasso—which was outside the realist canon taught in Chinese art academies of the day. Color became a great concern. Although much of Huang Rui's early work was representational, he also exhibited in the first Xingxing exhibition such examples of pure abstraction as *Infinite Space,* a work in which his feeling for the deep colors and mysterious compositions of Paul Klee may be evident. His series on the Yuanmingyuan abstracts and anthropomorphizes the stone ruins until in *Memory and Dream of Yuanmingyuan* they become the five fingers of a hand.

Finally, and perhaps typical of much Chinese art of the period, Huang's engagement with the human figure in 1979 became intensely concerned with style: from realistic to abstract, from allegorical or symbolic to purely formal. *April 5, 1976,* shown in the 1979 exhibition, is painted in what was in its day a fairly standard realistic style. The painting published in the *New York Times* article was a portrait of a young woman in a simplified and clear linear style with touches of the manner of Van Gogh. Others are more purely abstract. One may thus see diverse experiments in different manners within the work of this single artist, much as a landscape painter of China's past might create an album of painting in the various styles of the Song and Yuan periods. By the 1980 Xingxing exhibition, his work had moved in a far more abstract direction, which had a strong cubist flavor and many non-objective images. A painting of seamstresses in a simplified outline style set the course for the next stage in his development.[80] Following the last Xingxing exhibition, the organizers began to receive invitations to speak at various schools, from CAFA (then directed by Jiang Feng) to those in remote local regions. They took the opportunity to spread the word about their artistic aims, as well as to meet fellow artists and see their country. From October of 1980 to January of 1981, Huang Rui and Ma Desheng, accompanied by Chen Yansheng, visited twenty-six cities in Shanxi, Shaanxi, Guangxi, Sichuan, and Guangdong.

Upon their return and following the almost simultaneous demise of *Today* and the Xingxing under political pressure, Huang Rui arrived at a more consistent and more abstract figural style, which is represented in the present exhibition. In 1981, after the abolition of Democracy Wall by the authorities, Huang Rui commemorated his relationship with the wall through images of his artist friends, as well as poet-colleagues Gu Cheng (1956–1993), Bei Dao, Zhao Nan, and Ying Zi and the political activist Liu Qing, who was by that time in prison. His highly abstracted memory views of Beijing alleys and courtyards adopt a subdued palette and reduce human figures to small shadowy forms (pl. 36). Only in a work suggesting the comforts of an interior space or in images of the Forbidden City is red permitted to reassert

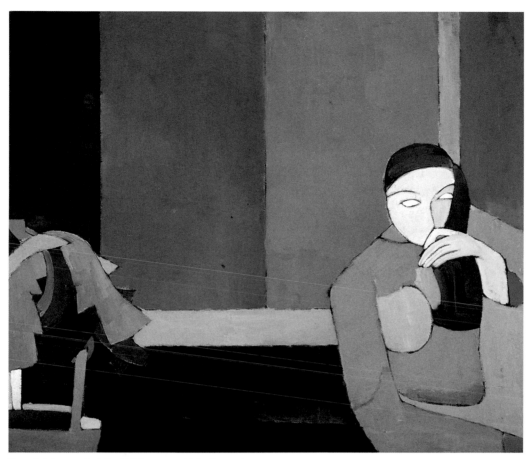

Plate 37. Huang Rui (b. 1952), *Door, Girl, Plant*, 1981.
Oil on canvas; 90 x 76 cm (unframed). Collection of the artist

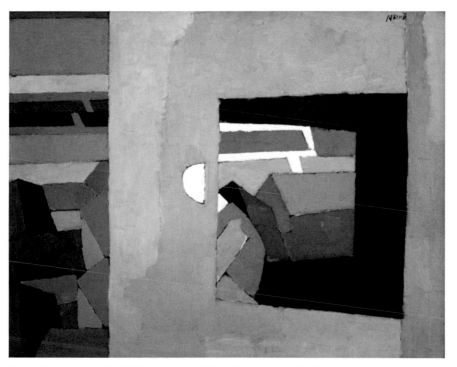

Plate 38. Huang Rui (b. 1952), *Overlook*, 1981. Oil on canvas; 78.5 x 99 cm (unframed),
84.8 x 104.6 cm (framed). Collection of the artist

itself. In the same period he began a series of mixed media works in which, like Braque or Picasso, he integrated printed ephemera in his oil paintings. The found objects glued to his canvases were anything but neutral formal elements—Chinese newspapers of the day were filled with life and death proclamations, to which he added images of the *White Haired Girl*, a model theatrical work of the Cultural Revolution that revolves around a never-mentioned rape. Guan Yi has thus suggested that the powerfully absurd juxtapositions associated with the 1985 avant-garde—a Chinese Dada or, in more contemporary terms, a Fluxus-like impulse—should be traced back to the Xingxing.[81]

From August 14 to 19, 1983, Huang Rui, Ma Desheng, and Wang Keping held a three-man show in a rented space at Zixinlu Elementary School in the Xuanwu district of Beijing. Huang showed many of his recent abstract Beijing street scenes. Originally scheduled to run until August 21, the exhibition was closed on August 19 by the Beijing City Public Security Bureau, and the artists were criticized by name in internal documents of the art system. Later they learned that all three had been banned from exhibiting, joining any government organization, or having their names mentioned in the media. This censorship, which remained in effect until 2000, was in many ways successful in erasing their contributions to the history of Chinese art.

In 1982 Huang Rui met a Japanese exchange student whom he would later marry, and in July 1984, he moved to Japan, in his words, leaving the Chinese art scene. He has exhibited extensively in Japan, Asia, Europe, and elsewhere, moving from painting into new media, including photography, installation art, and performance art. He returned briefly to China between 1992 and 1994. Since 2002, while continuing his career as a performance artist, his considerable organizational skills and a portion of his creativity have been focused on the 798 Factory in Beijing, where he was the first to establish a studio. By helping other artists become established there he is credited as the founder of the now-famous arts district.

Ma Desheng (b. 1952; pls. 39–43). Huang Rui's most important partner in organizing the Xingxing exhibitions was Ma Desheng, who grew up in the heart of old Beijing and attended the Fensiting Elementary School in the East District. Afflicted with polio from childhood, he was unable to participate in after-school activities and spent his spare time at home watching his brother paint and teaching himself to draw from *lianhuanhua* (literally, "linked pictures") comic books. In 1971 he was assigned a job at a typewriter factory, and then in 1972 his work unit merged with the Business Machine Research Institute, where he worked as a draftsman until 1985. During the course of his employment, he was sent by his work unit to attend painting classes at the Workers Cultural Palace. There he encountered Huang Rui and Wuming artist Ma Kelu. He also came to know Wuming artists Zhang Wei and Liu Shi.

Ma Desheng recalls that he and his colleagues would be taken to the countryside every year to experience the life of the peasants, and that the poverty of his fellow Chinese had a great impact on him. He recalls, furthermore, that from the time Mao died, modernist influences, particularly in the form of humanistic concerns and social critiques, began to surface. The works of Edvard Munch and Kathe Kollwitz particularly shocked and attracted him. After accepting his short story, "A Skinny Weakling," for publication, the editors of *Today* asked Ma to do illustrations, which they envisioned would give the journal a better look on Democracy Wall. He remembers doing more than a hundred images. Since he had a day job, these commissions would require him to stay up all night to cut woodblocks and stencils. Ma Desheng also became very involved in the actual production of *Today*, which he recalls being printed at the home of a peasant, the windows pasted over to keep the activity secret, and using ink Ma Desheng had stolen from his company. During this time he and Huang Rui became close friends.

The impact of Democracy Wall on Ma Desheng, as on all young people in Beijing, was great. All felt compelled to defend their rights to express their own opinions, complaints, and dissatisfactions with the government. They absorbed the various forms of expression posted by their compatriots along with the contents. A group of unofficial painters from Guizhou hung their work on Democracy Wall and impressed them all. One of the Guizhou artists, Yin Guangzhong, was later asked to join the Xingxing.

Ma Desheng was tireless, selfless, and gifted at bringing people together. His friends joked that just as they had emulated "Iron Man" Wang (a Maoist labor hero), so they now followed the indefatigable Ma Desheng. Huang Rui considered him an essential partner in the organization of the show. When the two set about organizing the exhibition, they agreed on two standards: 1) speak truth (no fake "red-shiny-bright" propaganda images and only opinions that were authentic) and 2) pursue formal variety, which is to say, pluralism in style and form. Modernist styles—such as surrealism, for one—would be suitable. Emphasizing formal beauty, the organizers began to look for artists who fit within these standards.

The Xingxing, in contrast to the clear collective identity of the Wuming group, was a more temporary band of artists, brought together to stage an exhibition. They were all friends, and in the spirit of the time, they operated quite democratically. Given that pluralism and diversity were their goals, there was no jury; each artist simply brought some works for the show. Although art was their main focus, it was impossible in the context of their time for them to separate what they did from politics. China's system of laws had not been reconstructed then, and there were no regulations about publishing or exhibitions. They were fortunate to be able to use this loophole to make their case. Moreover, neither the outgoing leader Hua Guofeng nor the incoming leader Deng Xiaoping wished to be responsible for a cultural crackdown during the very sensitive period of transition.

Although all the artists agreed that their purpose was to display art, it is not entirely possible to separate the art objects, which are mainly apolitical, from the highly charged context in which they were shown. Each participant probably had his or her own interpretation of this situation. To paraphrase Ma Desheng's view, the exhibition was a vehicle to tell their audience that art is like life and that both need variety. It was thus a statement of opposition to the culture of the Cultural Revolution and perhaps to that of the entire Mao era. Or, in other words, art is linked to life, and it is a human right. The exhibition's very existence was thus a political statement.

In retrospect, the artists and activists of 1979 seem both idealistic and fearless. When the police came to the Xingxing show on the second day and asked who organized the event, Ma Desheng immediately took responsibility. And after discussing the ins and outs of the regulations at the police station, Ma Desheng and Huang Rui convinced the police that there were no grounds on which they could be held. Similarly, proponents of the October 1st demonstration argued that the constitution did not forbid marches or parades and on those grounds decided to push ahead to assert their rights. The individual freedoms that were the subject of much of their art were not yet recognized by the state, so their art exhibition was intensively implicated in politics. Direct political subject matter became taboo after the 1980 exhibition, but so did even such seemingly apolitical themes as the female nude. Due to political pressure, Ma Desheng left China in 1985 and in 1986 settled in Paris, where he exhibits his paintings and prints and continues to write and perform poetry.

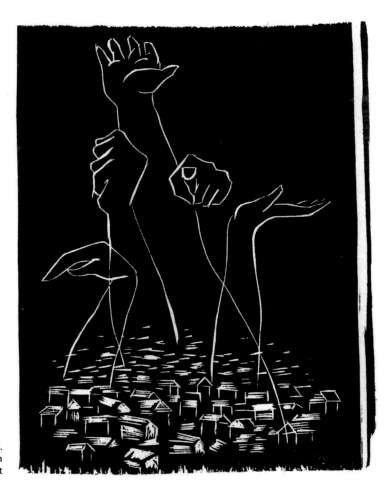

Plate 39. Ma Desheng (b. 1952), *The People's Cry*, 1979. Woodblock print; 17 x 14 cm (unframed), 39 x 34.5 cm (framed). Collection of the artist

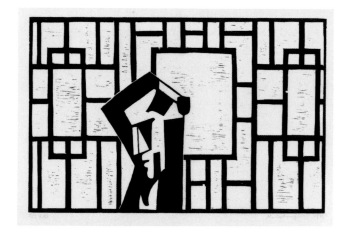

Plate 40

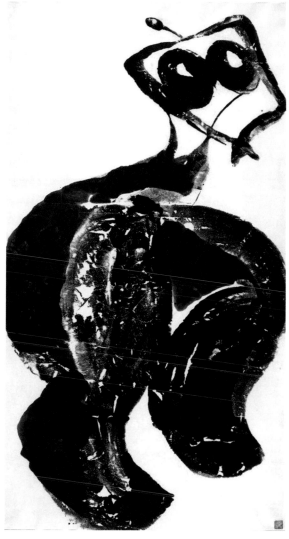

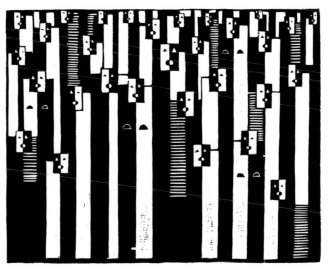

Plate 41

Plate 43

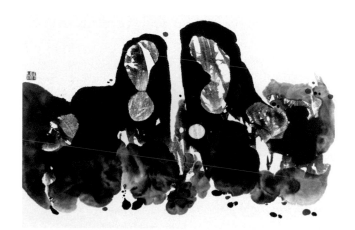

Plate 42

Plate 40. Ma Desheng (b. 1952), *Untitled*, 1980. Woodblock print; 34 x 52 cm (unframed), 55 x 63.5 cm (framed). Collection of the artist

Plate 41. Ma Desheng (b. 1952), *Untitled*, 1980. Woodblock print; 34.5 x 43 cm (unframed), 55 x 73 cm (framed). Collection of the artist

Plate 42. Ma Desheng (b. 1952), *Mountain Landscape*, 1983. Ink on paper; 62 x 90 cm (framed). Collection of Joan Lebold Cohen and Jerome A. Cohen

Plate 43. Ma Desheng (b. 1952), *Dancing Woman*, 1983. Ink on paper; 81 x 62 cm (framed). Collection of Fred Gordon

Wang Keping (b. 1949; pls. 44–47). As his literary circle was outside that of the *Today* group, Wang Keping was a comparative late-comer to the core Xingxing group. But once a member, he became a mainstay both artistically and organizationally. In many regards his artwork was the most vivid and original; he was also one of the politically courageous members. Wang Keping had grown up and gone to school in nearby Tianjin, attending the attached middle school of Hebei University. His father was head of the Tianjin Writers Association, and the author of a well-known early novel on the Sino-Japanese War. His mother was an actress who worked in Beijing. Considered a naughty child, he was not selected to participate in extra-curricular activities, and his father required him to practice calligraphy in order to stay out of trouble. Because the family loved theater and constantly received free tickets from his parents' work units, Wang was well-versed in drama from childhood.

As a teenager during the Cultural Revolution he had initially thrown himself into the Red Guard movement, even participating in destroying the furnishings of a Catholic church in Tianjin. His father became a target at the end of 1966, however, and the young Wang Keping saw firsthand the suffering of the victims. His own family was suddenly destitute. In 1969 he was sent down to a military farm in the countryside of Nenjiang in northern Heilongjiang, near Siberia. He was made miserable with the filth and the lice on the farm and with the almost unbearable psychological pressure of daily political indoctrination. He wrote constant complaints to his parents and finally persuaded his mother, who was a veteran of the Communist Eighth Route Army, to make inquiries of old comrades about the possibility of a job in the military. In the summer of 1970 she succeeded in having him transferred to a military drama troop in Kunming. He served in the southwest from the age of twenty-one to twenty-six.

In 1975 Wang Keping was able to return to Beijing as an actor for the Central Broadcasting Company. Tired of poorly written propagandistic roles, however, he began to write his own scripts. This work impressed his superiors, and he was transferred to the screenplay department. As relations warmed between China and France in 1978, he recalls seeing a French play and learning something amazing—a play could be written with time going backwards. Moreover, this encounter with the absurd appealed to him immensely and seems to have begun to frame the way he viewed his own existence as a cog in the revolutionary machinery. As a professional writer he was now asked to submit all work for approval, which resulted in endless requests for revision (and recopying). Most of the suggestions seemed meaningless, so he started submitting his old drafts with new covers. Nobody noticed, but neither did they produce his drama. He stopped going regularly to the office, which gave him time for his own pursuits.

Frustrated as a writer and inspired by a close friend at work, the portraitist Bai Jingzhou, who had graduated from the attached middle school of CAFA and would later be accepted into the Academy, he began to turn his attention to visual art. Concluding that he had no aptitude for painting, he began making sculptures in which unexpected forms emerged from oddly shaped pieces of scrap wood. Obtaining art supplies for private use in a rigidly centralized socialist economy was a tremendous obstacle. Most goods were not available for sale, and even if they were, almost everyone was destitute, so barter and theft of state property were the two primary modes of economic exchange for such materials. Wang first collected some small pieces of wood when he was doing relief work for the Tangshan earthquake, but he later found a charcoal shop near his home in Beijing that would give him misshapen fragments in exchange for free movie tickets.

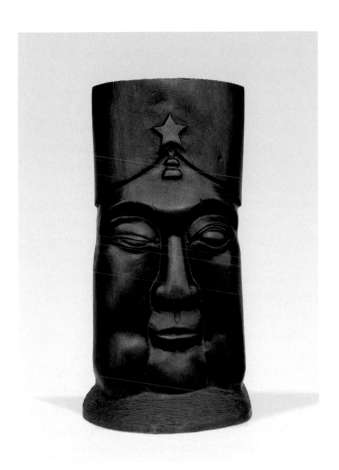

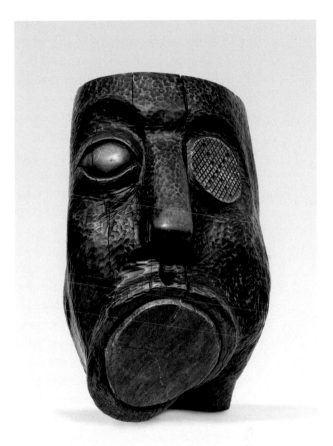

Plate 44. Wang Keping (b. 1949), *Idol*, 1979.
Wood; 57 x 40 x 15 cm. Collection of the artist

Plate 45. Wang Keping (b. 1949), *Silent*, 1979.
Wood; 48 x 24 x 23 cm. Collection of the artist

His earliest sculpture was the rosewood *Long Live Chairman Mao* (1978), in which he carved a chanting mouth and saluting arm from a piece of scrap furniture.[82] Highly theatrical in theme and execution, the finishing touch was Wang's insertion of Mao's Red Book into the upraised hand. The sculpture is made of what might be called "found objects," the mundane detritus of everyday life, but in the context of early post-Cultural Revolution China, these ordinary things retained a dangerous emotional charge as relics of the rituals of mass delusion. In a series of artworks that were absurd, bitter, and powerfully shocking all at once, Wang explored the deformations of human society wrought by the Cultural Revolution.

At the same time, inspired by what he saw on Democracy Wall, he submitted his scripts to the underground magazines and was published in both *Fertile Soil* and *Beijing Spring*. From then on he began establishing relationships within a circle of writers and editors that differed somewhat in composition from the *Today* cohort.

Wang Keping was the child of artistically talented parents, but his family was oriented toward literature and theater, not visual arts. Worldly in many ways, he was a poised and principled spokesman for the group. But his complete (or pretended) ignorance of even the names of famous European masters was a source of dismay to some of his fellow Xingxing members. Although he was clearly committed to a cosmopolitan vision of art and life, his sculptural work has never been directly modeled on foreign examples. Links might be found with the traditional Chinese craft of woodworking in which gnarled branches and trees are polished into the shapes of chairs, tables, or abstract designs. In any case, his creativity as a sculptor in wood was entirely self-generated and self-taught. And, although a brilliantly talented writer, Wang Keping has largely eschewed theorizing about his own sculpture. Whether political or sensual in theme, whether sharp or gentle in tone, its expressive power is direct and seems to need no verbal mediation.

The stories that Wang, the former screenwriter, spins about his life in art are self-deprecating, amusing, and sometimes absurd, resembling a theatrical vignette more than art criticism. One story he tells sounds comical, but given the irrational standards of the day may convey a certain core of truth about life in post-Cultural Revolution Beijing. He recalls being extremely impressed, even envious, that his friend Bai Jingzhou had obtained a portable cassette tape player by trading one of his oil paintings to a foreigner. Even if such a machine could be found for purchase in China, no Chinese in the 1970s had the necessary ration tickets or foreign exchange certificates to buy one by legal means. In Wang Keping's account, the reason everyone needed a tape recorder was to invite people over for dancing parties, and without dancing parties there would be no way to find a girl. He claims to have started making art as a way to get a tape recorder.

Although involved with *Beijing Spring* and *Fertile Soil,* Wang Keping was not known to the *Today* artists until an unexpected encounter with a freethinking artist of the older generation. The recently rehabilitated "rightist" Yuan Yunsheng had travelled to Yunnan to research a mural he had been commissioned to paint at the Beijing Airport. While there he had met Wang Keping's sister and brother-in-law, who worked in the Kunming Military District arts troupe (*wengongtuan*), and on Yuan's departure they had asked him to deliver some things to her family in Beijing. When the Wang family invited Yuan to stay for dinner, he incidentally happened upon Wang Keping's carvings. Delighted to have discovered this new talent, Yuan suggested to the *Today* illustrator Qu Leilei that the two young artists should meet. Qu Leilei, who worked at CCTV, then found that his office building was right next to Wang Keping's. He made numerous visits there to see him, but Wang was always absent.

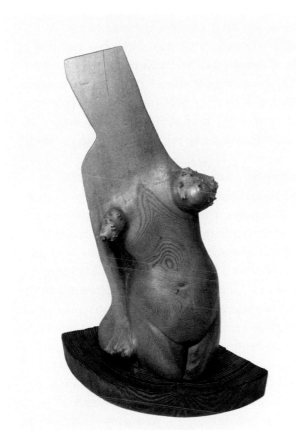

Plate 46. Wang Keping (b. 1949), *Torso*, 1979. Wood; 38.7 x 16.5 x 10.2 cm. Collection of Joan Lebold Cohen and Jerome A. Cohen

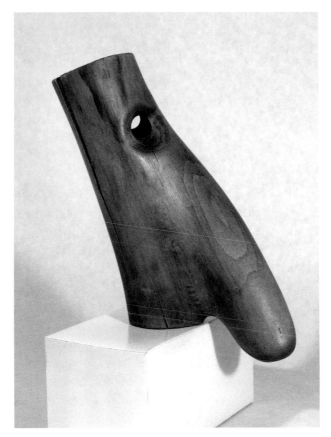

Plate 47. Wang Keping (b. 1949), *Nose*, 1980. Wood; 22.9 x 12.7 x 15.2 cm. Collection of Joan Lebold Cohen and Jerome A. Cohen

Finally, Qu waited for him on payday and succeeded in making contact. Qu then introduced him to Huang Rui and Ma Desheng for the Xingxing exhibition.

Wang's first dozen works were his most political; although in some instances painful, they were also imbued with a profoundly absurdist humor. Cheerfully enduring the constant rejection of his film scripts at his job, his home sculpture studio transformed his frustration into a theater of political protest. Many of the Xingxing artists worked, either explicitly or implicitly, at overcoming the repression of human sensuality that was at the heart of the psychologically deforming ideology of the Cultural Revolution. Wang Keping's expressive and sometimes erotic figural images, in which the sensuality of material and subject merge, were the most successful. Xingxing colleague Zhong Acheng recalls meeting Wang for the first time at Huang Rui's house: "He was a gentle sort, but his sculpture was shocking and amusing and full of brute strength; it had this ingenious yet mature quality about it. Wang was a good poet, too."[83]

As we have seen, Wang Keping went on to play a very important role in both exhibitions and the 1979 demonstration. From an aesthetic perspective, his astonishingly direct sculpted images, which attracted almost all viewers, Chinese and foreign alike, are in large measure the reason for the great success of the Xingxing exhibitions. Among the works by Wang Keping exhibited on the Chinese National Art Gallery fence were *Silent* (pl. 45), *Torso* (pl. 46),[84] *Chain*, and *Pillar of Society*. *Silent* is a shocking work in which the natural configuration of knots in the wood comprise a blinded eye and a stoppered mouth. Vividly conveying the psychological state of every person who had lived through the Cultural Revolution, it caused a sensation. In the second exhibition, held at the Chinese National Art Gallery, he exhibited *Idol* (pl. 44) and *Fist,* breaking both political and sexual taboos.

Wang claims that *Idol* was not intended to look like Chairman Mao and that, if you compare it to a photograph of Mao Zedong, it doesn't resemble the late leader. It was, he says, actually modeled on the only source at hand, his own face, but his goal was to create an image of such generality that it might stimulate criticism of idolatry. Whatever his intention, everyone sees it as Mao, or perhaps a hybrid image of Mao and a plump Guanyin bodhisattva. And, in any case, the shocking and amusing image was a powerful critique of the worship of Chairman Mao.

There are a few key members who have ensured that the Xingxing, from the perspective of the group, would not be completely forgotten. Wang Keping and the Xingxing were frequently criticized for cultivating the foreign media.[85] Beyond the importance of his artwork, Wang's gregarious personality, literary talent, and personal courage, as well as his interest in befriending foreign journalists and students, assured that news of the Xingxing was published and preserved abroad and would therefore not easily be completely buried at home.[86] Nevertheless, with the emergence in China of younger generations of critics educated in the canon from which the Xingxing were excised, this underground history must be constantly re-excavated. Wang's interest and personal courage in bringing foreign friends to the shows were among the reasons the government censors could not expunge the Xingxing from the art historical record. In May of 1984, Wang Keping moved to France. By that time, the Xingxing had come to an end.

Qu Leilei (b. 1951). Qu Leilei became involved with the *Today* group as an illustrator (see figs. 9–10). He had been born in China's far north, in Qiqiha'er, Heilongjiang, not far from Siberia. His father, Qu Bo (1923–2002), had joined the Eighth Route Army as a teenager and fought in the People's Liberation Army's campaign to take control of China's northeast after the Sino-Japanese War. Qu Bo became famous for an often reprinted novel, *Tracks in the Snowy Forest* (*Linhai xueyuan*), based on his experiences in Manchuria. Ironically, the story became the basis of one of Jiang Qing's Cultural Revolution theatrical works, *Taking Tiger Mountain by Strategy,* even though its author had by then been condemned. As Qu Leilei

Fig. 9. Qu Leilei, *Mother*, 1979. Ink on paper; 13 x 18 cm. Private collection. Image courtesy of the artist

recalls, his mother was an intellectual of artistic temperament, and his father more a man of action. When Qu was four his family moved to Beijing, where he would begin school. He was equally interested in sports, art, and medicine, but once the Cultural Revolution began all but the private activity of art was closed off to him. His elementary school art teacher, Tan Wancun, had studied with the famous ink painter Qi Baishi. Qu studied both free brush (*xieyi*) and outline style (*gongbi*) bird-and-flower painting with him and also copied *lianhuanhua.* About fifteen when the Cultural Revolution began, he was sent to Heilongjiang, in Manchuria, to labor. But probably through family connections, he was soon able to join the Navy, where he rose quickly through the ranks.

Qu was sent to the Chinese Academy of Sciences as part of a military propaganda team, which, in the strange administrative pattern of the Cultural Revolution, actually administered the institute. Although still just a kid, he was put in a supervisory position over old and accomplished intellectuals. Perhaps even more strongly than most other young people of his generation, he was completely shaken by the Lin Biao affair. His father had been trained by and served under Lin Biao in Manchuria, and Qu Leilei had learned to admire Lin from his father. The events of September 1971 were shocking to him, and by his account they were a turning point that led him to begin thinking independently. His view of life collapsed, and his mental world was totally changed. He no longer had any interest in a military career. His promotion blocked because of the criticism directed at his father's novel, he decided to retire from the military. He returned to Beijing and began seriously painting in 1973, switching from traditional painting to Western styles, particularly Russian and French

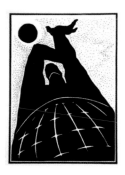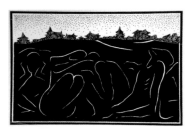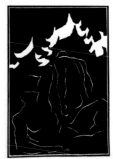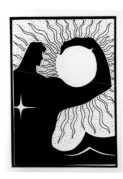

Fig. 10, a–e. Qu Leilei, *The Fatherland nos. 1, 2, 3, 4, 7*, 1980. Ink on paper; 18 x 12 cm, 12 x 18 cm (no. 3). Private collection. Image courtesy of the artist

modernism. From that time on he also worked for CCTV, doing lighting for TV shoots. In 1976 he was sent to the site of the Tangshan earthquake to do investigative reporting and saw firsthand the terribly large number of people who had died; at night he would make drawings and paintings inspired by what he saw. In 1978, when CAFA began accepting graduate students in painting, Qu Leilei applied but was not admitted. As a result, he continued working at CCTV and even won a prize for his design.

In the same year, 1978, he met the *Today* staff and began to do illustrations for the magazine. Some of the writers, particularly the poet Jiang He, appreciated his drawings; Qu Leilei illustrated his poems. He enthusiastically supported Huang Rui and Ma Desheng's decision to have an exhibition, introducing them to Wang Keping and other artists that he knew.

After Qu Leilei's leak of the Wei Jingsheng trial audio, an extraordinary act of courage, his prospects at the TV studio dimmed. Tape recorders were so rare that the court did not think to ban them from the secret trial. It was a loophole that perhaps saved him from prison, but afterwards his political reliability, and therefore his employability, in China was always in doubt. He thereafter decided to concentrate on painting. Qu left for Britain in 1985 and now lives and works in London, where he enjoys a successful career.

Zhong Acheng (b. 1949). Xingxing founder Zhong Acheng, who is not represented in this exhibition, is best-known today as a writer under the name Ah Cheng. He had begun painting during the Cultural Revolution when he was sent to various parts of the country, first Shanxi, then Inner Mongolia, and finally Yunnan. He only returned to Beijing in 1979, when he was assigned an editorial job at a bibliographic publication, *World Book Magazine* (*Shijie tushu zazhi*).[87] He wrote as a cultural commentator for *Today* and supplied illustrations, as well. After exhibiting with the Xingxing group, he turned back to literature and film, first collaborating with his film historian father and then emerging in the mid-1980s as an important writer of fiction and screenplays. He remains somewhat underrecognized even after his brilliant trilogy, *King of Chess*, *King of Trees*, and *King of Children*, inspired well-regarded films by directors Tian Zhuangzhuang and Chen Kaige.

Li Yongcun, a.k.a. Bo Yun (b. 1948). Other core members of the Xingxing group also emerged into China's creative community in the late Cultural Revolution with their writing. Li Yongcun was a pre-Cultural Revolution graduate of the attached middle school of CAFA and had entered the graduate program in art history in 1978. Because of this he was more sophisticated from a theoretical perspective. He served as art editor for *Fertile Soil*. During the 1979 protest march Wang Keping held a small sign that demanded artistic freedom on behalf of the "art division of *Fertile Soil* magazine." This was Li Yongcun's contribution to the event. His own work in the exhibitions, while not provocative, had a melancholy tone that certainly violated the standards of socialist realism. Writing under the name A Man, he contributed an article on the Xingxing exhibition to Bei Dao's special feature in *New Observer*.

Yan Li (b. 1954; pls. 48–51). A younger poet who had published prolifically in *Today,* Yan Li was invited into the Xingxing group after Huang Rui and Ma Desheng saw his work at the home of Li Shuang. He remains best-known today as a writer, but there is a strong complementary relationship between his surrealistic painting and his poetry.[88]

Yan Li was born in Beijing but was sent by his busy parents at the age of two months to be raised by his grandparents in Shanghai, where he entered the Balian Elementary School in the Luwan district in 1961. His grandfather, Yan Changshan, was a well-known traditional Chinese doctor in Shanghai who collected paintings and calligraphy.[89] When the Cultural Revolution began Yan Li was only eleven, old enough to remember what happened. He witnessed his grandparent's home being raided by the Red Guard five times. They said that his grandfather had treated many evil people, and on those grounds he was incarcerated at the end of 1967. Before he was locked up he asked a friend to take Yan Li back to Beijing. The last words he heard his grandfather speak were: "I cannot protect you anymore. Please go back to your parents in Beijing." The old man committed suicide four months later. Not long after he arrived in Beijing, Yan Li's parents were sent to Hengdong county, Hunan, for reeducation through labor in a work camp referred to as a May Seventh Cadre School. No one sent to such a place knew whether they could ever return to the city. His parents took his ten-year-old sister with them and left fourteen-year-old Yan Li in Beijing to attend Shehuilu Middle School in the West City District; if one family member maintained the family's Beijing residence registry, there might be a future possibility of reuniting. He lived alone for quite some time, until eventually his parents realized that with the schools closed and nothing constructive to do Yan Li was getting into trouble. They then enrolled him in a Hunan middle school, where the curriculum consisted

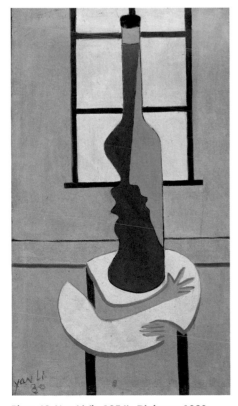

Plate 48. Yan Li (b. 1954), *Dialogue*, 1980.
Oil on canvas; 72 x 40 cm (framed).
Collection of the artist

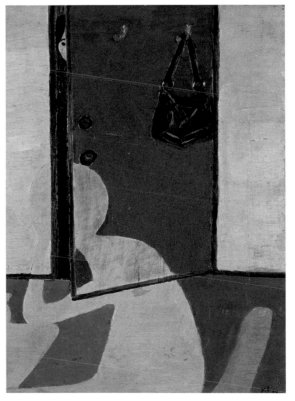

Plate 49. Yan Li (b. 1954), *Spying*, 1979. Oil on canvas;
53 x 38 cm (framed). Collection of the artist

of learning quotations from Chairman Mao, reading party proclamations in the newspaper, and mastering a few revolutionary slogans in English. Otherwise, students worked on the farm for half of every day. About a year later, in the middle of 1970, when he was sixteen, he returned to Beijing alone because his parents had heard that his classmates in Beijing had the chance to be assigned to factory employment. So he registered again at Shehuilu Middle School and was assigned to the Beijing No. 2 Machinery Factory, where he lived in the factory dorm.

Between 1970 and 1977 he met many poets in Beijing, including the slightly older Mang Ke, Bei Dao, and Duo Duo. Yan Li himself started to write poetry in 1973. The first modernist oil painting he ever saw was in the same year while in the company of Mang Ke at the dormitory of Lu Yansheng, a friend in the Railway Ministry. This was, to Yan Li, a really strange painting. At that time he didn't know what cubism was, but later he learned that the painter who made this work was named Peng Gang. During this period he gradually came to know many people who had the same interests in literature and art that he had and made such friends as Zhang Langlang, Zhang Liaoliao, Lu Yansheng, Lu Shuangqing, Peng Gang, Liu Yu, Lu Huanxin, Tao Jiakai, Tang Pinggang, and Chen Jiaming. His Beijing friends all read Western literature that had been translated and published before the Cultural Revolution, and they circulated within their circle as many of the banned books as they could find. This kind of life lasted until the end of the Cultural Revolution in 1977. When *Today* was established in 1978, Yan Li contributed poems; in that year he printed his first album of poetry. It was not until 1979 that he started to paint. He recalls that Li Shuang, whom Yan had met in 1978, gave him some reproductions of Russian and impressionist paintings since he had no books to use as reference, and he was suddenly inspired to paint. By that time he was already friends with some Wuming artists, particularly Zhang Wei, Li Shan, and Ma Kelu. Yan decided that poetry and painting would not be in conflict, and that he could express his ideas in both ways. Moreover, he really loved color because Beijing at that time was desperately gray. So from 1979 to 1981 his work was brightly colored.

Always busy, Yan Li somehow managed to miss most of the Xingxing meeting at which the crucial vote to demonstrate on October 1 was taken. Huang Rui had to deliver the news and plan to his house the night before the demonstration. Yan Li was out, and the note with instructions was intercepted by Yan Li's father. The following morning, his worried father, who had himself only recently returned from three years of bitter incarceration, refused to allow Yan Li to leave the house. Li Shuang arrived at about 8:00 a.m., and his father would not permit her to leave either. Not until after 9:30, when the time for the demonstration had passed, did his father open the door. The two had to rush to catch up with their colleagues. Yan Li was the custodian of the donations they had received during their outdoor exhibition, and after the demonstration was over, near noon, the core members decided to use the funds to celebrate their not having been arrested. They spent the money on a meal of Western food at Wangfujing, a meal which some feared might be their last together.

The cubist and surrealistic works Yan Li exhibited in the Xingxing exhibitions often seem to echo the modernist structure of his poetry. After the Xingxing was banned in 1981, Yan Li applied, with the help of a relative in New York, to study in the United States. It took almost four years before his passport was approved and he could leave China. In the meantime he had a solo painting exhibition in Shanghai in 1984. He moved to New York in April of 1985 to study English at Hunter College. Allen Ginsburg, who was a neighbor in New York's East Village, arranged a poetry reading at Brooklyn College for Yan Li's group of

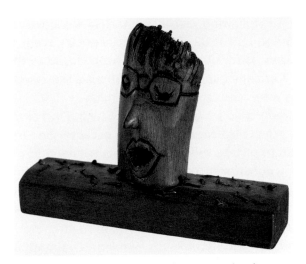

Plate 50. Yan Li (b. 1954), *Untitled*, 1980. Wood and steel nails; 14 x 18 x 4 cm. Collection of the artist

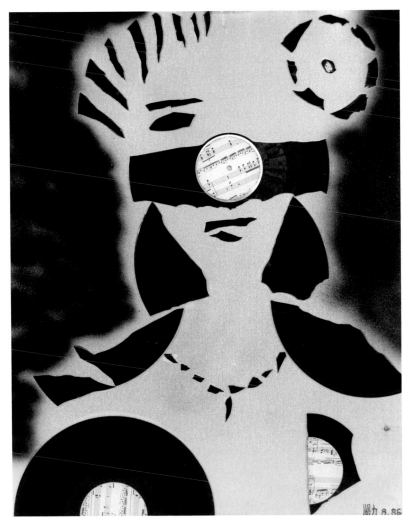

Plate 51. Yan Li (b. 1954), *Records*, 1986. Mixed media; 77.5 x 62.2 cm (framed). Collection of Joan Lebold Cohen and Jerome A. Cohen

poet-friends in 1986. The following year they established a poetry magazine called *First Line* (*Yihang*) that was in print until 1992. The unofficial poetry scene in China had remained vibrant. But because venues for publication had been closed to them, *First Line* provided a publication platform for many budding writers. About a thousand copies were printed of each issue, and some were always sent back to China.

Although not approved for publication in China, *First Line* was never declared to be counterrevolutionary. Yan Li believes this may be because the *First Line* poetry society insisted on a structure of private self-funding by its twenty-odd members, and their finances were supplemented by donations from literary friends like Ginsburg. The magazine was thus never associated by Chinese censors with the political positions of a foreign funding agency.

Records (pl. 51), a 1986 work composed of broken records mounted on canvas, is a fragmentary construction of a cultured self. Made soon after Yan Li arrived in New York, it might still be read through a Cultural Revolution lens. During that troubled time the Red Guard smashed private phonograph records as representative of the "four olds," and all but revolutionary music disappeared from public spaces. By the late 1970s, young culture seekers began to gather secretly at the homes of those who had escaped such destruction to listen to old recordings of classical and popular music, sharing the precious experience of beauty. Of course, by 1986 in New York, records were being discarded to make way for new technology. This work reverberates at the boundary between past and future, a backward-looking China and forward-looking West.

Since 1995, when Yan Li married in China, he lives part of the year in the US and part in Shanghai or Beijing. In 2003 he participated in the Iowa Writers Workshop as a fellow. Yan Li has published in recent years a number of small catalogues in which his poetry, both in the original Chinese and beautifully translated by Denis Mair, speak across the pages to his surrealistic paintings.

Li Shuang (b. 1957; pls. 52–55). One of only two female Xingxing exhibitors and the youngest of the early participants, Li Shuang was the daughter of two college professors, her father at Tsinghua University and her mother at Peking University. Li Shuang's father taught in China's most prestigious architecture department and was a member of the team that designed and constructed the Ten Great Buildings in Beijing for the tenth anniversary of the PRC in 1959. He had been designated a rightist in 1957, but because his skills were in such demand, his "punishment" was labor reform at the construction site of the Great Hall of the People. In this capacity he continued to advise in the construction despite his drastically reduced status. As though to punish the entire family, her mother, while not branded a rightist, was nevertheless exiled to Manchuria. At the time, Li Shuang was only three years old. With no one to care for her, she was sent to boarding school at the People's Literature Publishing House live-in nursery school. This arrangement was inadequate. Parents were supposed take their children home on weekends, but as a rightist her father had no control over his work schedule. Moreover, children of rightists suffered systematic discrimination. When her father arrived late to pick her up, she was forced to wait for him outdoors in the cold, where she developed frostbite.

Finally, Li Shuang was taken in by her grandparents, who were already caring for some of her cousins. Her grandfather had been a well-known dealer who sold painting, calligraphy, and antiques to Europeans and Americans. He had become quite wealthy, but the antique business was abolished in 1949. Because he had foreign language skills, however,

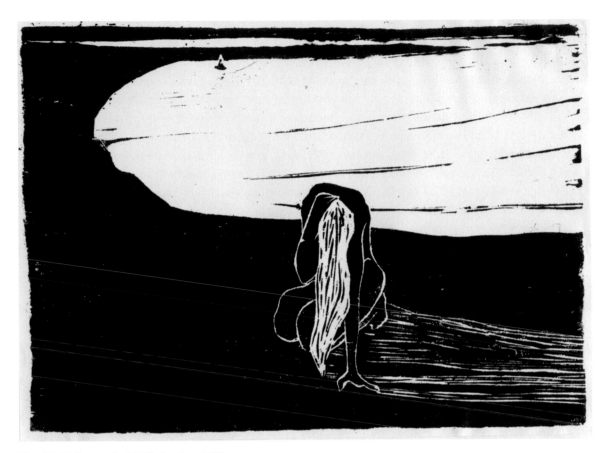

Plate 52. Li Shuang (b. 1957), *Parting*, 1980.
Woodblock print; 16.5 x 17 cm (unframed).
Collection of the artist

Plate 53. Li Shuang (b. 1957), *A Friend in the Wilderness*, 1980.
Woodblock print; 14 x 25 cm (unframed).
Collection of the artist

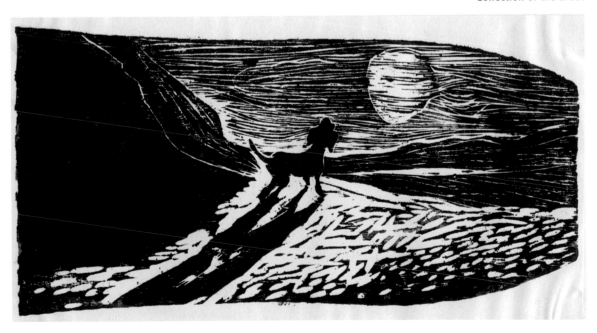

he was hired as an advisor to the Foreign Ministry. When Li Shuang was a child, his home was still filled with good quality antiques, and her grandfather liked to tell her stories about them. He even endeavored to teach her connoisseurship and authentication. Her grandmother encouraged her to paint and also pushed her to overcome her timidity and become independent. From childhood Li Shuang was thus surrounded by art.

When the Cultural Revolution began, Li Shuang returned to her parents' house. Her father had been invited back to teach in the architecture department at Tsinghua, but was still considered a rightist. Her mother had returned from Manchuria. As a collector of antiques and a Christian, Li Shuang's grandfather was an obvious target of the Cultural Revolution. When his home was raided by the Red Guard, her grandfather suffered a stroke and was paralyzed; her grandmother developed mental illness. Trouble started in Li Shuang's nuclear family in 1967 when it came to light that her father had gone to middle school in Taiwan. For that reason he was considered by the Red Guard to be a Taiwanese spy. Her home was raided five times, and the Red Guard destroyed everything, including the cooking pots and rice bowls. After the last raid, when she was in second grade, they were left with nothing to wear or to eat. All that was left was one pumpkin, which they ate over the course of three days.

During the Cultural Revolution, with schools closed and the family condemned, Li Shuang and her sister had no friends and were very isolated. At about the age of thirteen she suddenly felt that she wanted to paint and has since that time never stopped drawing and painting. At first there were no books left at home, so she had to obtain reproductions of watercolors with which to teach herself. Even though it was so difficult to get an apple, she would paint it first and then eat it. When she was about sixteen or seventeen she began painting landscapes at the Purple Bamboo Garden, which was near her home. In this park she began to make some friends and through them to meet many painters. Tang Pinggang was one of the first, and later she met Chi Xiaoqing and Chi Xiaoning. The Chi family, whose father, Chi Ning, had been a designer in the Beijing Film Studio, owned many nice reproduction albums, particularly of Soviet art. After their parents died, the two children lived alone. For Li Shuang it was one unfortunate person meeting others even more unfortunate, and she knew she was not alone in her unhappiness. In those unsettled times she also met writers like Yan Li and Bei Dao, as well as the children of high officials. By reducing every family to the same impoverished and broken state, the Cultural Revolution temporarily eliminated the newly formed class boundaries of the Communist state, particularly those between the families of privileged revolutionary cadres and those of the overthrown educated elite, like Li Shuang's grandfather. In that period, and only temporarily, the children of these quite different groups came together naturally.

Li Shuang's home was in the west side of the city, at Ganjiakou, where many young poets, musicians, painters, and democracy activists lived. During the late Cultural Revolution these young people organized many underground activities and cultural salons. In their different circles, they would gather to sing love songs, recite poetry, or paint nonpolitical landscapes, still lifes, or portraits. Violating revolutionary social and artistic standards, all of these activities would have been severely criticized and probably punished if they had come to light.

In 1976, after graduating from middle school, Li Shuang was sent to Gaoliying commune in Shunyi county to work as a farmer. This was the last year that students would be sent down to the countryside. When college entrance examinations were reintroduced, she sought to take the CAFA test. But her formal training was insufficient to qualify her for the exam. In 1978 she took the exam for the art department of the Film Academy and did very

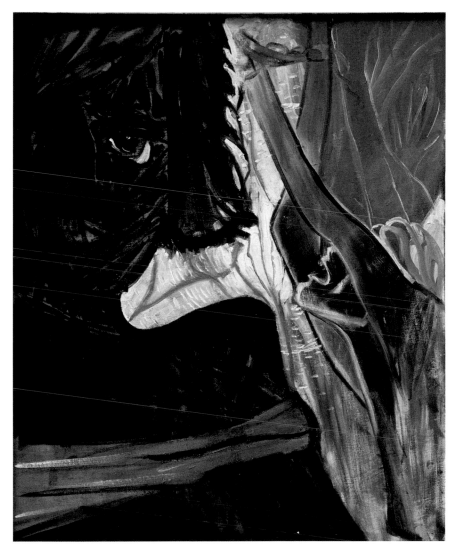

Plate 54. Li Shuang (b. 1957), *Red and Black*, 1979.
Oil on canvas; 69 x 54 cm (framed).
Collection of the artist

well in drawing, color, and all academic subjects, including math and language, but failed the politics examination. So she was returned to the countryside to labor. Later in the year, one of her friends showed her landscapes to a contact at Chinese National Youth Art Theater, and she was offered a job. In 1979, she went to work there as a stage set designer.

During the spring of 1979, when Huang Rui and Ma Desheng were selecting artists for the Xingxing show, someone introduced them to Li Shuang. They told her that they knew she was a painter. She believes it may have been through Mang Ke and Yan Li that they heard her name, although it is also possible that some of the Wuming artists, such as Zhang Wei and Ma Kelu, might have talked about her. At any rate, after looking at her work they invited her to join the still rather small group, which then consisted of Huang Rui, Ma Desheng, Zhong Acheng, Yan Li, Mang Ke, and Bei Dao. Wang Keping joined a little later, and they became the core organizers of the exhibition as well as very good friends.

Most of the Xingxing artists were older than Li Shuang, and she recalls that they were all more mature and had a higher degree of political sensitivity. She knew that joining their art group had some element of danger, because it seemed to touch the political realm. But her hard times as a child steeled her psychologically for what might lie ahead. The self-expressive goals of the Xingxing exhibition was most important—to speak out, to openly display emotion. Using art and poetry to express one's views of life seemed to her, in the context of the time, a unique and positive approach and a contrast with the democracy activists who were engaged in direct criticism. She was really excited, believing that their endeavor was truly different and, more importantly, feeling for the first time that she was doing something really right.

Li Shuang's work in the first Xingxing exhibition, *Red and Black* (pl. 54), expressed the shock and horror that everyone felt over the extraordinary injustices that continued to the very end of the Cultural Revolution. Her subject, Tianjin native Zhang Zhixin (1930–1975), was a dedicated party member who became critical of the personality cult of Mao Zedong and the Cultural Revolution leadership while working in the northeastern province of Liaoning. She was arrested in 1969, but never recanted, despite brainwashing, rape, and other forms of torture. Indeed, when brought forth for public humiliation, she not only failed to confess her errors but loudly declared her loyalty to the true Communist Party and her belief that Mao had hijacked its principles. To make matters worse for her, Mao's nephew Mao Yuanxin was responsible for Liaoning's administration. Unable to silence her, the authorities cut her vocal cords before executing her by firing squad on April 4, 1975. During the Beijing Spring in 1979 she was posthumously rehabilitated and officially designated a revolutionary martyr. Exposure of this matter caused a sensation at the time, but official interest rapidly cooled. That her motivation was patriotism and loyalty and her heroic action was to criticize the failings of the Communist Party from a position within it has made her a symbol of free speech and principled dissent that is still evoked by the courageous in China today. In Li Shuang's image, Zhang Zhixin, with a slash across her throat, gazes directly at the viewer with large eyes that express what her voice can no longer say. At the right, humanity raises its hands in lament.

As one of only two female artists in the exhibition, her images of female subjects speak to a kind of yearning different from that of her male counterparts. The oil painting *Light of Hope* (pl. 55), painted with a cool color palette on the back of a cotton bed sheet, and the prints *Parting* and *A Friend in the Wilderness* (see p. 89, pls. 52 & 53) were exhibited in the second Xingxing exhibition.

Government policies of the time advocated, at least in words, opening to the international community. The Xingxing would test this rhetoric in art. As in all aspects of the first exhibition's implementation, the artists used their personal networks to arrange publicity. Li Xiaobin documented the event with photos, and Li Shuang's friend, the late cinematographer Chi Xiaoning (1955–2007), filmed the proceedings.[90] When the show later moved to Huafangzhai, domestic and foreign photographers documented it. A staffer for the cultural section of the French embassy, Emmanuel Bellefroid, later gave them photos he had taken. The embassy also arranged an interview at Huang Rui's home that was later broadcast on French TV. Wang Keping, in Li Shuang's memory, served as their "minister of foreign affairs," frequently introducing foreign reporters to the shows and speaking to the press. After the Huafangzhai exhibition in 1979 they were invited to dine with the French ambassador.

In the fall of 1980, following the second Xingxing exhibition and just as restrictions in cultural and political policies began to tighten, a love affair developed between Li Shuang and Bellefroid. After about six months, she was arrested in his apartment in the diplomatic compound. In the eyes of the Chinese authorities their romance was a crime, and she was sentenced to two years in prison. The matter caused great diplomatic tension between France and China and became a cause célèbre in the French and international cultural world. After serving her sentence, she was expelled from China in 1983. She married Bellefroid and today works as an artist in Paris. In Li Shuang's view, she served as a scapegoat for the entire Xingxing enterprise, which was seen as dangerous to the state. Indeed, her arrest marked the end of the group's activities.

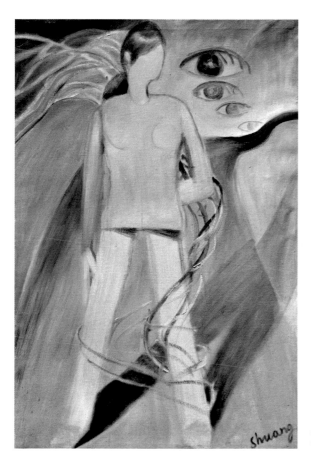

Plate 55. Li Shuang (b. 1957), *The Light of Hope*, 1980. Oil on canvas; 100 x 70 cm (unframed). Collection of the artist

Ai Weiwei (b. 1957; pls. 56–59). Although he was the son of a famous poet and Communist Party official, Ai Weiwei had a childhood that was anything but privileged. His father, Ai Qing (1910–1996), had studied art at the prestigious West Lake National Art Academy in Hangzhou and then for several years in France, where he fell in love with poetry. When he returned to Shanghai he became involved in leftist cultural circles and was soon arrested. He and Jiang Feng were imprisoned together for three years after being arrested in Shanghai by the Nationalist authorities in 1932. Ai Qing was condemned as a rightist in 1957. His punishment was particularly severe—he, his newly married wife, and his baby son Weiwei were exiled for almost twenty years, first to "the great northern wasteland" of Heilongjiang, and then, from 1959, to Shihezi on the edge of the Gobi desert in Xinjiang. Thus, despite his birth into an elite revolutionary family, Ai Weiwei grew up far from any cultural center and in bitter poverty.[91] After finishing high school at the age of eighteen,
Ai returned to Beijing in 1975. An artist friend of his father's offered to teach him painting, and so for two years he studied painting in this informal way. Although he had only just returned to the city from a lifetime in the provinces, he was briefly sent down to the countryside. In 1978 he gained admission to the Beijing Film Academy, entering in the same year as the internationally known filmmakers Zhang Yimou and Chen Kaige. Thus, although always a rebellious sort, as an art student Ai Weiwei was one of the very few participants who was technically (and briefly) a member of the art establishment.

Ai Weiwei, who was introduced to Huang Rui by the poet Mang Ke, exhibited seven or eight landscape paintings in each of the two Xingxing exhibitions. The paintings were the

Plate 56. Ai Weiwei (b. 1957), *Profile of Marcel Duchamp in a Coat Hanger*, **1980s. Wire; 68 x 50.8 cm. Collection of Ethan Cohen**

Plate 57. Ai Weiwei (b. 1957), *Quintessential Communist Umbrella Briefcase*, 1980s.
Mixed media; 25.4 x 86.4 x 8.3 cm. Collection of Ethan Cohen

results of a school trip to the Jiangnan and Shanghai areas, but were executed in a very bright expressionist style, a manner not particularly acceptable within the academy at that time. In addition to exhibiting his work, Ai Weiwei helped the organizers through his personal connections. His older half-sister worked for the Beijing Artists Association, and she was called upon to help when the police closed down the outdoor exhibition. Furthermore, Ai Qing's long friendship with Jiang Feng facilitated Xingxing efforts to persuade the elderly arts administrator of the worthiness of their exhibition proposal.

In 1980, Ai Weiwei's parents Ai Qing and Gao Ying accepted a residency at the Iowa Writer's Workshop. The following year Ai Weiwei left China for the US, where he eventually studied at the Parsons School of Design in New York. There, an absurdist sense of humor with some parallels to that of Wang Keping began to emerge in his work. Beginning with his coathanger portraits of Marcel Duchamp (pl. 56), he moved on to comment on the human condition with manipulations of readymade objects. A pair of wingtip shoes sliced and sewn together yielded toes headed in opposite directions. A briefcase decorated with the hammer and sickle is permanently joined to a black umbrella (pl. 57), perhaps foreshadowing the emergence of the new Communist cadre as world banker. In that period he also showed his works in the 1989 Xingxing retrospective *The Stars: Ten Years*.

Upon returning from New York when his father fell ill in 1993, he began a series of works in which his iconoclasm is aimed at China's traditions or, rather, at those who seek to preserve and maintain them. In 1997 he began reconstructing Chinese furniture in surrealistic configurations (e.g., pl. 58). In a subsequent series of installations and performances, he desecrates Neolithic pottery, one of China's most ancient art forms, by smashing or overpainting the vessels (pl. 59). Ai Weiwei, one of the youngest artists in the Xingxing group, developed a career abroad that responds to postmodern critical discourse. In Beijing, he helped to establish the China Art Archives & Warehouse (CAAW), and with Feng Boyi, he co-curated the 2000 art exhibition *Fuck Off* in Shanghai. Since his return, he has also involved himself in the social issues of a much-changed China that center around urban architecture and the human beings who inhabit it. He was detained by the authorities from April 3 to June 22, 2011, and as of this writing his movement remains restricted. Many observers believe his arrest was retaliation for his sharp criticism of government corruption.

Plate 58. Ai Weiwei (b. 1957), *Stool*, 1997, recreated in 2007. Wood stools (Qing dynasty, 1644–1911); 63 x 65 x 44 cm. Private collection

Plate 59. Ai Weiwei (b. 1957), *Drips Going Down – Ai to E*, 1997. Mixed media; 15.2 x 17.3 cm. Collection of Ethan Cohen

Outsider Art in Shanghai:
The Caocao She (Grass Society)

Like the Xingxing in Beijing, the Caocao she, or "Grass Society," in Shanghai was an artists' group established in the fall of 1979 for the purpose of holding an exhibition (fig. 11).[92] The founder of the group was a young man of the Red Guard generation, Qiu Deshu (b. 1948), who had shared many of the same experiences as his colleagues in the Wuming and Xingxing groups, and its membership consisted of seven artists from Shanghai and four from Hangzhou. Like the Wuming but unlike the Xingxing, the Caocao group included independent artists of an older generation. Qiu Deshu's co-founder was one of his teachers, Chen Jialing (b. 1937), an art school graduate who taught at the Shanghai Art School (Shanghai meishu xuexiao), a new institution formed in the 1960s.

This group whole-heartedly threw themselves into the pursuit of non-political *guohua* painting with the conviction that experimental ink painting had as much claim on modernity as did any other form of art. First, they rejected socialist realism and the use of Chinese ink as an empty gesture of nationalism. At the same time, they connected, either implicitly or explicitly, with the premodern ideology of ink painting as the self-expressive vehicle of China's literati class. The tradition of ink painting, which had flourished in Shanghai and indeed throughout the Zhejiang-Jiangsu region before Liberation, was an explicit target of Maoist cultural reforms which had condemned it as a feudal relic. Ink art was to the Maoist regime as threatening as modernism.

While the general outline of their rebellion against artistic censorship was spurred by passions that were widespread throughout the Chinese art world of the time, the specific forms taken by the Caocao group and their art stem from the particular historical developments of their region, which are somewhat different from those of Beijing. On the one hand, Shanghai had been a stronghold of the Gang of Four, and the Shanghai-Hangzhou area, with its art schools and publishing houses, was a major center of Cultural Revolution propaganda art. On the other hand, while badly crippled and with many of its most articulate voices silenced, the pre-Communist art world had nonetheless survived in remnants underground during the three decades of Maoist cultural domination. Whereas Beijing, as the capital, had seen an influx of party members from other cities—idealists dedicated to remaking China—and thus developed a new socialist culture, Shanghai was filled with elder artists who were not party members and had remained grounded in ideas and techniques formed in the pre-1949 period. As early as the 1920s and 1930s, ink painters in Shanghai had advocated a role for their art in the development of cosmopolitan modernism. Subjectivity, abstraction of form, emphasis on individuality, and independence of expression, as well as the gestural qualities of execution, were all elements of their tradition that the earlier generation of Chinese painters had seen as convergent with European art of the time. Their project to bring modern art and ink painting into alignment was interrupted in 1949 by the substitution of socialist realism for cosmopolitan modernism.

Thus, in the post-Cultural Revolution period, young Shanghai artists, like their colleagues in Beijing, eagerly turned to foreign models. At the same time, having grown up surrounded by traces of the modernist metropolitan culture of the 1920s and 1930s, which survived in the hearts of its older artists and in the imposing modernist architectural infrastructure, they could not be unaware that Shanghai had its own particular history of engagement with cosmopolitan modernity. Shanghai's culture had been banned as decadent under Mao, and Deng Xiaoping's regime never reopened this evaluation for debate. Under the surface, however, the city's reopening to the international community after 1978 simultaneously involved an unspoken and potentially dangerous reengagement with its own recent past.

The Cultural Revolution had left its particular mark on the city, as well. Following the deconstruction of the Artists Association during the Cultural Revolution, the loci for art exhibitions began to decentralize, shifting to small exhibition centers administered by labor unions and local districts. Many amateur artists whose talent had emerged in the late years of the Cultural Revolution were, like Qiu Deshu, assigned to work in such units. Some of these young artists were veterans of Red Guard demonstrations and had painted the required propaganda in the many Maoist movements of the Cultural Revolution. The older bureaucrats who assigned them to their jobs probably had no idea of the capabilities of this generation. All had undergone an extraordinary range of experiences during their adolescence and early adult years. They had excellent organizational and political skills and tended to be highly self-motivated, effective, independent, and oriented to public service. The unintended consequence of these job assignments was that, while the old bureaucracy was engaged in reconstructing itself, these local exhibition spaces, with their active young curators, emerged as primary venues for the display of the emerging art of the "open period."

The staffs of such centers were mainly men who had never received formal or academic artistic training but had been recognized during the Cultural Revolution as worker artists. An institution where such an artist was employed would not normally be subject to supervision by the Artists Association. And because they were only in small, district-level facilities, under normal circumstances the artists would not have attracted the notice of the municipal cultural bureau. The rebellion against orthodoxy that took place in Shanghai was, as in Beijing, the product of an outsider mentality, led by artists who had never been fully integrated into the official system they would attack.

In 1977 Qu Shunfa (a worker artist at the Xuhui District Cultural Center), along with future Caocao members Guo Runlin (b. 1940; a worker at a nearby radio and television factory) and Chen Juyuan, organized an apolitical watercolor exhibition at the Xuhui District Cultural Center that, for various reasons, attracted a great deal of attention. To raise the status and quality of the show, works were sought from the most famous artists in Shanghai, and Guo Runlin delivered watercolor paper to the homes of some of the old ink or oil painters, asking them to make new work in the watercolor medium. Working in a variety of styles, notable elders—including Guan Liang, Liu Haisu, Pan Sitong, Lei Yu, Fan Mingti, Zhu Ying, Zhu Qizhan, Li Yongsheng, and Ran Xi—joined the young amateurs. For many it was the first time they had exhibited since before the Cultural Revolution, and there was a feeling of great excitement in the air. Liu Haisu, who was yet to be rehabilitated, created a polychromatic *guohua* painting for the show. Although the organizers attempted to avoid the district inspection process by calling the show an "internal viewing," censors appeared before the opening and removed Liu Haisu's painting. Despite this rocky start, word of mouth spread throughout the Shanghai art world and the small gallery was filled with people. Paintings by

revered old artists whose works had not been seen for many years, along with those of brightly colored or casual subjects by younger artists, created a delightful contrast to the heavy themes and colors of the Cultural Revolution. In the past, following the Soviet academic model, such paintings were not considered finished works, but instead preparatory sketches. They were secretly prized by many for their authenticity, as they were so much freer than works in the official, politically themed exhibitions. Such an exhibition of individualistic work seemed like a signal to artists that they could now create apolitical paintings.

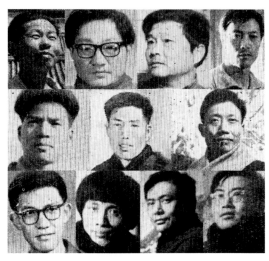

Fig. 11. The Caocao artists. Top row (from left): Yuan Songmin, Jiang Depu, Dai Dunbang, and Zeng Mi. Middle row: Xu Yinghuai, Pan Feilun, and Chen Jialing. Bottom row: Zhu Yinlin, Guo Runlin, Chen Juyuan, and Qiu Deshu. From the flyer "Caocao She: Art for the 1980s Exhibition," 1980. Courtesy of Qiu Deshu

Students at the Shanghai Drama Academy, including Zhang Jianjun and Shen Chen, organized the *Wild Rose Exhibition* (Ye qiangwei) in 1978. This group of students was the first to be admitted after the Cultural Revolution, and their all-inclusive attitude is typical of the period before new institutional and social frameworks had been established. The exhibition consisted of abstract art created by students, liberal young faculty like Li Shan (b. 1942), and some outsiders. Variously executed in oil, gouache, ink, and watercolor, the works encompassed the subjects of figures, landscapes, and still life from quasi-impressionist, cubist, or other relatively non-objective perspectives. None were very realistic, and the show was overall somewhat more contemporary than those held in the cultural centers because the academy students and faculty had access to books about modern art in the school library.

In February of 1979 an even more influential show, *The Twelve-Man Painting Exhibition*, was held at the Huangpu District Children's Palace. One of the participants, Luo Buzhen (b. 1943), worked at the children's palace and presumably facilitated the event. The eleven other exhibitors were Chen Juyuan, his brother Chen Juhong, Guo Runlin, Huang Azhong, Shen Tianwan, Wang Jianer (b. 1944), Qian Peichen, Xu Siji, Han Baiyou, Kong Boji, and Chen Junde. Their manifesto was written by Chen Juyuan, who raised the issues of exploration, innovation, pluralism, and freedom of artistic creation. The exhibited works depicted landscapes, still life, and figures from traditional theater in a range of modern styles from impressionism to cubism. The exhibitors included amateurs, but also some artists of a kind unique to Shanghai, such as Shen Tianwan (b. 1931). He had attended the Shanghai Art Academy and its later reincarnation, the East China Academy of Arts in Wuxi, between 1948 and 1954 and ran a private studio before the Cultural Revolution. His students Qian Peichen, Xu Siji, and Han Baiyou also participated. Kong Boji was the remarkably liberal party secretary of the art department of the Shanghai Drama Academy, and Chen Junde was a teacher there. Wang Jianer had graduated from the newly established Shanghai Art School in 1962 and would complete his course at the Drama Academy in 1979 before going on to study with Lu Yanshao at the Zhejiang Academy of Fine Arts. The show was notable for the comparatively modern styles in which the artists worked, as well as for non-political subject matter. For these reasons it attracted a great deal of notoriety.

The Caocao Exhibition

Thus, the Caocao group came into existence in an environment of independently organized art activities. Like the Wuming and Xingxing, the Caocao was brought together from several preexisting circles of artist friends. Many members of the group had already begun gathering to talk about art during the middle of the Cultural Revolution. Key members Qiu Deshu, Jiang Depu, and Chen Juyuan lived in the same neighborhood in the Luwan district of Shanghai and were in most frequent contact during this time. After the arrest of the Gang of Four in 1976, Qiu Deshu was delighted to be transferred from the factory where he worked shoveling coal to serve as a staff artist and exhibition designer (*meigong*) at the Luwan District Cultural Center. He began organizing non-mainstream art exhibitions and invited his artist friends to participate in events at the Cultural Center; the place became a platform for their artistic activities in subsequent months and years.

Among the friends a great debate erupted in those days—a heated discussion on the relationship of a work's form and its content. Finally they decided that a group effort to free themselves from the straitjackets of the past and present would be most effective. Collectively they worked to find a new artistic language, to demonstrate originality in three areas: spirit, style, and technique. Because the People's Republic had shut down all independent thinking, they wanted to open it up, to create "independence," and for this they needed collective action.

Ultimately, Qiu's most daring venture at the cultural center was to ask his friend and teacher Chen Jialing toward the end of 1979 to collaborate with him in organizing an unofficial artists' group. Because of his activist stance during the Red Guard period, Chen Jialing was not favored by senior arts administrators. But Qiu Deshu felt Chen's academic input would make his friend a valuable partner in the endeavor. They conceived their society as the "Independent Painters Group." Like the artists of the Beijing Spring, they believed that they lived at a historic moment, one in which they could change the Chinese cultural world for the good. Their name very clearly indicated their intention, which was to break their own practice from the bonds of the institutional system for art.

After reporting their exhibition plans to the director of the center, however, Qiu Deshu began to meet resistance. Most importantly, the director felt that the name they had chosen was politically inflammatory, immediately evoking the political revolution that followed the American Declaration of Independence. The exhibition could go forward, but under a different title. With some degree of irony, the artists retreated from the activist implications of the name Independent Painters Group and called themselves by the more modest name, the Grass (Caocao) Group. They had not surrendered and now compared themselves to the tiniest and most inconspicuous weeds, contrasting their stubborn persistence to the flamboyance of short-lived spring flowers. They consoled themselves with fragments of poetry—"even wildfires cannot burn them all, and when the spring wind blows they will grow again." Little sprouts of grass (*cao*), as the reduplication suggests, evoke the beginning of the independence of thought and artistic creation they hoped would flourish in the future as well as its potential to spread widely. Nevertheless, this political setback suggested dangers might lie ahead, and some of the original participants withdrew from the group. The first exhibition of the Caocao group did not, as a result, take place in 1979 as hoped but was postponed until early the following year.

The Shanghai members of the group were Qiu Deshu, Chen Jialing, Yuan Songming, Jiang Depu, Guo Runlin, Dai Dunbang, and Chen Juyuan. Many of them, like Qiu Deshe, did

not have formal academic training in art. Chen Jialing, who had gone to art school in Hangzhou, enlisted the participation of four of his schoolmates: Zeng Mi, Xu Yinghuai, Pan Feilun, and Zhu Yinling. With a forward-looking title, *The Grass Society: Painting Exhibition for the 1980s* (Caocao she bashi niandai huazhan), the show opened at the Luwan District Cultural Palace, 270

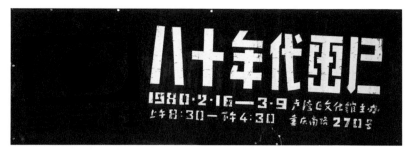

Fig. 12. Poster for *Caocao She: Art for the 1980s Exhibition,* February 16–March 9, 1980. Courtesy of Qiu Deshu. Photo by Kuiyi Shen

Chongqing South Road, on February 16, 1980 (fig. 12). It was scheduled to close on March 9. Most of the artists knew little of contemporary Western art, but were committed to innovation within ink painting. Trained on nothing but socialist realism, their idea was to develop something entirely new.

The manifesto for their exhibition, which was drafted by Chen Juyuan, reads:

> Grass—symbol of the strongest vitality/life force in nature—which grows everywhere and forms vast steppes, can also take root in remote soilless deserts, dangerous shores, and precipitous cliffs, is so widespread, ordinary, and resilient, yet brings to the world, year after year, luxuriance and hope. The Grass Society admires its spirit and character, and hopes, like grass, to spread a green carpet on the virgin soil of our fatherland's art. Our society is a voluntarily organized painting research group based on independence of spirit, originality of style, and uniqueness of technique. It intends to conduct experiments to continue and develop the great Chinese artistic tradition as a contribution to the nation's Four Modernizations.[93]

Although they changed the group name as required, they notably did not eliminate the principles of independence, originality, uniqueness, and individualism from their manifesto. In the political and historical context of the time, that they continued to stress independence as a basic principle was extremely important.

After the Cultural Revolution, many artists in China began to call for the spirit of humanism; this was seen within the academy in works of such "scar painters" and "rustic realists" as Cheng Conglin, Gao Xiaohua, He Duoling, or Luo Zhongli. To these artists the concept of humanism meant the larger truths of society and history. Their pursuit of human dignity took place in the context of the masses and was expressed in the language of the masses. It remained a communal expression in the Maoist sense, even though in basic content it turned against Mao's tenets. In contrast to this generalized social view, the Caocao group emphasized individual self-expression rather than the capturing of a universal social truth. For them, human value began with the individual, and in art they focused on finding a personal artistic language. This individualism was a particularly strong aspect of their approach in the context of their time, and their professed independence of spirit was why they were deemed to be so problematic. To be an artist, in their view, one needed to have independence and integrity, to withdraw from political art and political pressure, and to avoid propaganda and didacticism in art. Explicitly, they believed that they had a duty to develop independent techniques, unique styles, and subject matter (or lack of subject) that

would never compromise their integrity. The work of each Caocao artist, as he developed his own artistic language, came to reflect a clear modernist character.

Many of the other participants were, like Qiu Deshu, current or former factory workers. Unlike the Xingxing artists or even the Wuming, they had inherited or accumulated little political capital; they were completely exposed. Before the show formally opened, the authorities directed that a painting of a female nude and several abstract paintings by Qiu Deshu be removed. The modernist poster for the show was also taken down by the Cultural Center. The artists did not fight this interference and agreed to a compromise in order for the exhibition to go forward. However, with the political environment becoming increasingly tight, several artists withdrew from the show. And, indeed, it attracted the unfavorable attention of the local authorities, primarily on the grounds of abstraction.

The cautious Shanghai Artists Association, for some reason, sent two staff members to examine the show, and they reported ominously that it had "a tendency toward abstract art." Abstraction, like nudity, remained taboo in 1980; it was considered a serious ideological error, akin to political subversion. Moreover, although the Cultural Center had previously exhibited work by Zhejiang artists, the Shanghai Artists Association pointed out the participation of four Hangzhou artists as additional grounds for objecting to the show. Qiu Deshu was summoned to the director's office and informed of the unfavorable response of the Shanghai Artists Association. It was suggested that the show would have to come down.

Before Qiu Deshu had time to reschedule the deinstallation, however, a Shanghainese graduate student from CAFA, Tang Muli, arrived with Joan Lebold Cohen, an American art journalist and art historian, in tow. [94] In the spirit of openness toward the international world, which remained an official policy, curator Qiu Deshu gave them a gallery tour and fielded her questions. After he dutifully reported the visit to the center director he was called back for a serious talk and told that the Cultural Center would immediately close completely for remodeling. The Caocao exhibition, which had only been hung for a few days, would of course also come down.

The matter was reported to the Shanghai Municipal Party Committee's propaganda department, which then, in rhetoric frighteningly similar to that of the anti-rightist campaign or the Cultural Revolution, labeled the Caocao Group and their exhibition a "typical example of bourgeois liberalism in the Luwan district cultural system." Throughout 1980, Qiu Deshu was subjected to sustained public and private criticism at the hands of the party officials, and he was put under enormous political and personal pressure. As was done during the Cultural Revolution, he was forced to publicly confess and repent ideological failings, he was constantly watched, and his office frequently subjected to searches referred to as "sanitation inspections." The unbearable intensity and duration of this psychological attack caused the thirty-two-year-old Qiu to suffer a small stroke that led to temporary paralysis of his face and loss of speech. He recalls this as one of the lowest points in his life, far worse than his years spent shoveling coal during the Cultural Revolution. Needless to say, he was removed from a position of curatorial responsibility. In the end, as consolation, the artists were cheered by the many favorable comments in the guest book, which suggested to them that their show was extremely well-received by their viewers. Although they had achieved some of their goals, against this background they decided to disband. Eventually the members would need to pursue their goals alone.

The Caocao Group in Retrospect

Both Jiang Depu and Chen Juyuan had begun their formal art studies before the implementation of the Communist educational and economic system, and both were children of the fully developed metropolitan culture of Shanghai, East Asia's most vibrant city at that time. The Shanghai art world, having developed over several generations, had been fully integrated into the commercial and industrial society of a modern capitalist city. At its core was the art market, which broadly conceived, was a system of schools, publishers, factories, art shops, and collectors that provided steady, if constantly changing means of livelihood for visual artists of sufficient talent and versatility. The art market, in turn, was fueled by the cultural aspirations of Shanghai's wealthy and upper middle classes. Even when this social class was artificially abolished, the aspirations that went along with its well-established lifestyle remained—and such practices as hiring private art or music tutors for one's children persisted. It remained possible, if financially and socially difficult, for artists in Shanghai to survive outside the socialist system. Jiang Depu and Chen Juyuan, who were not party members, and by virtue of their irregular employment apparently did not receive very effective training in how Communism was to be implemented, continued to live in the upscale neighborhood where they had dwelt as children and to structure their professional lives almost as though Shanghai was still a capitalist city. It was not, of course. But for them the issues around artistic freedom involved not only what kinds of art to make, but their personal freedom to live the life of an artist. They persisted until they saw their native city reopen to commerce in the new millennium.

The Caocao group sought artistic freedom in the post-Cultural Revolution era, just as did the two Beijing groups we have examined. By using ink painting to challenge the status quo, they simultaneously engaged with several key problems in contemporary Chinese art. The least conspicuous, but most essential, was a task articulated as early as the 1920s— to make Chinese ink paintings that could participate equally in cosmopolitan culture and in the best of China's own cultural heritage. More obviously, they attacked socialist cultural norms by bringing abstraction back to ink painting and by reasserting the self-expressive goals of literati art. This independence of spirit was nothing new in Shanghai and despite all efforts had not been eradicated by PRC cultural policies. Within the living memory of many elderly artists were the artistic groups of the 1930s, including the short-lived Storm Society (Juelanshe). Established by French-trained Pang Xunqin and Japan-educated Ni Yide in 1931, the Storm Society adopted a modernist stance in their manifesto that foreshadowed the views of the Caocao group. A younger group associated with Pang and Ni had even exhibited under the name Independent Artists Association. This heritage in some respects compensated for the relative isolation from which Shanghai suffered in 1980. Beijing Spring did not only bring contemporary foreign culture to Shanghai; it also suggested license to openly build upon and celebrate the cosmopolitan in the city's own past.

The Caocao Artists

Qiu Deshu (b. 1948; pls. 60–64). Founder of the Caocao group, Qiu Deshu had been born into a well-educated Shanghai family and attended the No. 3 Middle Fuxing Road Elementary School and Jianqing Middle School. He loved painting from a very young age and attended after-school classes at the Luwan District Children's Palace, where he studied drawing, Western painting, and ink painting. During the Cultural Revolution he became a very passionate Red Guard painter. He graduated from the Sanhao High School in the Luwan district in 1967. When the "old three classes" received their job assignments in 1968, he went to work in the Huasheng Leather Factory. Later he was transferred to the No. 18 Plastics Factory. In both jobs, because of his strong physique, he was assigned to shovel coal into the boiler.

Although Red Guard art was displayed anonymously, the names of the best artists began to circulate by word of mouth. Qiu participated almost annually in Shanghai exhibitions that were organized for one political event or another. Because of his local reputation, he was selected by his factory in 1970 and 1973 to participate in the Workers Art Creation Classes held at the Shanghai Art School and co-organized by the Art School and the Shanghai Peoples' Art Publishing House; Qiu was assigned to the *lianhuanhua* illustration class. One of the most highly motivated young artists in the class, Qiu was considered a top student despite his irregular way of drawing, which involved pushing the wood of the pencil into the paper to create textured indentations. He began making illustrations for *lianhuanhua* story books, and his woodcuts of the time were shown in numerous Shanghai art exhibitions. He even exhibited a woodcut series in an exhibition at the Shanghai Art Gallery (now Shanghai Art Museum) on the occasion of Nixon's visit to the city. In the 1973 class he was taught the finer points of propaganda painting by Chen Jialing, a young instructor who would later become his friend.

These accomplishments led to Qiu Deshu's transfer in 1977, after the Cultural Revolution, to the Luwan District Cultural Center. As staff artist he was responsible for all manner of signage and decoration and, most significantly, for exhibition planning and implementation. As curator, he organized several quite daring exhibitions of ink painting. Twice, for the annual Spring Festival Art Exhibitions of 1978 and 1979, he invited senior artists to participate—artists who had been condemned in the Cultural Revolution but had not yet been politically rehabilitated. Among them were Liu Haisu, Qian Juntao, Xie Zhiliu, Lu Yanshao, Ying Yeping, and Tang Yun. For many young artists, these shows were the first opportunity ever to see original works by Shanghai's most venerable twentieth-century artists. In 1978, he also organized an exhibition of landscapes and other apolitical subjects by Zhejiang Academy of Fine Arts ink-painting faculty members Shu Chuanxi, Lu Kunfeng, and Hong Shiqing. And he organized the Caocao group exhibition in February 1980 at the Luwan District Cultural Center.

Between 1979 and the end of 1983 Qiu undertook many different kinds of experiments, studying the relationship between abstract paintings and calligraphy. He attempted to use seals as independent formal elements at the center of the painting rather than as mere identifying marks at the edges. He also experimented with techniques of pouring and splashing ink on the surface of the paper, manipulating the paper and slow ink flows to create abstract visual effects that for him expressed freedom of the spirit (pl. 64). On the back he began tearing holes in the paper to create painful gaps—partially destroying his painting to break through to a feeling of transcendence.

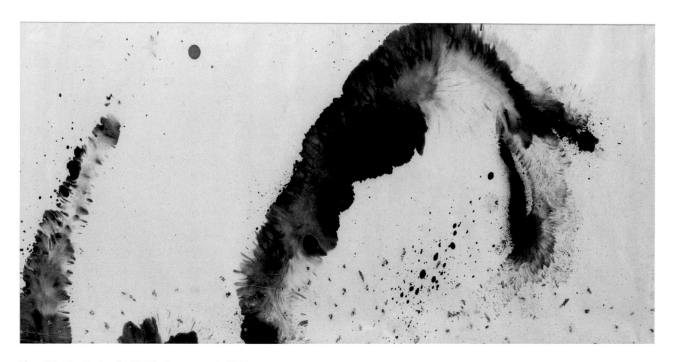

Plate 60. Qiu Deshu (b. 1948), *Empty no. 1*, 1982.
Ink on paper; 77.5 x 129.5 cm (framed).
Collection of Michael Micketti

Plate 61. Qiu Deshu (b. 1948), *3-5 Times Shouting*, 1980.
Ink on paper; 129.6 x 269.2 cm (framed).
Collection of Michael Micketti

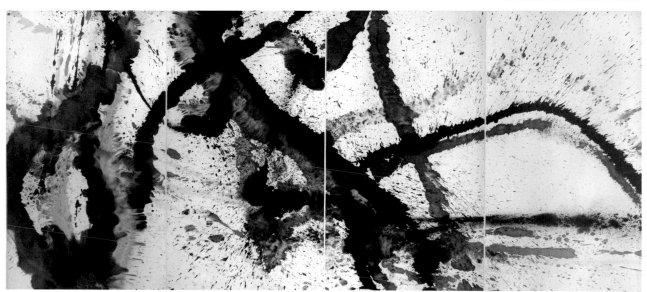

In 1981 the Museum of Fine Arts, Boston, sent an exhibition of American art to Shanghai and Beijing. After substantial controversy in Shanghai about whether the abstract paintings would be permitted, it opened at the Shanghai Museum, located at that time on South Henan Road. Qiu Deshu recalls his shock and pleasure at seeing the painting of Jackson Pollack. It confirmed his commitment to ink and abstraction, but the trauma of the Cultural Revolution seems to have led him to rip and tear his work. One day in 1982, as

Fig. 13. Qiu Deshu, *Cracking II_6-09*, 2009. Ink, acrylic, and paper on canvas; 90 x 360 cm. Collection of the artist. Photo by Kuiyi Shen

he walked, Qiu Deshu's eyes were struck by the appearance of cracks on the ground. He was then searching for a formal breakthrough and had begun experimenting with torn paper. From this time forward, cracks or fissures became a central image in his work (fig. 13). For him, as for some of the other worker-painters, abstraction was a position to be taken in opposition to both Maoist socialist realism and the official art of the 1980s.

For many years after his political difficulties in conjunction with the Caocao exhibition, Qiu Deshu was marginalized in the Chinese art world. Joan Lebold Cohen included three of his works in *Painting the Chinese Dream*, an exhibition held at Smith College Museum of Art and the Brooklyn Museum from 1982 to 1983, and arranged for him to come to the US as a visiting artist at Tufts University in the 1985/86 school year. At the school, he painted a large mural and had a solo show. Upon his return to Shanghai in 1986, he resigned from his previous job and became an independent artist. Only in 2008, after a quarter century of appreciation abroad, did he have a solo exhibition at the Shanghai Art Museum.

Plate 62. Qiu Deshu (b. 1948), *Transcendence*, 1980s. Ink on paper; 77.5 x 68.6 cm (framed). Collection of Michael Micketti

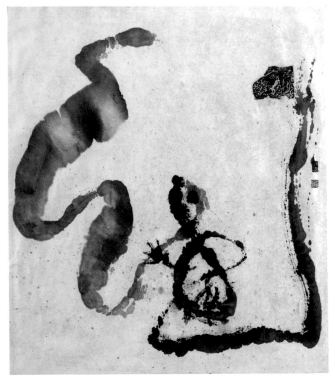

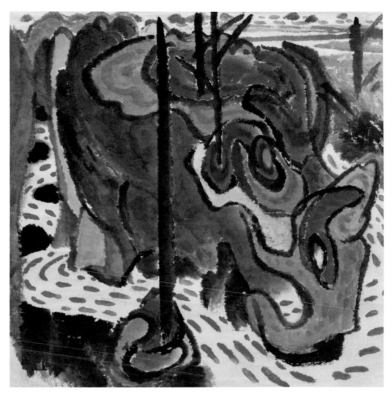

Plate 63. Qiu Deshu (b. 1948), *Rhythm of Stream*, 1979. Ink and color on paper; 68 x 68.5 cm (unframed). Collection of the artist

Plate 64. Qiu Deshu (b. 1948), *Days and Nights*, 1980.
Ink on paper; 77 x 132 cm (framed). Private collection

Chen Jialing (b. 1937; pls. 65–67). Born in Kangxian, Zhejiang, Chen Jialing entered the ink painting department of the Zhejiang Academy of Fine Arts in Hangzhou in 1958, immediately after the anti-rightist campaign. The academy, which had been a bastion of European modernism before Liberation, was also notable for its faculty in traditional Chinese painting. Both kinds of painting had been marginalized in the 1950s with the implementation of a socialist realist curriculum. In this period, the faculty had led the nation in the Maoist remaking of art. Their invention of socialist realist ink painting on Chinese paper was even labeled the "Zhejiang School." Chen Jialing was thus steeped in these revolutionary innovations and the primacy of figurative art, although his last years of school corresponded with a brief return to traditional practices. From 1961 to 1963 a short-lived liberalization of art followed China's split with the Soviet Union and the disastrous Great Leap Forward famine. The revolutionaries who had led the Zhejiang Academy were purged as rightists, and the pre-Liberation director, Pan Tianshou, an advocate of traditionalist bird-and-flower painting, was restored to his position. Defending the nation's artistic heritage on nationalist grounds, Pan Tianshou enjoyed some temporary success in restoring critical favor to this apolitical art. Indeed, Pan Tianshou himself emerged from the controversies of the day as one of the century's most brilliant ink painters, specializing in old cypresses, waterfalls, and birds. Chen Jialing's cohort of students enjoyed the benefit of renewed instruction in these arts, although by the time they graduated, the tide was beginning to turn back toward hardline policies.

Upon completion of his studies in 1963, Chen Jialing was appointed to be a teacher in the recently established Shanghai Art School.[95] In the early days of the Cultural Revolution

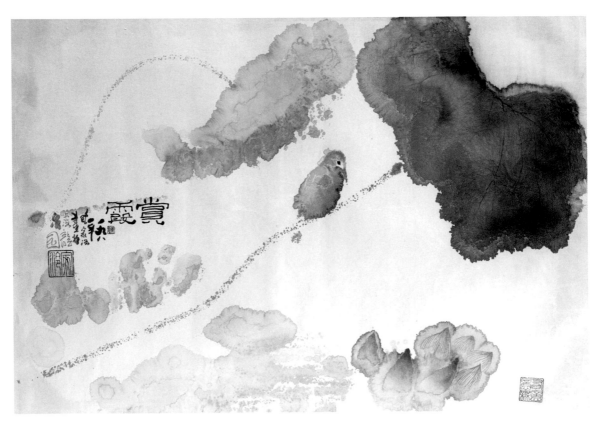

Plate 65. Chen Jialing (b. 1937), *Enjoying Twilight,* 1980.
Colored ink on paper; 89.5 x 120.7 cm (framed). Collection of Michael Micketti

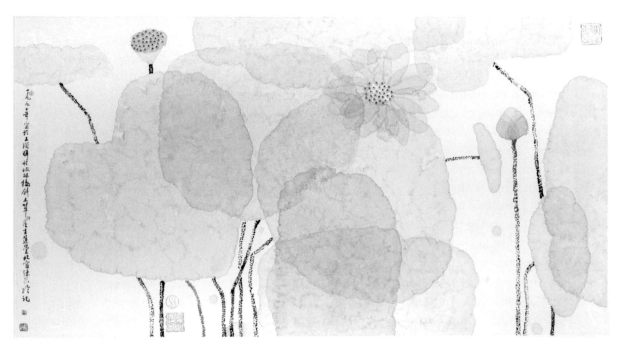

Plate 66. Chen Jialing (b. 1937), *White Lotus*, 1990.
Ink on paper; 119.4 x 200.7 cm (framed).
Collection of Michael Micketti

Plate 67. Chen Jialing (b. 1937), *Twilight*, 1980.
Ink and color on paper; 66 x 91.4 cm (framed).
Collection of Joan Lebold Cohen and Jerome A. Cohen

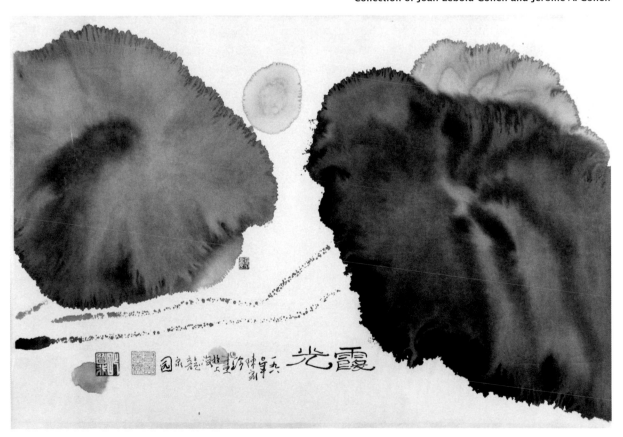

Chen became a Red Guard leader, and then, in the 1970s, he was selected to teach worker art classes in didactic figure painting. It was here that that Qiu Deshu met him.

After the Cultural Revolution, some academically trained ink painters, like Chen, pushed against Maoist art by a move in the self-expressive direction of literati painting. After having studied the extensive criticisms against this tradition when they were students, they were somewhat paradoxically better informed about it than most artists outside the academy. Familiar with both sides of the argument in favor of and against the survival of apolitical art, they were also well-prepared to choose when offered the opportunity. In the 1970s, Chen added to the technical instruction received under Pan Tianshou at the academy by studying landscape painting and calligraphy with Lu Yanshao, a traditionally trained former rightist who was retired in Shanghai. With his knowledge of the possibilities of ink art, Chen Jialing seems to have combined the self-expressive and abstract sides of literati painting in pursuit of a subjective response. Turning away from realism after the Cultural Revolution, his work became increasingly subjective.

The seventeenth-century individualist artist Zhu Da was highly appreciated by Chinese ink painters in the twentieth century, both for the formal beauty and originality of his painting and for his expression of discontent under a new ruling dynasty. In Chen Jialing's escape from the weight of Maoist art, he followed a similar stylistic approach, and in particular he returned to the traditional subject of the lotus, a Buddhist symbol of purity (pls. 65–67). Stepping away from socialist realism not only in subject but also in technique, Chen created his images not with conspicuously skillful strokes, but from a combination of accidentally puddled washes and artfully controlled dots and dabs of dry ink.

Qiu Deshu very much appreciated the theoretical support that Chen Jialing's academic training offered the Caocao exhibition project. Chen was an essential partner, as well, in introducing likeminded schoolmates from the Zhejiang Academy, including Zeng Mi, Xu Yinghuai, Pan Feilun, and Zhu Yinling, to the exhibition. In 1983, with the establishment of the College of Fine Arts at Shanghai University, Chen became a professor.

Jiang Depu (b. 1934; pls. 68–70). Born in Shanghai, Jiang Depu entered the Hangzhou National Art Academy in 1948. After Liberation the school was reorganized as the East China campus of CAFA (later renamed Zhejiang Academy of Fine Arts and now China Academy of Arts); Jiang continued to study painting there from 1950 to 1954. Upon graduation in 1954 he was assigned a job in Wuhan at the Hubei Art Studio of the Hubei Artists Association. Two years later, in 1956, a brief economic experiment encouraged the establishment of private art studios, so Jiang rather naively resigned from his state job to set up such a business. This liberal economic policy was almost immediately reversed, private enterprise prohibited, and Jiang subjected to severe criticism. Moreover, once he had resigned from the state system, it turned out that he was permanently banned from rejoining the network of socialist employment. As late as the 1980s, his colleagues were unable to obtain approval to hire him for a regular teaching post in Shanghai. He thus returned to his family home in the old French concession of Shanghai with no job, scraping by on miscellaneous freelance jobs for the rest of his career. From 1960 to 1962 he taught temporarily at the Harbin Art Academy in Heilongjiang. When he returned to Shanghai he began painting in ink. Lin Fengmian, the founder of the Hangzhou National Art Academy, lived in his neighborhood in the Luwan district near Fuxing Park. The older man's views of art had been completely rejected by the new art establishment, but in the post-famine-period liberalization he was granted a solo exhibition. Jiang occasionally sought his instruction.

By chance Jiang Depu also met Liu Haisu, who was then in disgrace as a "rightist," and the two men occasionally did ink paintings side by side. Encouraged by Liu, but also because of the hardships of obtaining oil painting materials as a private individual, he focused entirely on ink painting from this time forward. The abstract expressionist quality of Jiang's landscape paintings of the post-Mao period may have been inspired by the new directions the old master, Liu Haisu, was taking in his own work. There is visual evidence that Liu acquired some familiarity with the splashed-ink experiments made, beginning in the early 1970s, by his old friend Zhang Daqian, who lived abroad. Jiang built on these modern innovations, as well as on the work of the seventeenth-century artists, such as Shitao and Zhu Da, who had inspired the ink painters of 1920s and 1930s Shanghai.

During the Cultural Revolution, Jiang Depu was befriended by the younger Luwan district artists Chen Juyuan and Qiu Deshu as well as by other Shanghai artists in their circle, such as Chen Jialing. In the 1970s Jiang began exploring the formal possibilities of abstract ink painting. With no work unit, but still committed to painting, he was part of a decentralized, even individualistic, Shanghai art underground that survived from the 1950s until the 1990s, when he was joined by a large cohort of other artists who were not employed by the state. His paintings have been widely exhibited in China, Hong Kong, Japan, Singapore, and France.

Plate 68. Jiang Depu (b. 1934),
Black Symphony—Mountain and Moon, 1982.
Ink on paper; 68 x 68 cm (unframed).
Collection of the artist

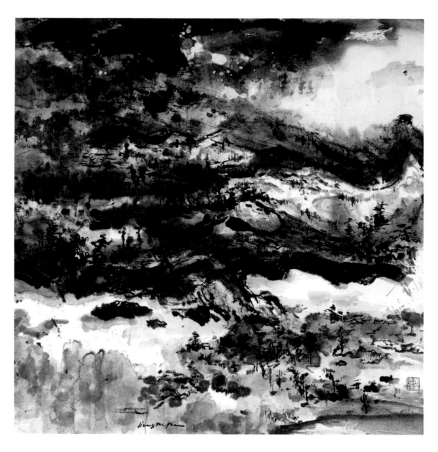

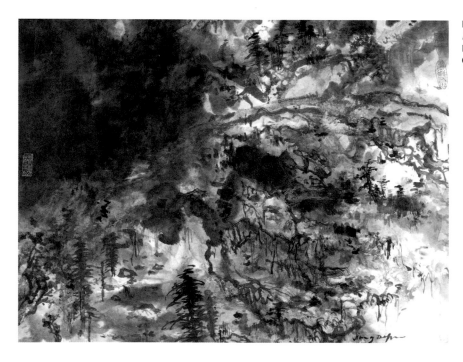

Plate 69. Jiang Depu (b. 1934),
Black Symphony—Mountain Creek, 1982.
Ink on paper; 69 x 68.5 cm (unframed).
Collection of the artist

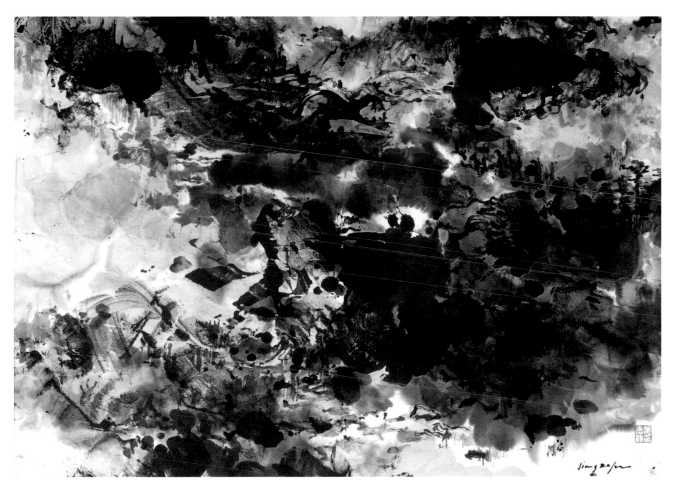

Plate 70. Jiang Depu (b. 1934), *Black Symphony—Mountain Wind*,
1979. Ink on paper; 59 x 82.5 cm (unframed). Collection of the artist

Chen Juyuan (b. 1939; pls. 71–72). The theorist of the Caocao group, Shanghai-born Chen Juyuan had begun his studies at the Shanghai Art Academy and then, after it was nationalized and relocated, completed them in 1954 at the East China Academy of Arts in Wuxi. He later enrolled at Anhui University to study foreign languages, but the famine in Anhui was so severe that the students had nothing to eat. He left before graduating and took refuge with his brother, who was working as an art editor in Fujian. Chen Juyuan then worked for a time as an art editor and designer at the Fujian People's Publishing House, but was never employed permanently by any work unit. Eventually he made his way back to Shanghai, where he continued to work in temporary jobs while devoting himself solely to art. In the 1980s he set up a design studio. He considers himself to be one of the first independent professional artists in Shanghai. His work has been shown in Amsterdam, London, Hamburg, Hong Kong, Singapore, and many other places.

Chen painted mainly in watercolors, gouache, and ink, and by the time of the Caocao exhibition he was mixing them together in unexpected ways. After returning to Shanghai he met many younger Shanghai artists, such as Guo Runlin, Qu Shunfa, Shen Tianwan, Chen Jialing, Luo Buzhen, and Xu Siji. In 1977, Chen Juyuan, Guo Runlin, and Qu Shunfa organized the influential *Watercolor Exhibition* at the Xuhui District Cultural Center. He wrote the manifestos for three major exhibitions of the period: the *Watercolor Exhibition*, the *Twelve-Man Painting Exhibition*, and the Caocao exhibition. All three shows overtly challenged the standards of the Cultural Revolution, which required political subject matter. These were painters who had developed their art primarily in the Shanghai underground after 1949. One important aspect of their approach in 1979 was simply to look back to the development of art that was interrupted in the 1940s. The works of reformist ink painters of those pre-Liberation days—such as Liu Haisu, who believed that Vincent Van Gogh shared the spirit of seventeenth-century ink painter Shitao, and Lin Fengmian, who sought to implement the spiritual principles of 1920s modernism with ink and gouache—were inspiring to the younger artists.

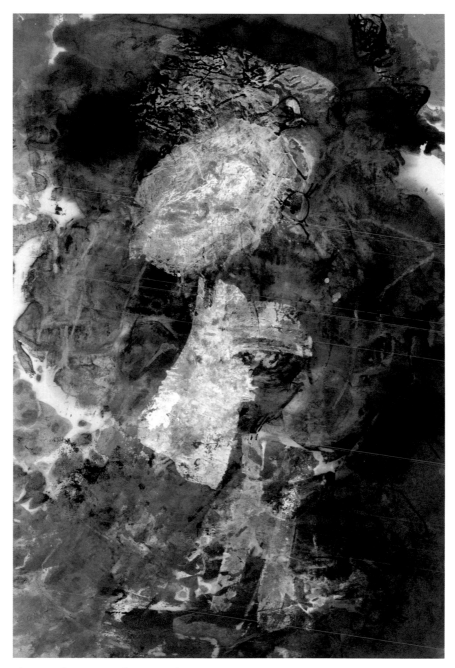

Plate 71. Chen Juyuan (b. 1939), *Abstract Expression I*, 1975.
Ink and watercolor on paper; 92 x 66 cm (unframed).
Collection of the artist

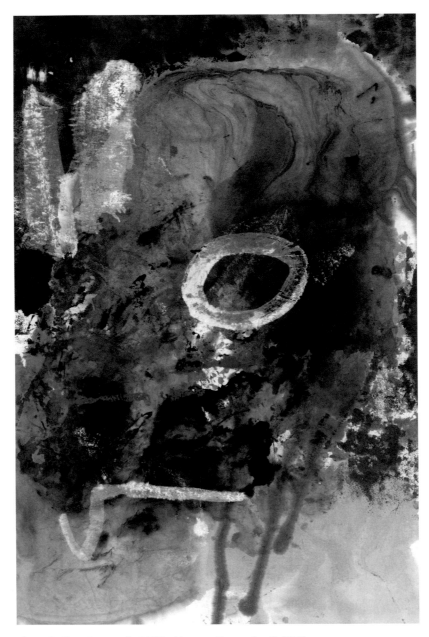

Plate 72. Chen Juyuan (b. 1939), *Abstract Expression II*, 1975.
Ink and watercolor on paper; 92 x 66 cm (unframed).
Collection of the artist

Notes

1. For an excellent overview of the Cultural Revolution, see Roderick MacFarquhar and Michael Schoenhals, *Mao's Last Revolution* (Cambridge, MA: Harvard University Press, 2008).

2. Qu Leilei, *A Visual Diary by Qu Leilei* (London: L.L. Books, 1996), p. 53.

3. Wang Aihe, "The Silk Tree" / "Hehuanshu," in *Wuming (No Name) Painting Catalogue*, ed. Wang Aihe, vol. 7, *Wang Aihe* (Hong Kong: Hong Kong University Press, 2009), p.15.

4. Wei Hai, "Art and Life" / "Yishu yu shengming," in *Wuming (No Name)*, vol. 8, *Wei Hai*, pp. 12, 15.

5. Katie de Tilley, "Wang Keping—The Wood Master," in *Wang Keping* (Hong Kong: Vibrant Life, 2008), p. 64.

6. Wang Aihe, "Wuming: Art and Solidarity in a Peculiar Historical Context" / "Wuming: teshu lishi tiaojianxia de yishu he tuanti," in *Wuming (No Name)*, vol. 7, p. 7.

7. Ibid., p. 7.

8. Among institutional collections in which Red Guard art may be found, see those of the International Institute of Social History, Amsterdam (http://chineseposters.net/index.php); the Chinese Poster Collection of the University of Westminster, London (http://chinaposters .westminster.ac.uk/zenphoto/); and the Ann Tompkins (Tang Fandi) and Lincoln Cushing Chinese Poster Collection, East Asian Library, U.C. Berkeley (http://www.docspopuli.org /ChinaPosters.html).

9. Mao Zedong's "Talks at the Yan'an Forum" was delivered in May of 1942. For a translation and discussion of the text, see Bonnie S. McDougall, *Mao Zedong's "Talks at the Yan'an Conference on Literature and Art": A Translation of the 1943 Text with Commentary*, Michigan Papers in Chinese Studies, no. 39 (Ann Arbor: University of Michigan Center for Chinese Studies, 1980). Mao's purpose at the forum, in which he declared art subordinate to revolutionary politics, was to mandate that artists be completely loyal to the party and that their art support it. Works selected for the 1972 exhibition also emphasized Mao's call for artists to become one with the workers, peasants, and soldiers.

10. For example, see Joan Lebold Cohen and Jerome Alan Cohen, *China Today and Its Ancient Treasures* (New York, Abrams, 1974).

11. These examples are not entirely hypothetical. See works by Tang Muli and Shen Jiawei in Julia F. Andrews, *Painters and Politics in the People's Republic of China* (Berkeley and Los Angeles: University of California Press, 1994), pp. 356 and 365.

12. After the arrest of the Gang of Four, Hua became simultaneously Chairman of the People's Republic of China, Chairman of the Communist Party, Chairman of the Central Military Committee, and Premier, a concentration of top official titles in civilian, party, and military administration that even Mao had never openly claimed.

13. The *liangge fanshi* (two whatevers) was published in "Xuehao wenjian zhuazhugang," an editorial appearing simultaneously in *Renmin ribao* [People's Daily], *Hongqi* [Red Flag], and *Jiefangjun bao* [Liberation Army Gazette] on Feb. 7, 1977.

14. This early period of Jiang Feng's career is briefly discussed in Andrews, *Painters and Politics*, pp. 12-28.

15. This excellent definition of the Yan'an rectification campaign by Yu Maochun, who characterizes it as "relentless," is found in *Encyclopedia of Modern China*, ed. David Pong (Detroit: Gale/Cengage, 2009), vol. 4, p. 123.

16. Wu Guanzhong, "Huihua de xingshi mei" [On the beauty of form in painting], in *Meishu* [Art] 1979.5: 33-35, 44. For some translated excerpts, see Wu Hung, ed., *Contemporary Chinese Art: Primary Documents* (New York: Museum of Modern Art, 2010), pp. 14-17.

17. Private experiments were certainly taking place, but the most outspoken of the experimenters, Yuan Yunsheng, was later advised by Jiang Feng not to show his large abstract canvases to his students. Yuan, who was a friend of Qu Leilei's father, had been so enthusiastic about the Stars outdoor exhibition that he dispatched his student Zeng Xiaojun to deliver two cartons of cigarettes to the artists as a show of support. See "Yuan Yunsheng fangtan" [Interview with Yuan Yunsheng], in Zhu Zhu, ed., *Yuandian* [Origin point] (Hong Kong: Shijie yishu chubanshe, 2007), p. 195.

18. We are very grateful to the members of the Wuming group for spending time to talk with us *en masse* and individually between 2009 and 2011. The help of Wang Aihe in arranging several group interviews and permitting us access to the pre-publication galleys of the thirteen-volume *Wuming (No Name) Painting Catalogue* was particularly critical, as has been the support of René Balcer and Carolyn Hsu. Zheng Ziyan and Ma Kelu both supplied us with invaluable additional manuscript and photographic material. In addition, for interviews with Ma Kelu, Michael Murray, and Zhang Wei, please see the Asia Art Archive website, "Materials of the Future: Documenting Contemporary Chinese Art from 1980-1990," http://www.china1980s.org/en/interview.aspx.

19. Wang Aihe, "Wuming: Art and Solidarity in a Peculiar Historical Context," in *Wuming (No Name)*, vol. 1, *Du Xia*, p. 9. This is the editor's preface that appears in every volume of *Wuming (No Name) Painting Catalogue*, ed. Wang Aihe, 13 vols. (Hong Kong: Hong Kong University Press, 2009).

20. Zhao Wenliang describes it as the Xihua Art Tutorial, which was run by a pair of sisters, Xiong Xianping and Xiong Xianling. According to Zhao's autobiography, the school was established by Madam Tang Shouyi, who had studied in Japan, and inherited by her two daughters. See his "Self-statement" / "Zishu," in *Wuming (No Name)*, vol. 11, *Zhao Wenliang*, p. 15. Shi Zhenyu's autobiography refers to a youth art tutorial at Guozijian (*Guozijian de qingnian buxi xuexiao*). Shi Zhenyu, "Artist Biography," in *Wuming (No Name)*, vol. 5, *Shi Zhenyu*, p. 4.

21. Shi Zhenyu, "Reminiscence" / "Wangshi," in *Wuming (No Name)*, vol. 5, *Shi Zhenyu*, p. 15.

22. No documentary evidence has surfaced to resolve the substantial controversy about the date of the exhibition. That it was at the New Year holiday is generally agreed, but memories of participants differ about whether it was Dec. 31, 1973, or, following the opinion of Zhao Wenliang, a year later, either December 31, 1974, or January 1, 1975. In deference to their senior member, Wuming publications have either adopted the later date or left the chronology intentionally murky. In any case, all agree on the event's great significance to the group.

23. The participants included Zhao Wenliang, Zhang Wei, Bao Le'an, Yang Yushi, Shi Zhenyu, Tian Yu, Kang Wanhua, Zhang Da'an, Zheng Ziyan, Wei Hai, Ma Kelu, Li Shan, Wang Aihe, and Shi Xixi. Gao Minglu, ed., *"Wuming": Yige beiju qianwei de lishi / The No Name: A History of a Self-exiled Avant-garde* (Guilin: Guangxi shifan daxue chubanshe, 2007), p. 271.

24. Wei Hai, "Yishu yu shengming," in *Wuming (No Name)*, vol. 8, *Wei Hai*, p. 11, slightly modified from translation, "Art and Life," p. 14. We have translated the term *Zhongguo tu youhua* as "provincial Chinese oil painting." *Tu*, the key word in the term, literally means "soil" and figuratively means "local" or "native." It can be positive, as in *tuchan* (local products), or negative, as in *tu baozi* (country bumpkin). When applied to oil painting, it generally takes the negative meaning, indicating Chinese artists ignorant of cosmopolitan standards of quality. In translating it as "provincial," we take the term figuratively to mean unfashionable, unsophisticated, limited in perspective, narrow and self-centered, as in the entry in *The American Heritage Dictionary of the English Language*, 3rd ed. (Boston: Houghton Mifflin Company, 1992), p. 1459, and when modified by "Chinese" to mean compatriots who were ignorant of the outside world.

25. Wang Aihe, "Wuming: Art and Solidarity," in *Wuming (No Name)*, vol. 7, p. 9.

26. The thirteen were Zhang Wei, Li Shan, Wang Aihe, Zheng Ziyan, Liu Shi, Shao Xiaogang, Wei Hai, Shi Xixi, Ma Kelu, Zhao Rugang, Zhao Wenliang, Yang Yushu, and Shi Zhenyu.

27. Wang Aihe, "Wuming: Art and Solidarity," in *Wuming (No Name)*, vol. 7, p. 9.

28. Jiang Feng's 1979 "Preface to New Spring Exhibition," as translated by Jane DeBevoise, "Seismic States: The Changing System of Support for Contemporary Art in China, 1978-1993" (PhD diss., The University of Hong Kong, 2008), p. 22.

29. Zhao Wenliang, "Dui yijiu qijiunian Wuming huazhan de huiyi" [Memoir of 1979 No Name exhibition], in *"Wuming": Yige beiju qianwei de lishi*, ed. Gao Minglu, pp. 196 and 197. A number of older artists, including Zhang Da'an, Tian Yu, Zhao Rugang, Hong Mai'en, Liu Youfei, Yang Yuehua, Cao Xiaomei, Shao Xiaogang, and Zhao Rugang, also showed in the side halls.

30. Participants identified in photographs of the exhibition, supplemented by those listed in "Chronology of the No Name Group's Activities," include Zhao Wenliang, Yang Yushu, Shi Zhenyu, Zhang Da'an, Tian Yu, Zhang Wei, Li Shan, Cao Shaomei, Wang Aihe, Ma Kelu, Shao Xiaogang, Liu Shi, Zheng Ziyan, Wei Hai, Zheng Zigang, Shi Xixi, Tian Shuying, Bu Maohua, Ma Jiangang, Wang Zhiping, Hong Mai'en, Liu Youfei, Zhao Rugang, and Yang Yuehua. See Gao Minglu, *"Wuming": Yige beiju qianwei de lishi*, pp. 277-80.

31. The second exhibition opened on July 7, 1981, and participants included the four old comrades, Zhao Wenliang, Yang Yushu, Shi Zhenyu, and Zhang Da'an, along with the younger artists Wei Hai, Wang Aihe, Ma Kelu, Zheng Ziyan, Zheng Zigang, Liu Shi, Tian Shuying, Shao Xiaogang, and other older artists. Zhang Wei and Li Shan did not participate.

32. See Gao Minglu, *"Wuming": Yige beiju qianwei de lishi*, p. 283.

33. Ibid. It should be noted, however, that an earlier scholarly recognition of the Wuming's role appeared in Li Xianting's 1993 survey of recent trends in Chinese art, which includes paintings by Zhao Wenliang and Yang Yushu; see Li, "Illustrated Notes to Major Trends in the Development of Contemporary Chinese Art," in *China's New Art: Post-1989, with a Retrospective from 1979-1989* (Hong Kong: Hanart TZ Gallery, 1993), pp. LXXVI and XC.

34. This narrative may be found in Gao Minglu, ed., *Inside Out: New Chinese Art* (New York: Asia Society; Berkeley: University of California Press, 1998), esp. pp. 20-22 and 197-98. It is also reflected in Julia F. Andrews and Minglu Gao,

Fragmented Memory: The Chinese Avant-garde in Exile (Columbus: Wexner Center for the Arts, 1993), and some other English language writings on contemporary Chinese art. In his most recent writing, Gao Minglu has revised this version of the development of modern Chinese art to include the role of the Wuming, stating: "Without the presence of underground art from this period, the narrative of the art history of the Cultural Revolution would be incomplete. But the No Name has also been an important phenomenon in the history of modernity and the avant-garde in China in the twentieth and early twenty-first century." Gao Minglu, "No Name Group: Contemporary Recluses—the Bo Yi's and Shu Qi's of the Cultural Revolution," in Melissa Chiu and Shengtian Zheng, eds., *Art and China's Revolution* (New York: Asia Society, 2008), p. 182.

35. Julia F. Andrews, "White Cat, Black Cat: Chinese Art and the Politics of Deng Xiaoping," in Kuiyi Shen et al., *Word and Meaning: Six Contemporary Chinese Artists* (Buffalo: State University of New York at Buffalo, Research Center in Art + Culture, 2000), pp. 19-29.

36. Shi Zhenyu, "Reminiscence," in *Wuming (No Name)*, vol. 5, *Shi Zhenyu*, pp. 14-16.

37. Ma Kelu, "Wuming niandai" [Years of the No Name], in Gao Minglu, *"Wuming": Yige beiju qianwei de lishi*, p. 219.

38. Zhang Wei, "An Extraordinary Journey: From Courtyard House to Supreme Court" / "Cong siheyuan dao zuigao fayuan," in *Wuming (No Name)*, vol. 10, *Zhang Wei*, pp. 15-19.

39. The other artists were Ai Weiwei, Li Shuang, Ma Desheng, Xing Fei, Yan Li, Yang Yiping, Yin Guanzhong, Zhao Gang, and Zhu Jinshi. See *Avant-garde Chinese Art, Beijing/New York* (New York: City Gallery; Poughkeepsie: Vassar College Art Gallery, 1986), with an essay by Michael Murray.

40. Li Shan, "Painting is Part of the Beautiful Life" / "Huihua shi meihao shenghuo de yi bufen," in *Wuming (No Name)*, vol. 2, *Li Shan*, pp.13-15.

41. Ma Kelu, "Self-statement" / "Zixu," in *Wuming (No Name)*, vol. 4, *Ma Kelu*, p. 14, and "Wuming niandai," pp. 223-28.

42. Ma Kelu, "Self-statement," with slight modifications to translation done by Lee Ambrozy and edited by René Balcer, p. 14.

43. Zheng Ziyan, "Paint to Follow the Heart" / "Xun neixin er hua," in *Wuming (No Name)*, vol. 13, *Zheng Ziyan*, pp. 14-16.

44. Ibid., p. 14.

45. According to Zheng Zigang, the reason was its "*haipai*" (Shanghai) quality, which refers, negatively, to a looseness and spontaneity of execution. It might not be an overreading of this comment to see it as evoking traces of his father's instruction, the father who had studied at Shanghai Art Academy. Zheng Zigang, "Self-statement" / "Zishu," in *Wuming (No Name)*, vol. 12, *Zheng Zigang*, p. 14.

46. Ibid., pp. 13-15.

47. Wei Hai, "Art and Life," in *Wuming (No Name)*, vol. 8, pp. 14-16.

48. Ibid., p. 14.

49. Ibid., p. 15.

50. Paraphrase of Wei Hai's "Art and Life," in *Wuming (No Name)*, vol. 8, p. 15.

51. Wang Aihe, "The Silk Tree," in *Wuming (No Name)*, vol. 7, pp. 15-20.

52. Liu Shi, "The Budding Season: In Memory of the Days of the Wuming Group" / "Nianhua shijie— ji 'wuming huahui' de neixienian," in *Wuming (No Name)*, vol. 3, *Liu Shi*, pp. 17-24.

53. Ibid., p. 18.

54. Ibid., p. 18.

55. Tian Shuying, "Self-statement" / "Zishu," in *Wuming (No Name)*, vol. 6, *Tian Shuying*, pp. 13-15.

56. Du Xia, "Self-statement" / "Zishu," in *Wuming (No Name)*, vol. 1, *Du Xia*, pp. 15-18.

57. For an example of his later work, see Julia F. Andrews and Kuyi Shen, *A Century in Crisis: Modernity and Tradition in the Art of Twentieth-Century China* (New York, Guggenheim Museum, 1998), no. 170.

58. We are very grateful to the artists of the Xingxing group for their time with us in repeated interviews and phone conversations between 2009 and 2011. We thank Huang Rui, Qu Leilei, Wang Keping, and especially Yan Li for providing us with invaluable publications. Joan Lebold Cohen and Ethan Cohen have both very kindly provided us repeated access to their archives and collections. Interviews with Wang Keping and Huang Rui may also be found on the Asia Art Archive website, "Materials of the Future."

59. Exhibition of Beijing Artworks to Celebrate the Thirtieth Anniversary of the Founding of the Peoples Republic of China, Chinese National Art Gallery (now NAMOC), October 1-31, 1979, sponsored by the Beijing Municipal Cultural Bureau, Municipal Labor Union, and Preparatory Committee of the Beijing Municipal Artists Association. See *Zhongguo meishu nianjian, 1949-1989*, ed. Chinese National Art Gallery (Guilin: Guangxi meishu chubanshe, 1993), p. 1032.

60. Citing Duoduo, Maghiel van Crevel in *Language Shattered: Contemporary Chinese Poetry and Duoduo* (Leiden: Research School CNWS, 1996), p. 32 n33, notes that the winter of 1969/70 saw the circulation of a great many such books and manuscripts among Beijing youth.

61. This reversal took place at the Third Plenary Session of the 11th CCP Congress. See Bérénice Angremy with Huang Rui, "Wind and Thunder, Characteristics of Early Works," in *Huang Rui: The Stars' Times, 1977-1984*, ed. Huang Rui (Beijing: The Thinking Hands + Guan Yi Contemporary Art Archive, 2007), p. 17. For a brief overview of the Democracy Wall movement, see Merle Goldman, "The Twentieth Anniversary of the Democracy Wall Movement," *Harvard Asia Quarterly* (Summer 1999), accessed May 21, 2011, http://www.worldlymind.org/demmerl.pdf.

62. Lü Peng, "Huang Rui in the Context of the 'Stars,'" in *Huang Rui: The Stars' Times*, p. 36.

63. The contributions of the visual artists may be examined in a three-part set of publications issued by the Today Literature Association on the thirtieth anniversary of the magazine in 2008: a boxed facsimile of all 12 mimeographed issues; *Today 30 / Jintian sanshinian*, ed. Xu Xiao (Beijing: Jintian wenxue zazhishe, 2008), a book of interviews, photos, illustrations, and various documentary materials; and *Commemorating the thirtieth anniversary of the founding of Jintian / Jinian "Jintian" wenxueshe chuangkan sanshi zhounian*, ed. E Fuming (Beijing: Jintian wenxue zazhishe, 2008), in which the texts of the magazines are transcribed and published in typeset format. No issues of *Jintian congkan*, the supplementary literary series, are reprinted, although some drawings by Qu Leilei and Zhong Acheng appear in *Today 30*. It is reported, however, that most copies of this publication set were seized and destroyed for failure to properly register it with the authorities.

64. Maghiel van Crevel, *Language Shattered*, p. 65. Based on his research on poetry of the period, particularly the careers of the poetry reading organizers Bei Dao and Mang Ke, van Crevel links the dates of the *Today* poetry readings to the fate of democracy activist Wei Jingsheng, who was arrested in late March, 1979, just a few weeks before the first reading and sentenced in October, shortly before the second reading. However, in the memory of one participant, Wang Keping, who was not associated with the *Today* group at this time, Wei Jingsheng and the poetry readings are not connected. Interview with Kuiyi Shen, Hong Kong, May 24, 2011. *Today* published its special issue on poetry (no. 3) on April 1, a week before the event. Xu Xiao, *Today 30*, p. 227.

65. Title page of Chang Tsong-zung, ed., *The Stars: Ten Years / Xingxing shinian* (Hong Kong: Hanart TZ Gallery, 1989); translation by Don Cohn.

66. From a talk given by Huang Rui in 2006. See Lü Peng, "Huang Rui in the Context of the 'Stars,'" p. 36. Also, Zhong Acheng recalled that Huang Rui came up with the name Xingxing, "Star-Star," during the meeting to initiate the exhibition, a meeting which was held in the editorial offices of *Today* in the spring. See Zhong Acheng, "Stars and sparks and flickers and flutters" / "Xingxing diandian," in Chang Tsong-zung, *The Stars: Ten Years*, p. 16. Huang and Ma Desheng have a consistent understanding of its meaning—countless tiny stars in opposition to the Maoist sun. Andrews, citing *Mao Zedong xuanji* [The collected works of Mao Zedong], vol. 1 (Beijing: n. p., 1952), pp. 101–111, suggested in *Painters and Politics* that it may have been a "naughty reference to a 1930 article by Mao Zedong that was often quoted during the Cultural Revolution: 'A tiny spark [*xingxing zhi huo*] can set the steppes ablaze,'" p. 396. In any case, it well captured the views of the organizers that art and life should be characterized by infinite diversity.

67. Wang Keping, "Xingxing wangshi" [Memoirs of the Stars exhibition], in Zhu Zhu, *Yuandian*, p. 217. Also, see the English version in *Wang Keping*, pp. 9–48.

68. Yu Feng was reportedly the person most active in providing this help.

69. In the article, Huang Rui's painting is titled *Portrait of a Girl*, and the sculpture, *Silenced*. *New York Times*, October 20, 1979, http://query.nytimes.com/mem/archive/pdf?res=F7081FF73D5C12728DDDA90A94D8415B898BF1D3.

70. *China Reconstructs* 29, no. 6 (June 1980): 54.

71. Huang Rui, in *Huang Rui: The Star's Times*, has listed as many as 32 members in the Xingxing group, adding: Xiao Dayuan, Zhou Maiyou, He Baosen, Zhang Shiqi, Gan Shaocheng, Guan Naixin, Li Yongqi, Zhao Dalu, Wang Luyan, Bao Pao, Song Hong, Chen Yansheng, Zhang Zhizhong, Liu Dazhuan, Cao Liwei, Wang Jianzhong, and Zheng Zhenting to the core list. In addition, Qu Leilei mentions Wuming artist Ma Kelu as participating in the Stars as well. Yin Guangzhong came from a group known as Five Young Painters from Guiyang, which first exhibited on Democracy Wall.

72. *Wang Keping*, p. 46.

73. Lü Peng, "Huang Rui in the Context of the 'Stars.'"

74. "Past Events and Present Existence: Gao Minglu and Huang Rui's Dialogue," in *Huang Rui: Stars' Times*, p. 53.

75. Ibid., p. 54.

76. Huguosi means "Temple to Protect the Kingdom."

77. Van Crevel notes the frequent gatherings of young Beijing poets in their family homes when they were supposed to be laboring in the countryside.

78. Guo later spent eighteen years in a mental institution.

79. This would have required having some connections in the period before China had begun to open up.

80. This work, which had been reproduced in *New Observer*, was subsequently lost during an exhibition in France.

81. Guan Yi and Huang Rui, "Mountains and Lakes, the Mutual Testimony of Discovery and Excavation," in *Huang Rui: The Stars Times*, p. 25.

82. Wang Keping recounts that he found the wood when helping his friend Bai Jingzhou build his kitchen.

83. Translated by Don Cohn, in Chang Tsong-zung, *The Stars: Ten Years*, p. 17.

84. This work was recently published under the title *Tattooed Woman* in *Wang Keping*, p. 70.

85. Fox Butterfield's *China: Alive in the Bitter Sea* (New York: Times Books, 1982), for example, has a chapter about his conversations with Wang Keping.

86. Andrews' brief account of the Xingxing in *Painters and Politics in the People's Republic of China*, pp. 397-99, is largely based on a 1986 interview with Wang. Excerpts from Wang Keping's diary, one of the most thorough (and entertaining) accounts ever written, was first published in 1989 in Chang Tsong-zung, *The Stars: Ten Years*, pp. 21-34, with a partial translation by Don Cohn. Wang supplemented the essay slightly in 2008 based on new information and has published it in several books and multiple languages. See the most recent trilingual version in *Wang Keping* (Hong Kong: Vibrant Life, 2008): "Memoirs of the Stars Exhibition," pp. 9-48; "Mémoires des Etoiles," pp. 274-304; and "Xingxing wangshi," pp. 329-42. Also in Zhu Zhu, *Yuandian*, pp. 216-30. It has served as raw material for almost every other recent account. Li Shuang has characterized Wang Keping as the group's "Minister of Foreign Affairs."

87. Later employed by the China Book Import and Export Company.

88. For a published interview with Yan Li by Michael Standaert (2004), see *Modern Chinese Literature and Culture Resource Center*, accessed May 1, 2011, http://mclc.osu.edu/rc/pubs/yan_li.htm.

89. This section is based on an essay by Yan Li, "Zixu: Lishi de suoying" [Author's preface: A compressed history], in *Shiwu shi tamen ziji de xiangzheng: Yan Li de chuangzuo yiji ta de pengyoumen* [Things are symbols of themselves: Yan Li's creative work and his friends], ed. Norman Spencer (Tehran: Ostoore Publications, 2005).

90. Among his many later accomplishments, Chi was lead cinematographer for Zhang Yimou's film, *The Story of Qiu Ju*, and for a sensationally popular TV series on the Yongzheng emperor.

91. *Encyclopædia Britannica Online*, s.v. "Ai Qing," accessed May 28, 2011, http://www.britannica.com/EBchecked/topic/10366/Ai-Qing.

92. We would like to thank the artists of the Caocao group for granting us interviews and answering our questions by telephone between 2009 and 2011. Qiu Deshu has been particularly generous and helpful in coordinating our meetings with his colleagues. Joan Lebold Cohen, Jane DeBevoise, and Michael Micketti have helped us locate the artists' early works. Please also see the Asia Art Archive, "Materials of the Future" website, for interviews with Joan Lebold Cohen and Ethan Cohen.

93. Exhibition flyer, 1980, lent by Qiu Deshu.

94. Tang Muli (b. 1948), the son of famous film director Tang Xiaodan, was then a graduate student at the Central Academy of Fine Arts.

95. Liu Haisu's private school of similar name had been disbanded some years earlier.

ARTISTS IN THE EXHIBITION

Ai Weiwei 艾未未 94-96; pls. 56-59

Chen Jialing 陈家泠 108-110; pls. 65-67

Chen Juyuan 陈巨源 114-16; pls. 71-72

Du Xia 杜霞 56-58; pls. 32-34

Huang Rui 黄锐 70-74; pls. 35-38

Jiang Depu 姜德溥 111-13; pls. 68-70

Li Shan 李珊 33-35; pls. 7-9

Li Shuang 李爽 88-93; pls. 52-55

Liu Shi 刘是 51-53; pls. 26-28

Ma Desheng 马德升 75-77; pls. 39-43

Ma Kelu 马可鲁 36-38; pls. 10-12

Qiu Deshu 仇德树 104-107; pls. 60-64

*Qu Leilei 曲磊磊 83-84; (figs. 9 & 10)

Shi Zhenyu 石振宇 26-28; pls. 1-3

Tian Shuying 田淑英 54-55; pls. 29-31

Wang Aihe 王爱和 48-50; pls. 23-25

Wang Keping 王克平 78-82; pls. 44-47

Wei Hai 韦海 44-48; pls. 19-22

Yan Li 严力 85-88; pls. 48-51

Zhang Wei 张伟 29-32; pls. 4-6

Zheng Zigang 郑子钢 42-43; pls. 16-18

Zheng Ziyan 郑子燕 39-41; pls. 13-15

*illustrated in the catalogue but not exhibited

EXHIBITION CHECKLIST

Wuming (No Name) Group

Shi Zhenyu 石振宇 (b. 1946)

1. *Yuyuantan Landscape* / 玉渊潭风景, 1965. Oil on paperboard; 15 x 20 cm (unframed), 40 x 50 cm (framed). Collection of the artist
2. *Qingdao* / 青岛, 1973. Oil on paperboard; 22 x 34 cm (unframed), 50 x 60 cm (framed). Collection of the artist
3. *Outside the Office Window* / 办公室窗外, 1976. Oil on paperboard; 13 x 26 cm (unframed), 45 x 55 cm (framed). Collection of the artist

Zhang Wei 张伟 (b. 1952)

4. *Temple of Heaven 1* / 天坛 1, 1976. Oil on paperboard; 20.5 x 25 cm (unframed), 42 x 51.5 cm (framed). Collection of the artist
5. *The Hall of Supreme Harmony* / 太和殿, 1976. Oil on paperboard; 18.7 x 25.6 cm (framed). Collection of Carolyn Hsu-Balcer and René Balcer
6. *White Pagoda* / 白塔, 1976. Oil on paperboard; 30.5 x 26.5 cm (framed). Collection of Carolyn Hsu-Balcer and René Balcer

Li Shan 李珊 (b. 1957)

7. *In the Rain* / 雨中, 1974–78. Oil on paperboard; 28 x 20.2 cm (unframed), 55 x 48 cm (framed). Collection of the artist
8. *Untitled* / 无题, 1974–78. Oil on paperboard; 19 x 18 cm (unframed), 50 x 50 cm (framed). Collection of the artist
9. *Dormitory* / 宿舍, 1976. Oil on paperboard; 19.5 x 27 cm (unframed), 55 x 48 cm (framed). Collection of the artist

Ma Kelu 马可鲁 (b. 1954)

10. *Snow at Wumen Gate* / 午門的雪, 1974. Oil on paperboard; 19.5 x 26 cm (framed). Collection of Carolyn Hsu-Balcer and René Balcer
11. *Chrysanthemum and Blue Pot* / 蓝壶菊花, 1974. Oil on paperboard; 39 x 31 cm (unframed). Collection of the artist
12. *Yinding Bridge* / 银锭桥, 1980. Oil on paperboard; 31 x 41 cm (unframed). Collection of the artist

Zheng Ziyan 郑子燕 (b. 1951)

13. *Winter View from Fusuijing Building* / 从福绥境大楼看到的冬景, 1976. Oil on paperboard; 30 x 38 cm (unframed), 50 x 63 cm (framed). Collection of the artist
14. *Fragrance of Locust Tree Flowers in Beijing* / 京城槐花香, 1977. Oil on paperboard; 25.5 x 35 cm (framed). Collection of the artist
15. *Autumn in the Great Northern Wilderness* / 北大荒的秋天, 1979. Oil on paperboard; 30.8 x 37.8 cm (framed). Collection of the artist

Zheng Zigang 郑子钢 (b. 1953)

16. *Sunset over the Farm Dormitory* / 场区夕阳, 1973. Oil on paperboard; 19.7 x 26.7 cm (framed). Collection of Carolyn Hsu-Balcer and René Balcer
17. *Clean Winter* / 净冬, 1974. Oil on paperboard; 19.7 x 27.5 cm (unframed), 56 x 50 cm (framed). Collection of the artist
18. *Golden Great Northern Wilderness* / 金色的北大荒, 1978. Oil on paperboard; 50 x 58 cm (unframed), 54 x 63 cm (framed). Collection of the artist

Wei Hai 韦海 (1952–2010)

19. *Small Red Bridge* / 小红桥, 1975. Oil on paperboard; 27.8 x 19.8 cm (framed). Collection of Carolyn Hsu-Balcer and René Balcer
20. *Red Lips* / 红嘴唇, 1976. Oil on paperboard; 56 x 40 cm (unframed), 85 x 68 cm (framed). Collection of the artist's estate
21. *Snow at Shishahai* / 什刹海冬雪, 1978. Oil on paperboard; 27 x 39 cm (unframed), 57 x 49 cm (framed). Collection of the artist's estate
22. *Golden Path* / 金色暖道, 1975–77. Oil on paperboard; 39 x 26.8 cm (unframed), 55 x 42 cm (framed). Collection of the artist's estate

Wang Aihe 王爱和 (b. 1953)

23. *Home* / 家, 1973. Oil on paperboard; 19.6 x 27 cm (unframed). Collection of the artist

24. *Moonlight Night* / 月夜, 1974. Oil on paperboard; 23.7 x 19.6 cm (unframed). Collection of the artist
25. *Yard* / 家院, 1974–75. Oil on paperboard; 27.1 x 17.7 cm (unframed). Collection of the artist

Liu Shi 刘是 (b. 1955)

26. *Hope* / 希望, 1975–76. Oil on cardboard; 12.7 x 17.8 cm (unframed), 60.5 x 70.5 cm (framed). Collection of the artist
27. *Grandfather* / 祖父, 1978. Oil on canvas; 73 x 50 cm (unframed), 89.8 x 67.8 cm (framed). Collection of Na-Loretta Law
28. *Small Hills* / 小山, 1975–76. Oil on paperboard; 16 x 26 cm (framed). Collection of Carolyn Hsu-Balcer and René Balcer

Tian Shuying 田淑英 (b. 1955)

29. *Two White Crabapples in Blossom* / 两棵白海棠, 1977–78. Oil on paper; 28.5 x 31.2 cm (unframed). Collection of the artist
30. *Greenhouse* / 花房, 1977. Oil on paperboard; 19.5 x 26.7 cm (unframed). Collection of the artist
31. *Temple of Heaven* / 天坛, 1979–80. Oil on paper; 27 x 20 cm (unframed). Collection of the artist

Du Xia 杜霞 (b. 1951)

32. *Snow-Capped Terrace Field* / 白雪盖山田, 1985. Oil on paper; 17.8 x 25.7 cm (unframed), 56 x 63 cm (framed). Collection of the artist
33. *Red Autumn Leaves* / 一束红叶, 1973. Oil on paper; 20.8 x 26.8 cm (unframed), 60 x 65 cm (framed). Collection of the artist
34. *Winter Outside the Window* / 窗外是冬, 1975. Oil on paper; 25.7 x 18.2 cm (unframed), 64 x 56 cm (framed). Collection of the artist

The Xingxing (Stars) Group

Huang Rui 黄锐 (b. 1952)

35. *Forbidden City* / 故宫内宫, 1979. Oil on canvas; 69 x 79 cm (unframed), 74.8 x 84.7 cm (framed). Collection of the artist
36. *Childhood Memory* / 童年的记忆, 1981. Oil on canvas; 89.5 x 78.5 cm (unframed), 110 x 100 cm (framed). Collection of Cees Hendriske
37. *Door, Girl, Plant* / 门前, 1981. Oil on canvas; 90 x 76 cm (unframed). Collection of the artist
38. *Overlook* / 远望, 1981. Oil on canvas; 78.5 x 99 cm (unframed), 84.8 x 104.6 cm (framed). Collection of the artist

Ma Desheng 马德升 (b. 1952)

39. *The People's Cry* / 人民的呼声, 1979. Woodblock print; 17 x 14 cm (unframed), 39 x 34.5 cm (framed). Collection of the artist
40. *Untitled* / 无题, 1980. Woodblock print; 34 x 52 cm (unframed), 55 x 63.5 cm (framed). Collection of the artist
41. *Untitled* / 无题, 1980. Woodblock print; 34.5 x 43 cm (unframed), 55 x 73 cm (framed). Collection of the artist
42. *Mountain Landscape* / 山景, 1983. Ink on paper; 62 x 90 cm (framed). Collection of Joan Lebold Cohen and Jerome A. Cohen
43. *Dancing Woman* / 跳舞的女人, 1983. Ink on paper; 81 x 62 cm (framed). Collection of Fred Gordon

Wang Keping 王克平 (b. 1949)

44. *Idol* / 偶像, 1979. Wood; 57 x 40 x 15 cm. Collection of the artist
45. *Silent* / 沉默, 1979. Wood; 48 x 24 x 23 cm. Collection of the artist
46. *Torso* / 女人体, 1979. Wood; 38.7 x 16.5 x 10.2 cm. Collection of Joan Lebold Cohen and Jerome A. Cohen
47. *Nose* / 鼻子, 1980. Wood; 22.9 x 12.7 x 15.2 cm. Collection of Joan Lebold Cohen and Jerome A. Cohen

Yan Li 严力 (b. 1954)

48. *Dialogue* /对话, 1980. Oil on canvas; 72 x 40 cm (framed). Collection of the artist

49. *Spying* / 窥视, 1979. Oil on canvas; 53 x 38 cm (framed). Collection of the artist

50. *Untitled* / 无题, 1980. Wood and steel nails; 14 x 18 x 4 cm. Collection of the artist

51. *Records* / 破碎的唱片, 1986. Mixed media; 77.5 x 62.2 cm (framed). Collection of Joan Lebold Cohen and Jerome A. Cohen

Li Shuang 李爽 (b. 1957)

52. *Parting* / 别离, 1980. Woodblock print; 16.5 x 17 cm (unframed). Collection of the artist

53. *A Friend in the Wilderness* / 荒野的知音, 1980. Woodblock print; 14 x 25 cm (unframed). Collection of the artist

54. *Red and Black* / 红与黑, 1979. Oil on canvas; 69 x 54 cm (framed). Collection of the artist

55. *The Light of Hope* / 希望之光, 1980. Oil on canvas; 100 x 70 cm (unframed). Collection of the artist

Ai Weiwei 艾未未 (b. 1957)

56. *Profile of Marcel Duchamp in a Coat Hanger* / 衣架构成的杜尚侧影, 1980s. Wire; 68 x 50.8 cm. Collection of Ethan Cohen

57. *Quintessential Communist Umbrella Brief-case* / 典型的共产党雨伞皮箱, 1980s. Mixed media; 25.4 x 86.4 x 8.3 cm. Collection of Ethan Cohen

58. *Stool* / 凳子, 1997, recreated in 2007. Wood stools (Qing dynasty, 1644-1911); 63 x 65 x 44 cm. Private collection

59. *Drips Going Down - Ai to E* / 滴, 1997. Mixed media;15.2 x 17.3 cm. Collection of Ethan Cohen

Not in the exhibition

Qu Leilei 曲磊磊 (b. 1951)

Mother / 母亲, 1979. Ink on paper, 13 x 18 cm. Private collection (fig. 9)

The Fatherland nos. 1-4 & 7 / 祖国 1-4 & 7, 1980. Ink on paper; 18 x 12 cm, 12 x 18 cm (no. 3). Private collection (fig. 10, a-e)

The Caocao She (Grass Society)

Qiu Deshu 仇德树 (b. 1948)

60. *Empty no. 1* / 空 #1, 1982. Ink on paper; 77.5 x 129.5 cm (framed). Collection of Michael Micketti

61. *3-5 Times Shouting* / 释放, 1980. Ink on paper; 129.5 x 269.2 cm (framed). Collection of Michael Micketti

62. *Transcendence* / 超脱, 1980s. Ink on paper; 77.5 x 68.6 cm (framed). Collection of Michael Micketti

63. *Rhythm of Stream* / 溪的演奏, 1979. Ink and color on paper; 68 x 68.5 cm (unframed). Collection of the artist

64. *Days and Nights* / 日日夜夜, 1980. Ink on paper; 77 x 132 cm (framed). Private collection

Chen Jialing 陈家泠 (b. 1937)

65. *Enjoying Twilight* / 赏霞, 1980. Colored ink on paper; 89.5 x 120.7 cm (framed). Collection of Michael Micketti

66. *White Lotus* / 白荷, 1990. Ink on paper; 119.4 x 200.7 cm (framed). Collection of Michael Micketti

67. *Twilight* / 霞光, 1980. Ink and color on paper; 66 x 91.4 cm (framed). Collection of Joan Lebold Cohen and Jerome A. Cohen

Jiang Depu 姜德溥 (b. 1934)

68. *Black Symphony—Mountain and Moon* / 黑色交响——山月, 1982. Ink on paper; 68 x 68 cm (unframed). Collection of the artist

69. *Black Symphony—Mountain Creek* / 黑色交响——山溪, 1982. Ink on paper; 69 x 68.5 cm (unframed). Collection of the artist

70. *Black Symphony—Mountain Wind* / 黑色交响——山风, 1979. Ink on paper; 59 x 82.5 cm (unframed). Collection of the artist

Chen Juyuan 陈巨源 (b. 1939)

71. *Abstract Expression I* / 抽象表现之一, 1975. Ink and watercolor on paper; 92 x 66 cm (unframed). Collection of the artist

72. *Abstract Expression II* / 抽象表现之二, 1975. Ink and watercolor on paper; 92 x 66 cm (unframed). Collection of the artist

Chinese Characters
for Selected Names and Terms

Ai Qing　艾青

Ai Weiwei　艾未未

Bai Jingzhou　白敬周

Bamiancao　八面槽

Banhua　版画

Bao Le'an　包乐安

Baochansi　宝禅寺

Baozi Hutong　包子胡同

Bei Dao (Zhao Zhenkai)　北岛
　　（赵振开）

Beidaihe　北戴河

Beihai　北海

Beijing zhi chun　北京之春

Biyun　碧云

Cankao xiaoxi　参考消息

Cao Liwei　曹力伟

Cao Xiaomei　曹晓梅

Caocao　草草

Caocao she　草草社

Chang'an　長安

Chaoyangmennei　朝阳门内

Chen Fosheng　陈佛生

Chen Jialing　陈家泠

Chen Juhong　陈巨洪

Chen Junde　陈钧德

Chen Juyuan　陈巨源

Chen Kaige　陈凯歌

Chen Shaoping　陈少平

Chen Yansheng　陈延生

Cheng Conglin　程丛林

Chengdu　成都

Chi Ning　池宁

Chi Xiaoning　池小宁

Chi Xiaoqing　池小青

Dai Dunbang　戴敦邦

Datong　大同

Deng Xiaoping　邓小平

Diaoyutai　钓鱼台

Dongjiaominxiang　东交民巷

Dongmeichang　东煤厂

Dongzhimen　东直门

Du Xia　杜霞

Duo Duo (Li Shizheng)　多多（栗世征）

Fan Mingti　樊明体

Feng Guodong　冯国栋

Feng Yidai　冯亦代

Fujian　福建

Funü zazhi　妇女杂志

Fusuijing　福绥境

Fuxing　复兴

Gan Shaocheng　甘少成

Ganjiakou　甘家口

Gao Lan　高岚

Gao Minglu　高名潞

Gao Xiaohua　高小华

Gao Ying　高英

Gaoliying　高里营

gongbi　工笔

Gu Cheng　顾城

Gu Dexin　顾德新

Guan Liang　关良

Guan Yi　管艺

Guangming ribao　光明日报

Guiyang　贵阳

Guizhou　贵州

Guo Runlin　郭润林

guohua　国画

Han Baiyou　韓柏友

Harbin, Haerbin　哈尔滨

He Baosen　何寶森

He Duoling　何多苓

Hebei　河北

heibanbao　黑板报

Heilongjiang　黑龙江

Hengdong　衡东

hong haiyang　红海洋

Hong Mai'en　洪迈恩

Hong Shiqing　洪世清

Hou Yimin　侯逸民

Houhai　后海

Hu Yaobang　胡耀邦

Hua Guofeng　华国锋

Huafangzhai　画舫斋

Huang Azhong　黃阿忠

Huang Jianzhong　黃建中

Huang Rui　黄锐

Huang Shan　黄山

Huang Xinbo　黄新波

Huang Yongyu　黄永玉

Huang Zhen　黄镇

Huasheng　华胜

Hubei　湖北

Huguosi　护国寺

Hui Wa　灰娃

Hunan　湖南

Jiang Depu　姜德溥

Jiang Feng　江丰

Jiang Qing　江青

Jiaotong　交通

Jingshan　景山

Jintian　今天

Kong Boji　孔伯基

Kun　昆

Kushuitan　枯水潭

Lei Yu　雷雨

Li Hua　李桦

Li Shan (b. 1942)　李山

Li Shan (b. 1957)　李珊

Li Shuang　李爽

Li Xianting　栗宪庭

Li Xiaobin　李小斌

Li Yongcun (Bo Yun)　李永存（薄云）

Li Yongsen　李咏森

lianhuanhua　连环画

Lianhuanhua bao　连环画报

Liaoning　辽宁

lilong　里弄

Lin Biao　林彪

Lin Fengmian　林风眠

Lin Gang　林岗

Linhai xueyuan　林海雪原

Linyi　临猗

Liu Guosong　刘国松

Liu Haisu　刘海粟

Liu Qing　刘青

Liu Shaoqi　刘少奇

Liu Shi　刘是

Liu Xun　刘迅

Liu Youfei　刘又飞

Liubukou　六部口

Lu Kunfeng　庐坤峰

Lu Xun　鲁迅

Lu Yanshao　陆俨少

Lu Yansheng　陆延生
Luo Buzhen　罗步臻
Luo Zhongli　罗中立
Luwan　卢湾
Ma Desheng　马德升
Ma Kelu　马可鲁
Mang Ke (Jiang Shiwei)
　　芒克（姜世伟）
Mao Lizi　毛栗子
Mao Yuanxin　毛远新
Mao Zedong　毛泽东
meigong　美工
Meishu　美术
menglong　朦胧
Nanjing　南京
Nenjiang　嫩江
Ni Yide　倪贻德
Pan Feilun　潘飞仑
Pan Sitong　潘思同
Pan Tianshou　潘天寿
Pang Tao　庞涛
Pang Xunqin　庞薰琹
Peng Gang　彭刚
Pinggu　平谷
Puyi　溥仪
Qi Baishi　齐白石
Qian Juntao　钱君陶
Qian Peichen　钱培琛
Qianmen　前门
Qin Yufen　秦玉芬
Qinghai　青海
Qiqiha'er　齐齐哈尔
Qiu Deshu　仇德树
Qu Bo　曲波
Qu Leilei　曲磊磊
Qu Shunfa　瞿顺发
Ran Xi　冉熙
Renming huabao　人民画报
Sanhao　三好
Shanxi　山西
Shao Dazhen　邵大箴
Shao Fei　邵飞
Shao Xiaogang　邵小刚
Shehuilu　社会路
Shen Chen　沈忱
Shen Tianwan　沈天万
Shi Xixi　史习习
Shi Zhenyu　石振宇
Shifuma　石驸马
Shijie tushu zazhi　世界图书杂志

Shishahai　什刹海
Shitao　石涛
Shizhi (Guo Lusheng)
　　食指（郭路生）
Shouruo de ren　瘦弱的人
Shu Chuanxi　舒传羲
Shuaifuyuan　帅府园
Shunyi　顺义
Sun Dali　孙大力
Tan Wancun　谭万村
Tang Muli　汤沐黎
Tang Pinggang　唐平刚
Tang Yun　唐云
Tian Shuying　田淑英
Tian Yu　田玉
Tian Zhuangzhuang　田壮壮
Tian'anmen　天安门
Tianjin　天津
Tsinghua　清华
Uchiyama Kakichi　内山嘉吉
Wang Aihe　王爱和
Wang Hongwen　王洪文
Wang Jianer　王健尔
Wang Keping　王克平
Wang Luyan　王鲁炎
Wang Zhiping　王志平
Wangfujing　王府井
Wei Hai　韦海
Wei Jiangfan　韦江凡
Wei Jingsheng　魏京生
wengongtuan　文工团
Wotu　沃土
Wu Guanzhong　吴冠中
Wumen　午门
Wuming　无名
Xia Yan　夏衍
Xidan　西单
Xie Yali　谢亚力
Xie Zhiliu　谢稚柳
xieyi　写意
Xihua　熙化
Xingxing　星星
Xinjiang　新疆
Xu Beihong　徐悲鸿
Xu Siji　徐思基
Xu Yinghuai　徐英槐
Xuanwu　宣武
Xuhui　徐汇
Yan Cangshan　严苍山
Yan Li　严力

Yan'an　延安
Yang Yiping　杨益平
Yang Yuehua　杨跃华
Yang Yushu　杨雨澍
Yanle Hutong　燕乐胡同
Yao Wenyuan　姚文元
Ye qiangwei　野蔷薇
Yihang　一行
Yin Guangzhong　尹光中
Ying Yeping　应野平
Ying Zi　英子
Yingding　银锭
Yuan Songmin　袁颂民
Yuan Yunsheng　袁运生
Yuanmingyuan　圆明园
Yuyuantan　玉渊潭
Zeng Mi　曾宓
Zhang Chunqiao　张春桥
Zhang Da'an　张达安
Zhang Daqian　张大千
Zhang Jianjun　张健君
Zhang Wei　张伟
Zhang Yimou　张艺谋
Zhang Zhixin　张志新
Zhang Zhunli　张准利
Zhao Gang　赵刚
Zhao Nan　赵南
Zhao Rugang　赵汝刚
Zhao Wenliang　赵文量
Zao Wou-ki (Zhao Wuji)　赵无极
Zhejiang　浙江
Zheng Yefu　郑野夫
Zheng Zigang　郑子钢
Zheng Ziyan　郑子燕
Zhengda　正大
Zhong Acheng　钟阿城
Zhong Dianfei　钟惦斐
Zhongnanhai　中南海
Zhongshan　中山
Zhou Enlai　周恩来
Zhou Maiyou　周迈游
Zhou Xi　周熙
Zhou Yang　周扬
Zhu Da　朱耷
Zhu De　朱德
Zhu Jingshi　朱金石
Zhu Qizhan　朱屺瞻
Zhu Ying　朱膺
Zhu Yinlin　朱垠嶙
Zizhuyuan　紫竹院

BIBLIOGRAPHY

Andrews, Julia F. *Painters and Politics in the People's Republic of China*. Berkeley and Los Angeles: University of California Press, 1994.

_____. "White Cat, Black Cat: Chinese Art and the Politics of Deng Xiaoping." In Kuiyi Shen et al., *Word and Meaning: Six Contemporary Chinese Artists*, pp. 19–29. Buffalo: State University of New York at Buffalo, Research Center in Art + Culture, 2000.

Andrews, Julia F. and Kuiyi Shen. *A Century in Crisis: Modernity and Tradition in the Art of Twentieth-Century China*. New York: Guggenheim Museum, 1998.

Andrews, Julia and Minglu Gao. *Fragmented Memory: The Chinese Avant-garde in Exile*. Columbus: Wexner Center for the Arts, 1993.

Chang Tsong-zung, ed. *The Stars: Ten Years / Xingxing shinian*. Hong Kong, Taipei, New York: Hanart 2, 1989.

Chiu, Melissa and Shengtian Zheng, eds. *Art and China's Revolution*. New York and New Haven: Asia Society and Yale University Press, 2009.

Cohen, Joan Lebold. *The New Chinese Painting: 1949–1986*. New York: Harry N. Abrams, Inc., 1987.

Cohen, Joan Lebold and Jerome Alan Cohen. *China Today and Its Ancient Treasures*. New York, Abrams, 1974.

Crevel, Maghiel van. *Language Shattered: Contemporary Chinese Poetry and Duoduo*. Leiden:Research School CNWS, 1996.

Cushing, Lincoln and Ann Tompkins, eds. *Chinese Posters: Art from the Great Proletarian Cultural Revolution*. San Francisco: Chronicle Books, 2007.

de Tilley, Katie. "Wang Keping—The Wood Master." In *Wang Keping*, pp. 61–72.

DeBevoise, Jane. "Seismic States: The Changing System of Support for Contemporary Art in China, 1978-1993." PhD diss., The University of Hong Kong, 2008.

Demand for Artistic Freedom: Xingxing's Twentieth Anniversary. Tokyo: Tokyo Art Gallery, 2000. Exhibition catalogue.

Du Xia. "Self-statement" / "Zishu." In Wang Aihe, *Wuming (No Name) Painting Catalogue*, vol. 1, trans. Wu Di, Julien De Jaillon, and René Balcer, pp. 11–18.

E Fuming, ed. *Commemorating the thirtieth anniversary of the founding of Jintian / Jinian "Jintian" wenxueshe chuangkan sanshi zhounian*. Beijing: Jintian wenxue zazhishe, 2008.

Gao Minglu, ed. *Inside Out: New Chinese Art*. New York: Asia Society; Berkeley: University of California Press, 1998.

_____. "No Name Group: Contemporary Recluses— the Bo Yi's and Shu Qi's of the Cultural Revolution." In *Art and China's Revolution*, edited by Melissa Chiu and Shengtian Zheng, pp. 179–85.

_____, ed. "*Wuming*": *Yige beiju qianwei de lishi / The No Name: A History of a Self-exiled Avant-garde*. Guilin: Guangxi shifan daxue chubanshe, 2007.

Guan Lan, ed. *25th Anniversary of Cao-Cao Artist Society*. Shanghai: Haishangshan, 2005.

Huang Rui, ed. *Huang Rui: The Stars' Times, 1977–1984*. Hong Kong: Thinking Hands + Guanyi Contemporary Art Archive, 2007.

Huo Shaoxia. *Xingxing yishujia: Zhongguo dangdai yishu de xianfeng 1979-2000* [The Stars artists: Pioneer of contemporary Chinese art 1979–2000]. Taipei: Artist Publishing Co. 2007.

Jintian [*Today*], nos. 1–9 (1979-80). Facsimile editions. Beijing : Jintian wenxue zazhishe, 2008.

Landsberger, Stefan R., Marvin van der Heijden, and Kuiyi Shen. *Chinese Posters: The IISH-Landsberger Collections*. Munich: Prestel, 2009.

Li Shan. "Painting is Part of the Beautiful Life" / "Huihua shi meihao shenghuo de yi bufen." In Wang Aihe, *Wuming (No Name) Painting Catalogue*, vol. 2, trans. Hu Yue and Julien De Jaillon, pp. 11–15.

Liu Shi. "The Budding Season: In Memory of the Days of the *Wuming* Group" / "Nianghua shijie—ji 'wuming huahui' de neixienian." In Wang Aihe, *Wuming (No Name) Painting Catalogue*, vol. 3, trans. Hu Yafei, Deng Xiaorong, Loretta Law, and René Balcer, pp. 11–24.

Ma Kelu. "Self-statement" / "Zixu." In Wang Aihe, *Wuming (No Name) Painting Catalogue,* vol. 2, trans. Lee Ambrozy and René Balcer. pp. 12-15.

_____. "Wuming niandai [xuanzai]" [Years of the No Name (Selection)]. In *"Wuming:" Yige beiju qian-wei de lishi,* edited by Gao Minglu, pp. 207-30.

McDougall, Bonnie S. *Mao Zedong's "Talks at the Yan'an Conference on Literature and Art": A Translation of the 1943 Text with Commentary.* Michigan Papers in Chinese Studies, no. 39. Ann Arbor: University of Michigan Center for Chinese Studies, 1980.

MacFarquhar, Roderick and Michael Schoenhals. *Mao's Last Revolution.* Cambridge, MA: Harvard University Press, 2008.

Murray, Michael. "The Power of Images: An Introduction to the Exhibition." In *Avant-Garde Chinese Art, Beijing/New York,* pp. 5-16. New York: City Gallery, New York; Vassar College Art Gallery, 1986.

"Poèmes et Art en Chine: Les 'Non-officiels.'" Special issue, *DOC(k)S,* nos. 41-45 (Winter 1981/82).

Pong, David, ed. *Encyclopedia of Modern China.* 4 vols. Detroit: Gale/Cengage, 2009.

Post-Mao Dreaming: Chinese Contemporary Art. Northhampton: Smith College Museum of Art, 2009.

Qu Leilei. *A Visual Diary by Qu Leilei.* London: L. L. Books, 1996.

Shen, Kuiyi. "Propaganda Posters and Art during the Cultural Revolution." In *Art and China's Revolution,* edited by Melissa Chiu and Shengtian Zheng, pp. 149-64.

Shi Zhenyu. "Reminiscence" / "Wangshi." In Wang Aihe, *Wuming (No Name) Painting Catalogue,* vol. 5, trans. Shi Zhenyuan, Shi Ying, and Rene Balcer, pp. 11-16.

Spencer, Norman, ed. *Shiwu shi tamen ziji de xiangzheng: Yan Li de chuangzuo yiji ta de pengyoumen* [Things are symbols of themselves: Yan Li's creative work and his friends]. Tehran: Ostoore Publications, 2005.

Tian Shuying. "Self-statement" / "Zishu." In Wang Aihe, *Wuming (No Name) Painting Catalogue,* vol. 6, trans. Wo Hoi Kwan and René Balcer, pp. 13-15.

Wang Aihe. "The Silk Tree" / "Hehuanshu." In Wang Aihe, *Wuming (No Name) Painting Catalogue,* vol. 7, pp. 11-20.

_____. "Wuming: Art and Solidarity in a Peculiar Historical Context" / "Wuming: teshu lishi tiaojianxia de yishu he tuanti." In Wang Aihe, *Wuming (No Name) Painting Catalogue,* vol. 7, pp. 5-10. Appears in each of the 13 volumes.

_____, ed. *Wuming (No Name) Painting Catalogue.* 13 vols. Hong Kong: Hong Kong University Press, 2009.

Wang Keping. Hong Kong: A Vibrant Life Publication, 2008.

Wei Hai. "Art and Life" / "Yishu yu shengming." In Wang Aihe, *Wuming (No Name) Painting Catalogue,* vol. 8, trans. Wu Di, Julien De Jaillon, and René Balcer, pp. 11-16.

Wenxue ziliao [Literature materials], nos. 1-3 (1980), supplement to *Jintian* [*Today*]. Facsimile editions. Beijing : Jintian wenxue zazhishe, 2008.

Wu Guanzhong. "Huihua de xingshi mei" [On the beauty of form in painting]. In *Meishu* [Art] 1979.5: 33-35, 44.

Wu Hung, ed. *Contemporary Chinese Art: Primary Documents.* New York: Museum of Modern Art, 2010.

Xu Xiao, ed. *Today30 / Jintian sanshinian.* Beijing: Jintian wenxue zazhishe, 2008.

Yang Xiao Machuan and Zheng Lei. *Liebian: shi'er yue zhang (dui hua Qiu Deshu)* [Fissures: December volume (dialogue with Qiu Deshu)]. Shanghai: Shanghai baijia chubanshe, 2009.

Zhang Wei. "An Extraordinary Journey: From Courtyard House to Supreme Court" / "Cong siheyuan dao zuigao fayuan." In Wang Aihe, *Wuming (No Name) Painting Catalogue,* vol. 10, trans. Elaine Woo and Greg M. Thomas, pp. 12-19.

Zheng Zigang. "Self-statement" / "Zishu." In Wang Aihe, *Wuming (No Name) Painting Catalogue,* vol. 12, trans. Zheng Luoyi, Julien De Jaillon, and René Balcer, pp. 11-15.

Zheng Ziyan. "Paint to Follow the Heart" / "Xun neixin er hua." In Wang Aihe, *Wuming (No Name) Painting Catalogue,* vol. 13, trans. Wu Di, Julien De Jaillon, and René Balcer, pp. 11-16.

Zhu Pu, ed. *Liebian—Qiu Deshu* [Fissuring—Qiu Deshu]. Shanghai: Shanghai meishuguan, 1994.

Zhu Zhu, ed. *Yuandian* [Origin point]. Hong Kong: Shijie yishu chubanshe, 2007.

CHINA INSTITUTE GALLERY EXHIBITIONS: 1966-2011

1. SELECTIONS OF CHINESE ART FROM PRIVATE COLLECTIONS IN THE METROPOLITAN AREA
November 15, 1966-February 15, 1967
Curator: Mrs. Gilbert Katz

2. ART STYLES OF ANCIENT SHANG
April 5-June 11, 1967
Curator: Jean Young

3. ANIMALS AND BIRDS IN CHINESE ART
October 25, 1967-January 28, 1968
Curator: Fong Chow

4. GARDENS IN CHINESE ART
March 21-May 26, 1968
Curator: Wan-go H.C. Weng

5. CHINESE JADE THROUGH THE CENTURIES
October 24, 1968-January 26, 1969
Curator: Joan M. Hartman

6. FOREIGNERS IN ANCIENT CHINESE ART
March 27-May 25, 1969
Curator: Ezekiel Schloss

7. CHINESE PAINTED ENAMELS
October 23, 1969-February 1, 1970
Curator: J.A. Lloyd Hyde

8. ALBUM LEAVES FROM THE SUNG AND YUAN DYNASTIES
March 26-May 30, 1970
Curator: C.C. Wang

9. MING PORCELAINS: A RETROSPECTIVE
October 29, 1970-January 31, 1971
Curator: Suzanne G. Valenstein

10. CHINESE SILK TAPESTRY: K'O-SSU
March 24-May 27, 1971
Curator: Jean Mailey

11. EARLY CHINESE GOLD AND SILVER
October 21, 1971-January 30, 1972
Curator: Dr. Paul Singer

12. DRAGONS IN CHINESE ART
March 23-May 28, 1972
Curator: Hugo Munsterberg

13. WINTRY FORESTS, OLD TREES: SOME LANDSCAPE THEMES IN CHINESE PAINTING
October 26, 1972-January 28, 1973
Curator: Richard Barnhart

14. CERAMICS IN THE LIAO DYNASTY: NORTH AND SOUTH OF THE GREAT WALL
March 15-May 28, 1973
Curator: Yutaka Mino

15. CHINA TRADE PORCELAIN: A STUDY IN DOUBLE REFLECTIONS
October 25, 1973-January 27, 1974
Curator: Claire le Corbeiller

16. TANTRIC BUDDHIST ART
March 14-May 24, 1974
Curator: Eleanor Olson

17. FRIENDS OF WEN CHENG-MING: A VIEW FROM THE CRAWFORD COLLECTION
October 24, 1974-January 26, 1975
Curators: Marc F. Wilson and Kwan S. Wong

18. ANCIENT CHINESE JADES FROM THE BUFFALO MUSEUM OF SCIENCE
April 3-June 15, 1975
Curator: Joan M. Hartman

19. ART OF THE SIX DYNASTIES: CENTURIES OF CHANGE AND INNOVATION
October 29, 1975-February 1, 1976
Curator: Annette L. Juliano

20. CHINA'S INFLUENCE ON AMERICAN CULTURE IN THE 18TH AND 19TH CENTURIES
April 8-June 13, 1976
Curators: Henry Trubner and William Jay Rathburn
(Exhibition traveled to the Seattle Art Museum, October 7-November 28, 1976)

21. CHINESE FOLK ART IN AMERICAN COLLECTIONS: EARLY 15TH THROUGH 20TH CENTURIES
October 27, 1976-January 30, 1977
Curator: Tseng Yu-Ho Ecke

22. EARLY CHINESE MINIATURES
March 16-May 29, 1977
Curator: Dr. Paul Singer

23. I-HSING WARE
October 28, 1977-January 29, 1978
Curator: Terese Tse Bartholomew
(Exhibition traveled to the Nelson Gallery of Art, Kansas City, February 19-May 21, 1978, and the Asian Art Museum of San Francisco, June 16-September 21, 1978)

24. EMBROIDERY OF IMPERIAL CHINA
March 17-May 28, 1978
Curator: Jean Mailey

25. ORIGINS OF CHINESE CERAMICS
October 25, 1978-January 28, 1979
Curator: Clarence F. Shangraw

26. ART OF THE HAN
March 14-May 27, 1979
Curator: Ezekiel Schloss

27. TREASURES FROM THE METROPOLITAN MUSEUM OF ART
October 25-November 25, 1979
Curator: Clarence F. Shangraw

28. CHINESE ART FROM THE NEWARK MUSEUM
March 19-May 25, 1980
Curators: Valrae Reynolds and Yen Fen Pei

29. CHINESE PORCELAINS IN EUROPEAN MOUNTS
October 22, 1980-January 25, 1981
Curator: Sir Francis Watson

30. FREEDOM OF CLAY AND BRUSH THROUGH SEVEN CENTURIES IN NORTHERN CHINA: TZ'U-CHOU TYPE WARES 960-1600 A.D.
March 16-May 24, 1981
Curator: Yutaka Mino
(Exhibition originated at Indianapolis Museum of Art)

31. THE ART OF CHINESE KNOTTING
July 29-September 21, 1981
Curator: Hsia-Sheng Chen

32. MASTERPIECES OF SUNG AND YUAN DYNASTY CALLIGRAPHY FROM THE JOHN M. CRAWFORD JR. COLLECTION
October 21, 1981-January 31, 1982
Curator: Kwan S. Wong, assisted by Stephen Addiss
(Exhibition traveled to the Spencer Museum, University of Kansas, March 14-April 18, 1982)

33. THE COMMUNION OF SCHOLARS: CHINESE ART AT YALE
March 20-May 30, 1982
Curator: Mary Gardner Neill
(Exhibition traveled to the Museum of Fine Arts, Houston, June 22-August 22, 1982, and the Yale Art Gallery, New Haven, October 5, 1982-April 17, 1983)

34. CHINA FROM WITHIN
November 4-December 12, 1982
A Smithsonian Institution Travelling Services Exhibition, organized by the International Photography Society in cooperation with the China Exhibition Agency, Beijing, and the Chinese Embassy, Washington, DC

35. BAMBOO CARVING OF CHINA
March 18-May 29, 1983
Curators: Wang Shixiang and Wan-go H.C. Weng
(Exhibition traveled to The Nelson-Atkins Museum of Art, Kansas City, July 24-September 11, 1983, and the Asian Art Museum of San Francisco, October 3, 1983-January 15, 1984)

36. CHINESE CERAMICS OF THE TRANSITIONAL PERIOD: 1620-1683
October 21, 1983-January 29, 1984
Curator: Stephen Little
(Exhibition traveled to the Kimbell Art Museum, Fort Worth, May 26-August 26, 1984)

37. MASTERPIECES OF CHINESE EXPORT PORCELAIN AND RELATED DECORATIVE ARTS FROM THE MOTTAHEDEH COLLECTION
February 10-March 7, 1984
U.S.-China 200 Bicentennial Exhibition, organized by Anita Christy

38. CHINESE TRADITIONAL ARCHITECTURE
April 6-June 10, 1984
Curator: Nancy Shatzman Steinhardt
(Exhibition traveled to Allegheny College, Meadeville, PA, March 28-April 19, 1985; Marlboro College, Marlboro, VT, September 11-October 31, 1985; State University of New York, Binghamton, NY January 7-February 27, 1986)

39. CHINESE RARE BOOKS IN AMERICAN COLLECTIONS
October 20, 1984-January 29, 1985
Curator: Soren Edgren

40. THE SUMPTUOUS BASKET: CHINESE LACQUER WITH BASKETRY PANELS
March 20-June 3, 1985
Curator: James C.Y. Watt

41. KERNELS OF ENERGY, BONES OF EARTH: THE ROCK IN CHINESE ART
October 26, 1985-January 26, 1986
Curator: John Hay

42. PUPPETRY OF CHINA
April 19-June 29, 1986
Curator: Roberta Helmer Stalberg
Organized by the Center for Puppetry Arts, Atlanta

43. SELECTIONS OF CHINESE ART FROM PRIVATE COLLECTIONS
October 18, 1986-January 4, 1987
Exhibition celebrating the 60th Anniversary of China Institute and the 20th Anniversary of China Institute Gallery, organized by James C.Y. Watt and Annette L. Juliano

44. 1987 NEW YEAR EXHIBITION

45. CHINESE FOLK ART
April 4-May 30, 1987
Curator: Nancy Zeng Berliner

46. RICHLY WOVEN TRADITIONS: COSTUMES OF THE MIAO OF SOUTHWEST CHINA AND BEYOND
October 22, 1987-January 4, 1988
Curator: Theresa Reilly

47. 1988 NEW YEAR EXHIBITION
February 4-February 24, 1988

48. RITUAL AND POWER: JADES OF ANCIENT CHINA
April 23-June 19, 1988
Curator: Elizabeth Childs-Johnson

49. STORIES FROM CHINA'S PAST
September 17-November 12, 1988
Organized by The Chinese Culture Center of San Francisco

50. 1989 NEW YEAR EXHIBITION: LANTERNS
January 28-February 25, 1989

51. MIND LANDSCAPES: THE PAINTINGS OF C.C. WANG
April 3-May 27, 1989
Curator: Jerome Silbergeld

52. CHINA BETWEEN REVOLUTIONS: PHOTOGRAPHY BY SIDNEY D. GAMBLE, 1917-1927
June 29-September 9, 1989
Organized by The Sidney D. Gamble Foundation for China Studies and China Institute in America

53. VIEWS FROM JADE TERRACE: CHINESE WOMEN ARTISTS, 1300-1912
October 5-December 2, 1989
Organized by Indianapolis Museum of Art

54. 1990 NEW YEAR EXHIBITION: THE CHINESE EARTH-VIEWS OF NATURE
January-March 1990
Curator: Anita Christy

55. CLEAR AS CRYSTAL, RED AS FLAME: LATER CHINESE GLASS
April 21-June 16, 1990
Curator: Claudia Brown and Donald Rabiner

56. THE ECCENTRIC PAINTERS OF YANGZHOU
October 20 December 15, 1990
Curator: Vito Giacalone

57. 1991 NEW YEAR EXHIBITION: CHILDREN IN CHINESE ART
January 26-March 2, 1991
Organized under the auspices of the China Institute Women's Association

58. ANCIENT CHINESE BRONZE ART: CASTING THE PRECIOUS SACRAL VESSEL
April 20-June 15, 1991
Curator: W. Thomas Chase

59. EARLY CHINESE CERAMICS FROM NEW YORK STATE MUSEUMS
October 19-December 14, 1991
Curator: Martie W. Young

60. TREASURES OF THE LAST EMPEROR: SELECTIONS FROM THE PALACE MUSEUM, BEIJING
February 1-March 7, 1992
Curator: Lawrence Wu

61. LAMAS, PRINCES AND BRIGANDS: PHOTOGRAPHS BY JOSEPH ROCK OF THE TIBETAN BORDERLANDS OF CHINA
April 15-July 31, 1992
Curator: Michael Aris

62. WORD AS IMAGE: THE ART OF CHINESE SEAL ENGRAVING
October 21-December 12, 1992
Curator: Jason C. Kuo

63. A YEAR OF GOOD FORTUNE-1993: LEGENDS OF THE ROOSTER AND TRADITIONS OF THE CHINESE NEW YEAR
January 19-March 6, 1993
Curator: Willow Weilan Hai

64. DISCARDING THE BRUSH: GAO QIPEI, 1660-1734
April 17-June 12, 1993
Curator: Klass Ruitenbeek
Organized by the Rijksmuseum Amsterdam

65. AS YOU WISH: SYMBOL AND MEANING ON CHINESE PORCELAINS FROM THE TAFT MUSEUM
October 23-January 15, 1994
Curator: David T. Johnson

66. SENDING AWAY THE OLD, WELCOMING THE NEW
February 5-March 5, 1994
Curator: Karen Kane

67. CAPTURING A WORLD: CHINA AND ITS PEOPLE—PHOTOGRAPHY BY JOHN THOMSON
March 26-June 11, 1994
Organized by the British Council; catalogue by the British Council

68. AT THE DRAGON COURT: CHINESE EMBROIDERED MANDARIN SQUARES FROM THE SCHUYLER V.R. CAMMANN COLLECTION
October 20-December 22, 1994
Brochure from similar show which took place at Yale Univ. Art Gallery
Curator: John Finlay

69. ANIMALS OF THE CHINESE ZODIAC: CELEBRATING CHINESE NEW YEAR
January 20-March 4, 1995
Curator: Willow Weilan Hai

*70. CHINESE PORCELAINS OF THE SEVENTEENTH CENTURY: LANDSCAPES, SCHOLARS' MOTIFS AND NARRATIVES
April 22-August 5, 1995
Curator: Julia B. Curtis

71. ABSTRACTION AND EXPRESSION IN CHINESE CALLIGRAPHY
October 14-December 21, 1995
Curator: H. Christopher Luce
(Exhibition traveled to the Seattle Art Museum, Seattle, Washington, November 21, 1996-March 23, 1997 and to the Santa Barbara Museum of Art, Santa Barbara, California, September 18-November 21, 1999)

72. CALLIGRAPHY AS LIVING ART: SELECTIONS FROM THE JILL SACKLER CHINESE CALLIGRAPHY COMPETITION
February 3-March 9, 1996
Curator: Willow Weilan Hai, in conjunction with the Arthur M. Sackler Foundation, Washington, D.C.

73. HARE'S FUR, TORTOISESHELL AND PARTRIDGE FEATHERS: CHINESE BROWN-AND BLACK-GLAZED CERAMICS, 400-1400
April 20-July 6, 1996
Curator: Robert Mowry
Organized by the Harvard University Art Museum, Massachusetts

*74. THE LIFE OF A PATRON: ZHOU LIANGGONG (1612-1672) AND THE PAINTERS OF SEVENTEENTH-CENTURY CHINA
October 23-December 21, 1996
Curator: Hongnam Kim

75. ADORNMENT FOR ETERNITY: STATUS AND RANK IN CHINESE ORNAMENT
February 6–July 14, 1997
Curators: Julia White and Emma Bunker
Organized by the Denver Art Museum

*76. POWER AND VIRTUE: THE HORSE IN CHINESE ART
September 11–December 13, 1997
Curator: Robert E. Harrist, Jr.

77. SCENT OF INK: THE ROY AND MARILYN PAPP COLLECTION OF CHINESE ART
February 5–June 20, 1998
Curator: Claudia Brown
Organized by the Phoenix Art Museum

78. CHINESE SNUFF BOTTLES FROM THE PAMELA R. LESSING FRIEDMAN COLLECTION
September 16–December 13, 1998
Organized by the Asian Art Coordinating Council

*79. A LITERATI LIFE IN THE TWENTIETH CENTURY: WANG FANGYU—ARTIST, SCHOLAR, CONNOISSEUR
February 11–June 20, 1999
Curator: H. Christopher Luce

*80. THE RESONANCE OF THE QIN IN EAST ASIAN ART
September 16–December 12, 1999
Curator: Stephen Addiss

81. 2000 NEW YEAR EXHIBITION: THE STORY OF RED
January 12–February 11, 2000
Curator: Willow Weilan Hai Chang

*82. DAWN OF THE YELLOW EARTH: ANCIENT CHINESE CERAMICS FROM THE MEIYINTANG COLLECTION
March 21–June 18, 2000
Curator: Regina Krahl
(Exhibition traveled to the Fresno Metropolitan Museum of Art, Fresno, California, August 11–November 12, 2000)

* 83. THE CHINESE PAINTER AS POET
September 14–December 10, 2000
Curator: Jonathan Chaves

84. LIVING HERITAGE: VERNACULAR ENVIRONMENT IN CHINA
January 25–June 10, 2001
Curator: Kai-yin Lo

*85. EXQUISITE MOMENTS: WEST LAKE & SOUTHERN SONG ART
September 25–December 9, 2001
Curator: Hui-shu Lee

86. CIRCLES OF REFLECTION: THE CARTER COLLECTION OF CHINESE BRONZE MIRRORS
February 7–June 2, 2002
Curator: Ju-hsi Chou

*87. BLANC DE CHINE: DIVINE IMAGES IN PORCELAIN
September 19–December 7, 2002
Curator: John Ayer

88. WEAVING CHINA'S PAST: THE AMY S. CLAQUE COLLECTION OF CHINESE TEXTILES
January 29–June 7, 2003
Curator: Claudia Brown

*89. PASSION FOR THE MOUNTAINS: 17TH CENTURY LANDSCAPE PAINTINGS FROM THE NANJING MUSEUM
September 18–December 20, 2003
Curator: Willow Weilan Hai Chang

90. GOLD & JADE: IMPERIAL JEWELRY OF THE MING DYNASTY FROM THE NANJING MUNICIPAL MUSEUM
February 12–June 5, 2004
Organized by Nanjing Municipal Museum & the China Institute Gallery

91. THE SCHOLAR AS COLLECTOR: CHINESE ART AT YALE
September 23–December 11, 2004
Curator: David Ake Sensabaugh

*92. PROVIDING FOR THE AFTERLIFE: "BRILLIANT ARTIFACTS" FROM SHANDONG
February 3–June 4, 2005
Curators: Susan L. Beningson & Carry Liu

93. MASTERPIECES OF CHINESE LACQUER FROM THE MIKE HEALY COLLECTION
September 16–December 3, 2005
Curator: Julia M. White
Organized by the Honolulu Academy of Arts

*94. TRADE TASTE & TRANSFORMATION: JINGDEZHEN PORCELAIN FOR JAPAN, 1620–1645
February 2–June 10, 2006
Curator: Julia B. Curtis
(Exhibition traveled to the Honolulu Academy of Arts, Hawaii, July 19–October 8, 2006)

95. THE BEAUTY OF CHINESE GARDENS
June 28–August 12, 2006
Organized by the China Institute Gallery

*96. SHU: REINVENTING BOOKS IN CONTEMPORARY CHINESE ART
Part I: September 28–November 11, 2006
Part II: December 13–February 24, 2007
Curator: Wu Hung
(Exhibition traveled to Seattle Asian Art Museum, Washington, August 9–December 2, 2007, and Honolulu Academy of Arts, Hawaii, June 25–August 31, 2008)

97. TEA, WINE AND POETRY: THE ART OF DRINKING VESSELS THE INTERNATIONAL ASIAN ART FAIR, NEW YORK
March 23–March 28, 2007
Organized by the China Institute Gallery

98. TEA, WINE AND POETRY: QING DYNASTY LITERATI AND THEIR DRINKING VESSELS
March 24–June 16, 2007
Curators: Guo Ruoyu and Soong Shu Kong
Organized by the University Museum and Art Gallery, The University of Hong Kong

*99. BUDDHIST SCULPTURE FROM CHINA: SELECTIONS FROM XI'AN BEILIN MUSEUM, FIFTH THROUGH NINTH CENTURIES
September 20–December 8, 2007
Curator: Annette L. Juliano

*100. ENCHANTED STORIES: CHINESE SHADOW THEATER IN SHAANXI
January 31–May 11, 2008
Curators: Chen Shanqiao, Li Hongjun, and Zhao Nong
Organized by China Institute Gallery in collaboration with Shaanxi Provincial Art Gallery

101. BEIJING 2008: A PHOTOGRAPHIC JOURNEY
June 12–August 17, 2008
A special exhibition organized by the China Institute Gallery and the Beijing Archive Bureau

*102. THE LAST EMPEROR'S COLLECTION: MASTERPIECES OF PAINTING AND CALLIGRAPHY FROM THE LIAONING PROVINCIAL MUSEUM
September 25–December 14, 2008
Curators: Willow Weilan Hai Chang, Yang Renkai, and David Ake Sensabaugh

103. NOBLE TOMBS AT MAWANGDUI: ART AND LIFE IN THE CHANGSHA KINGDOM, THIRD CENTURY BCE TO FIRST CENTURY CE
February 12–June 7, 2009
Curator: Chen Jianming
Organized by China Institute Gallery and Hunan Provincial Museum
(Exhibition traveled to Santa Barbara Museum of Art, September 19–December 13, 2009)

*104. HUMANISM IN CHINA: A CONTEMPORARY RECORD OF PHOTOGRAPHY
September 24–December 13, 2009
Organized by the Guangdong Museum of Art.
Re-organized by China Institute Gallery and Jerome Silbergeld.

*105. CONFUCIUS: HIS LIFE AND LEGACY IN ART
February 11–June 13, 2010
Curators: Lu Wensheng and Julia K. Murray

106. WOODCUTS IN MODERN CHINA, 1937–2008: TOWARDS A UNIVERSAL PICTORIAL LANGUAGE
September 16–December 5, 2010
Exhibition organized by the Picker Art Gallery at Colgate University

*107. ALONG THE YANGZI RIVER: REGIONAL CULTURE OF THE BRONZE AGE FROM HUNAN
January 27–June 12, 2011
Curators: Chen Jianming, Jay Xu, and Fu Juliang
Organized under the direction of Willow Weilan Hai Chang in collaboration with the Hunan Provincial Museum

* Exhibition catalogues currently available for sale.
For information on the availability of these titles and others, please contact China Institute in America at (212) 744-8181.

Younghee Kim-Wait and Jarrett F. Wait
Angela H. King
James J. and Helen D. Lally
Helen Y. and William E. Little
Robert W. and Virginia Riggs Lyons
Clare Tweedy McMorris and Howard McMorris, III
Gerard M. Meistrell
William N. Raiford
Howard and Mary Ann Rogers
Diane H. Schafer and Jeffrey A. Stein
Martha Sutherland and Barnaby Conrad III
Ann Tanenbaum
Charles J. Tanenbaum
Patricia P. Tang
Shao Fang and Cheryl L. Wang
Laura B. Whitman and Thomas Danziger
Yvonne L. C. and Frederick Wong
Denis C. and Kathleen Yang
Robert P. and Barbara Youngman

GALLERY COMMITTEE

Diane H. Schafer, Chair
Agnes Gund, Vice-Chair
Yvonne L.C. Wong, Vice-Chair

Susan L. Beningson
Claudia Brown
James J. Chin
Mary Wadsworth Darby
Jane DeBevoise
Robert E. Harrist, Jr.
Jonathan Hay
Maxwell K. Hearn
Annette L. Juliano
Peter Rupert Lighte
David Ake Sensabaugh
Jerome Silbergeld
Sophia Sheng
Nancy S. Steinhardt
Julie Grimes Waldorf
Marie-Hélène Weill

GALLERY STAFF

Willow Weilan Hai Chang, Director
Beth Eisenstaedt, Registrar and Manager
Yue Ma, Art Education Manager

DOCENTS

Viviane Chen
Janis M. Eltz
Ka Wing Karen Ng
Roberta Nitka
Patricia Reilly
Betty Tom

VOLUNTEERS

Ann Dillon
Jackie Handel
Gloria Young